SO-AIJ-241

HAWAII
DREAMSCAPES REVEALED

Big Island

HAWAII DREAM

SCAPES REVEALED

Big Island

ANDREW DOUGHTY

AUTHOR & PHOTOGRAPHER

LEONA BOYD

PHOTOGRAPHER

WIZARD
PUBLICATIONS
INC

© Copyright 2007 Wizard Publications, Inc.
All rights reserved.

ISBN 13: 978–0–9717279–6–0
ISBN 10: 0–9717279–6–1
LCCN: 2006929845

Printed in China

All photographs by: Andrew Doughty & Leona Boyd
Book design by: Lisa Pollak

Wizard Publications, Inc.
P.O. Box 991, Lihu'e, HI 96766–0991
Web site: www.wizardpub.com
E-mail: aloha@wizardpub.com

To my beautiful children, *Ashley and Brandon—Since the first time I felt you move, you were the most important part of my life. With all my heart I love you and am so very proud of you both. Don't forget to live life to its fullest.*

To my parents, *Oma and Hezzie—You brought me into this world. I only wish you could of been here to see who I have become. I hope I would have made you proud. And to the parents who took me under their wing, Norma and Earl (Mom and Dad)—You gave me the model of life that I live by to this day, and saved and guided me to be the person that I am.* —Leona Boyd

To all the readers over the years *who have made me such a blessed man—I literally couldn't have done it without you, and to you I gratefully dedicate this first edition of Dreamscapes.* —Andrew Doughty

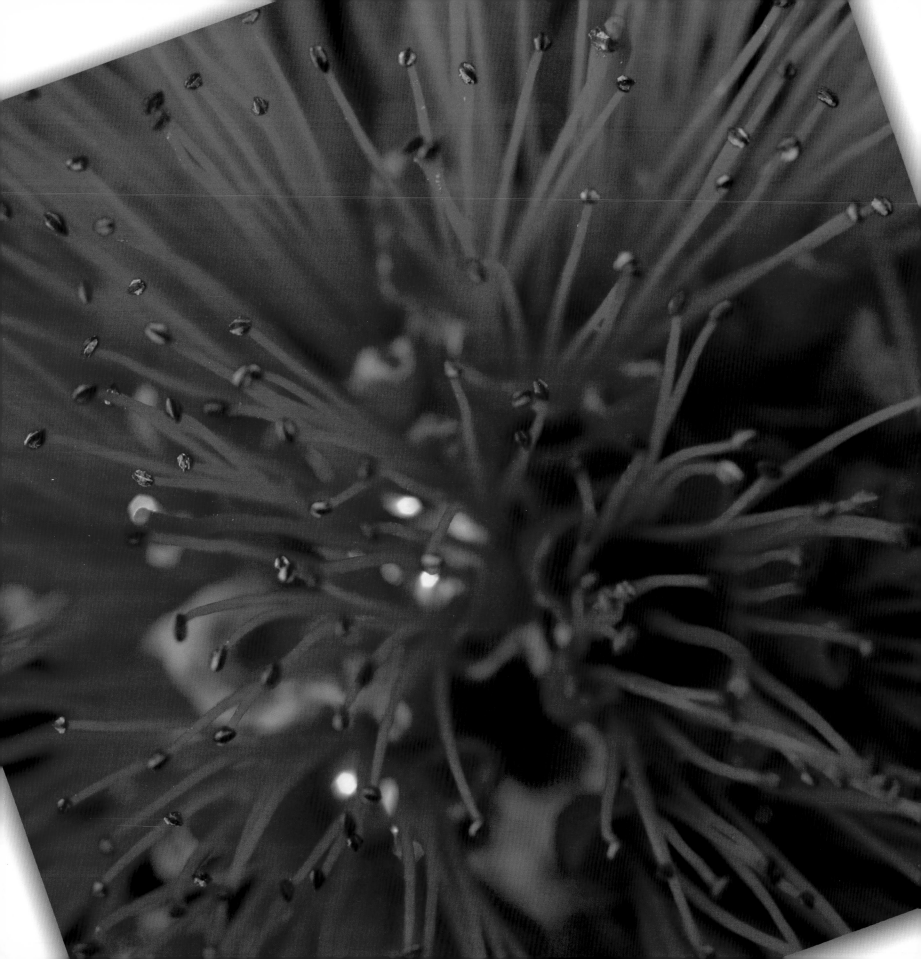

Introduction

The dictionary defines a dreamscape as "a landscape or scene with the strangeness or mystery characteristic of dreams." You'd be hard pressed to find a place that fits that description more perfectly than Hawai'i. Here you find a land of strangeness, an air of mystery and the stuff of dreams. It's hard to overstate the uniqueness of these islands. If you travel the world, you won't have trouble finding beautiful lands of simple surf and sea. But in Hawai'i all the elements come together in ways unimaginable elsewhere.

Each of the Hawaiian islands is fantastically different. It's as if they were adopted into the island chain from different families, seeming to come from different stocks of island DNA. Their uniqueness is a result of time and each island's tireless migration away from its place of birth.

Beneath the islands lies a powerful island-making machine. Called a hot spot by geologists, it is a rupture in the earth's crust where a constant and unrelenting blast of magma forces its way to the surface. But the surface is actually a tectonic plate that is constantly in motion. Moving northwest at roughly the speed that your fingernails grow, it acts as a conveyor belt for the islands, carrying them away from their source of lava. Islands form above the hot spot and characterize themselves with smooth mountains and active volcanoes. Over time they drift away on this tectonic cruise, their fires go out, and they slowly sink and erode back into the sea.

The northwest islands, such as Kaua'i and O'ahu, are older and farther north on this conveyor belt. Time has had a chance to carve lovely scars onto their surfaces. Water has embraced and blessed, rearranged and nurtured the land. As you travel southeast, you're actually traveling forward in time until you finally reach the Big Island, and it's timely location directly above the hot spot.

▼ *Gnarly 'ohi'a trees are decorated by lovely lehua blossoms.*

The Big Island of Hawai'i is the youngest star of the Hawaiian chain. It's made up of five volcanoes, each born successively. The oldest is Kohala and it is there that you start to see the aging process. Deep valleys along the Hamakua Coast and waterfalls that tumble into the ocean are characteristics of mountains that have eroded from the life-giving yet corrosive rainfall and the endless battle with a raging sea.

Hualalai comes next, followed by Mauna Kea reaching the majestic height of 13,769 feet. At that altitude you've ascended far above the tropics. Snow-capped peaks and lunar landscapes are common. Imagine a place where you're close enough to kiss the stars and look down on the clouds below you.

Mauna Loa was the next volcano to emerge, then along came Kilauea. Resting on the side of Mauna Loa, it might not look like a separate mountain, but Kilauea has its own magma chamber, creating a distinct identity from the more impressive Mauna Loa. Kilauea is the youngest, noisiest and most dramatic volcano. Restless and fidgety, this captivating and ever-changing volcano makes lava viewing synonymous with a Big Island visit.

Sprinkled among these volcanoes is a land more rich and diverse than perhaps any on the planet. This is a land that has ten of the world's fifteen types of climatic zones. Imagine a scene and you'll likely find it on the Big Island. You'll encounter a place where snow and luscious sand beaches studded with colorful coral reefs exist side by side. Where peaceful waterfalls and tropical flowers, meet intense lava flows and noxious sulfuric fumes. Contrasting landscapes and impossible colors challenge reality. The vast pasturelands of the nation's largest cattle ranch are here along with arid deserts. And the remains of ancient Hawaiian temples are still here as are the descendants of those who built them.

When you have ingredients like this, you have a place of endless fascination, surprises and drama. You have a land that is unmatched anywhere in the world. You have Hawai'i, the Big Island.

Big Island

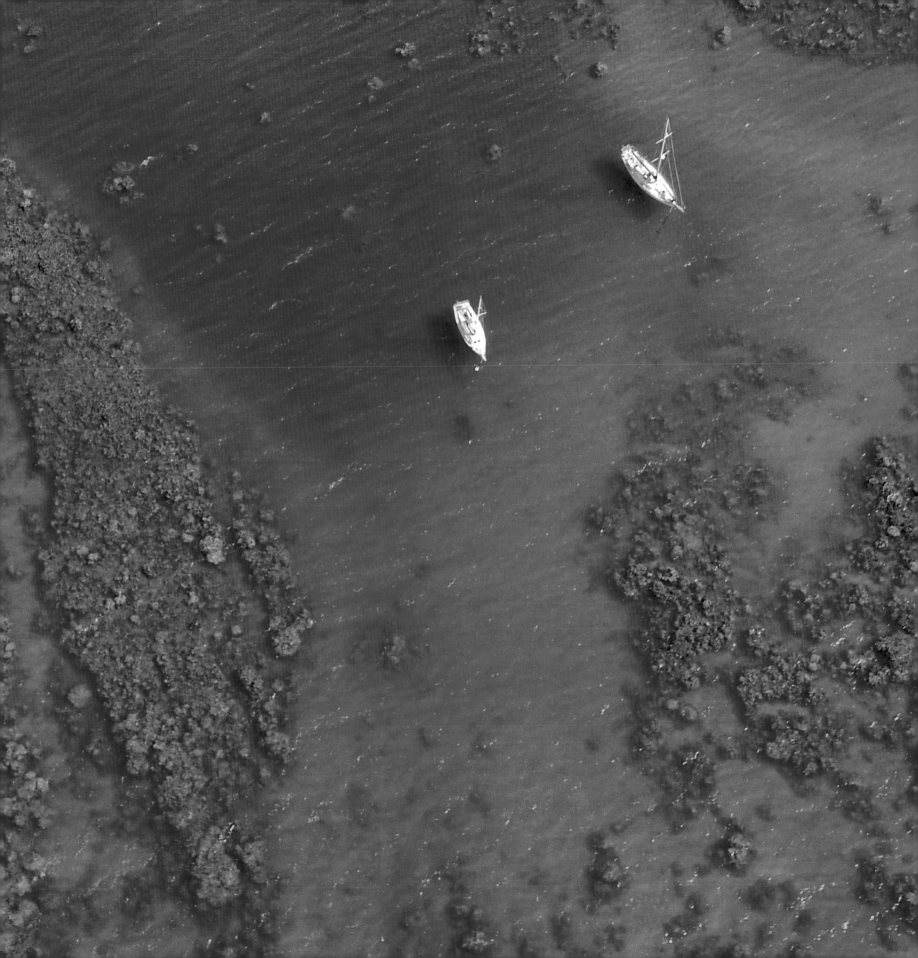

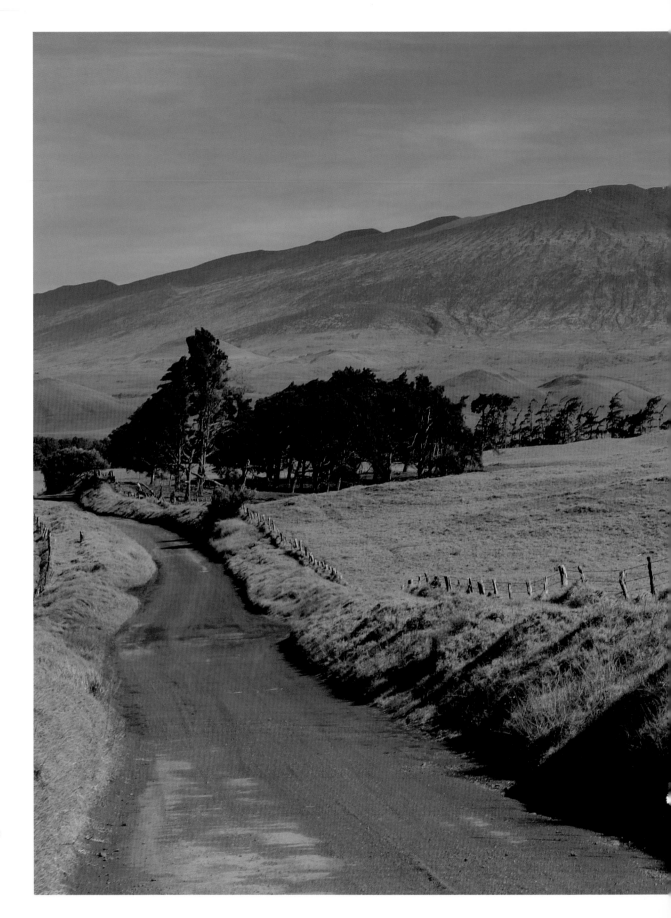

▼ *Mana Road behind the town of Waimea is not your typical tropical scene. Then again, the Big Island isn't your typical tropical island.*

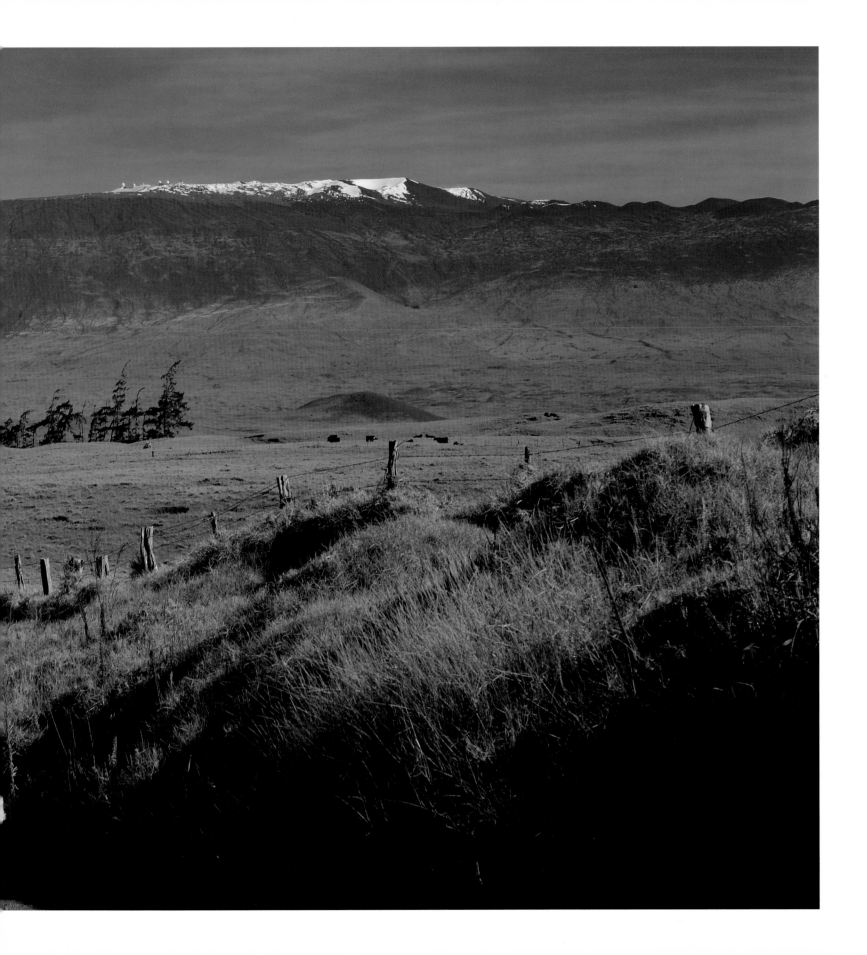

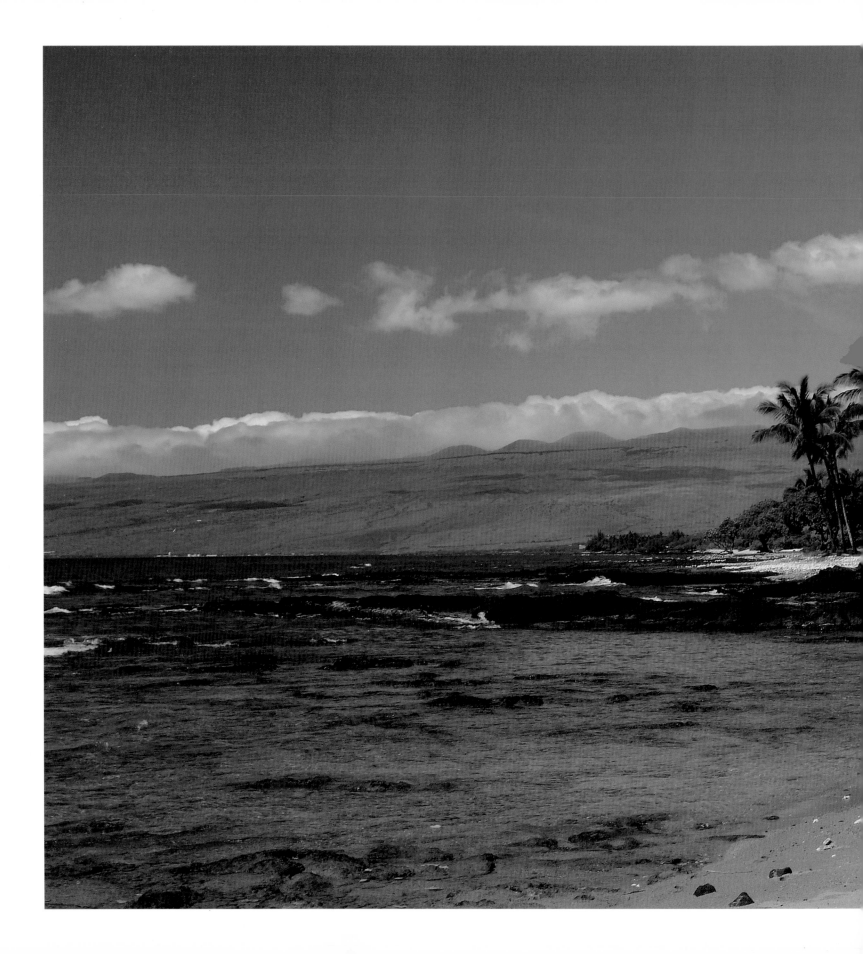

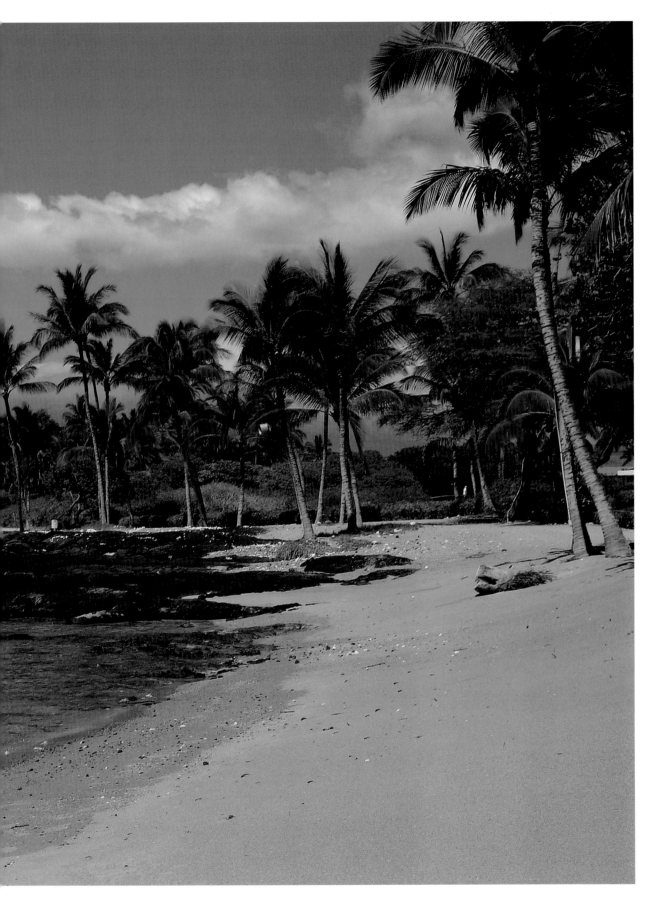

▼ *The Mauna Lani resort area sports coconut-strewn beaches.*

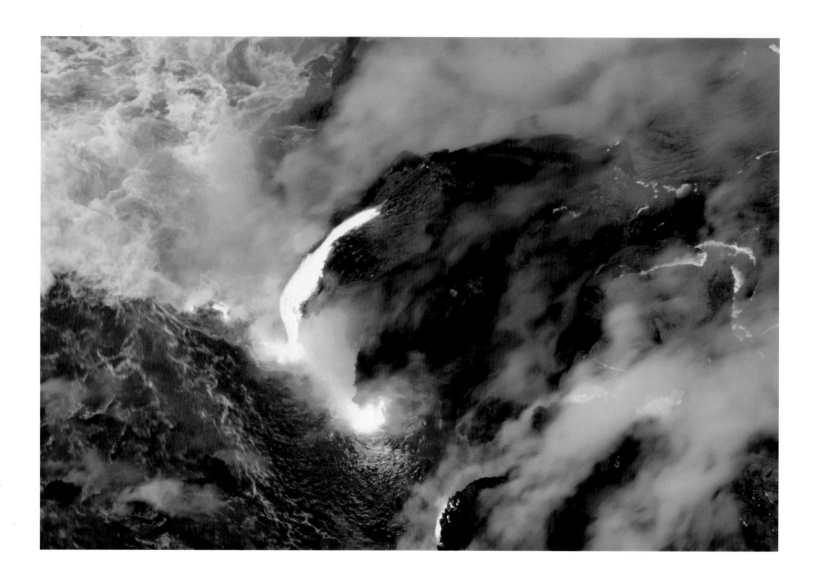

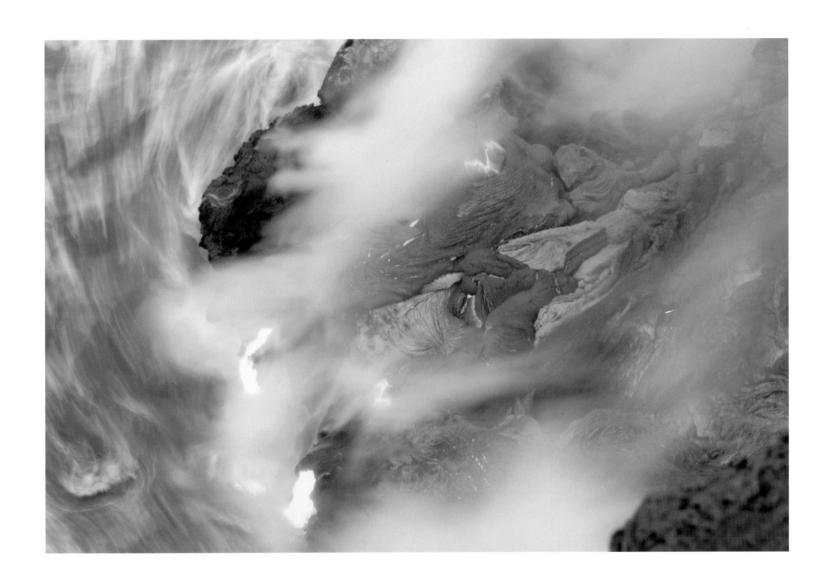

▼ *After its long journey from deep in the earth's crust, molten lava meets the cold reality of the sea.*

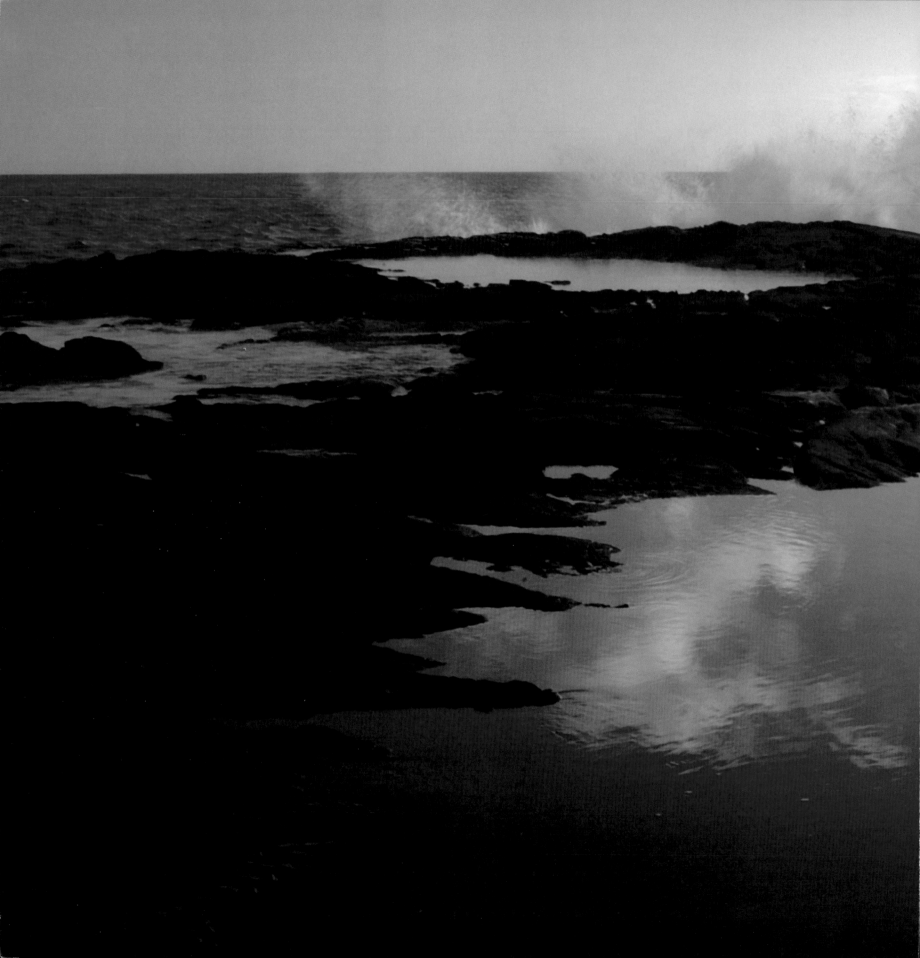

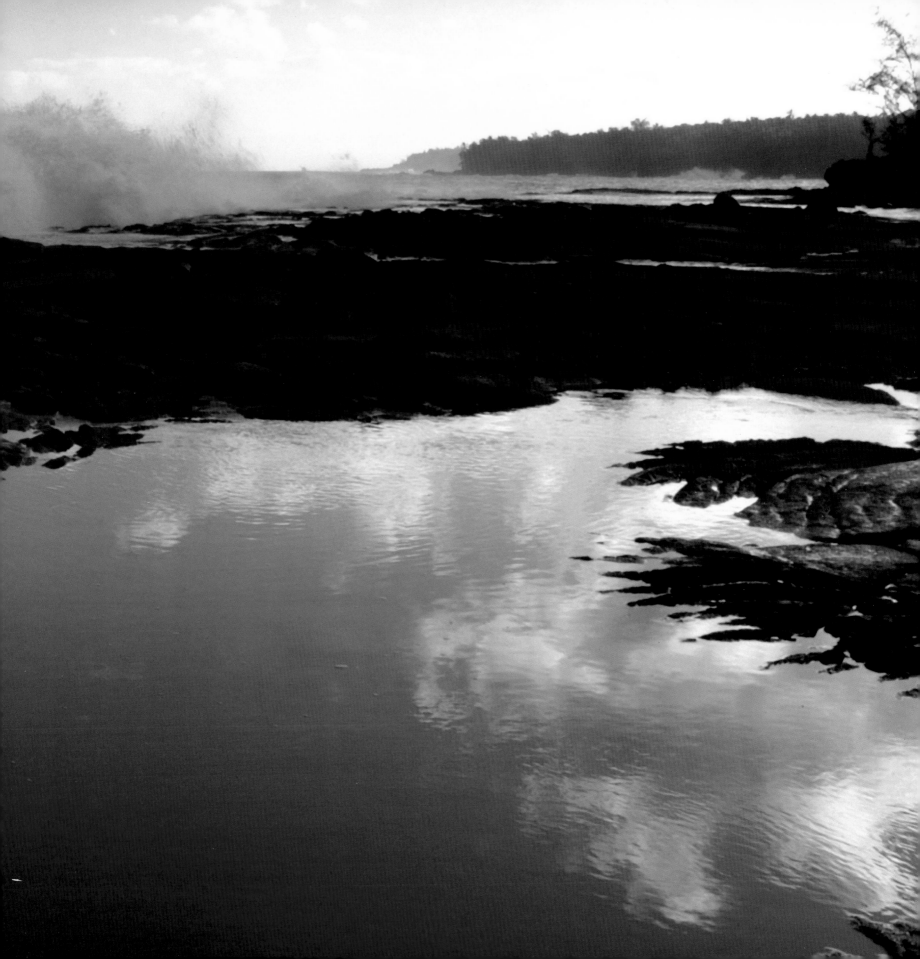

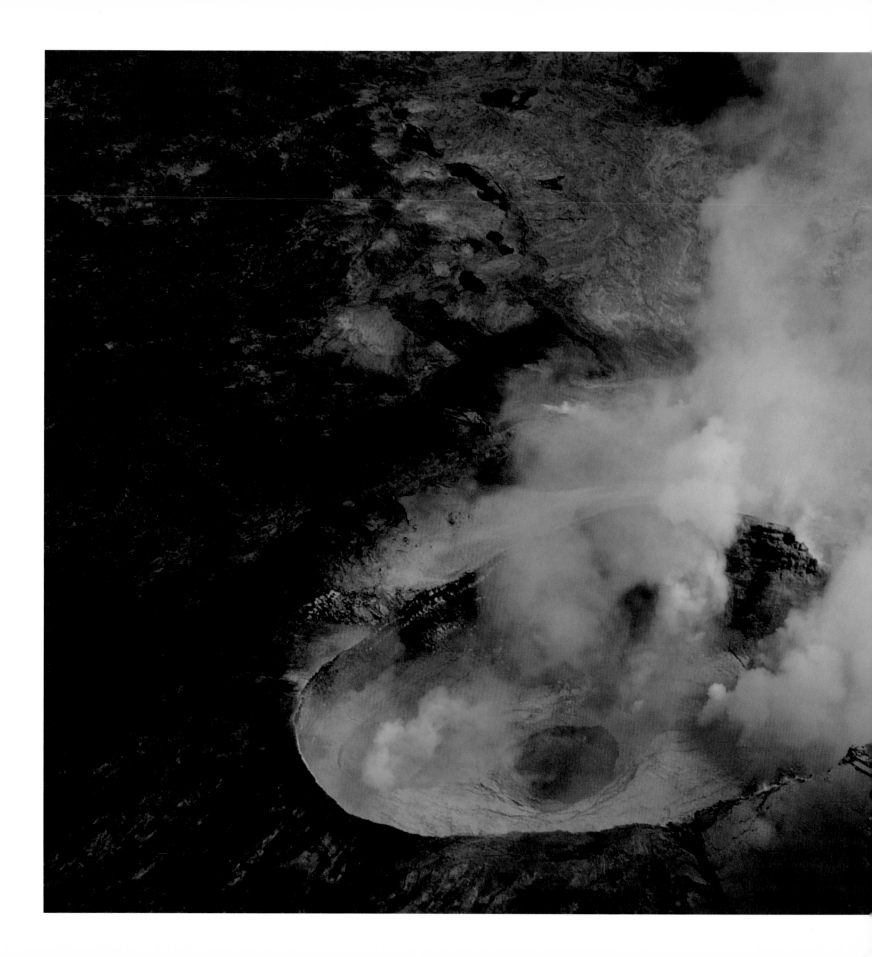

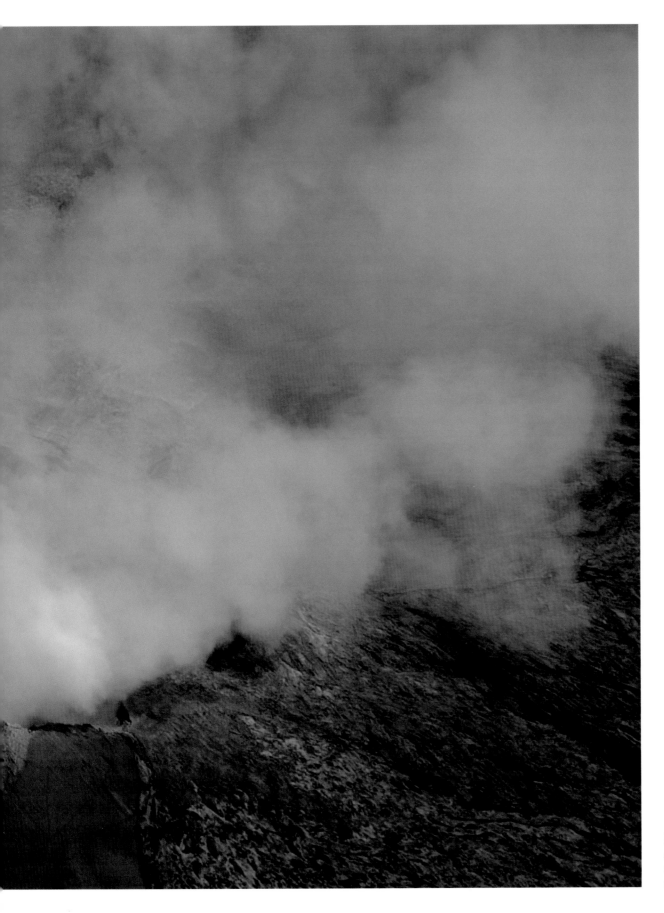

▼ *The star of Kilauea Volcano since the 1980s, Puʻu ʻOʻo has been the source of most of the island's new lava flows.*

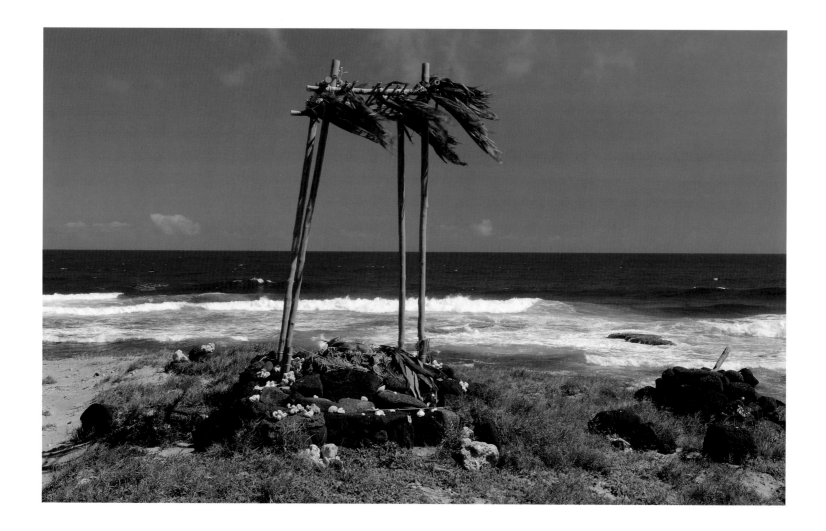

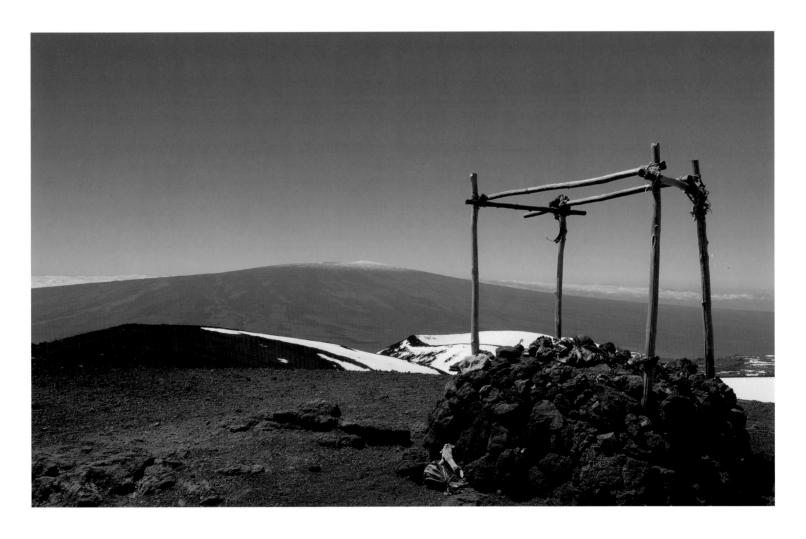

▼ *The first place the initial settlers to Hawaii probably landed was at South Point, photo at left. As they explored the island, they discovered something they never could have imagined—snow on top of Mauna Kea. At both places they would have built shrines. Their descendants still erect small shrines at places they consider sacred.*

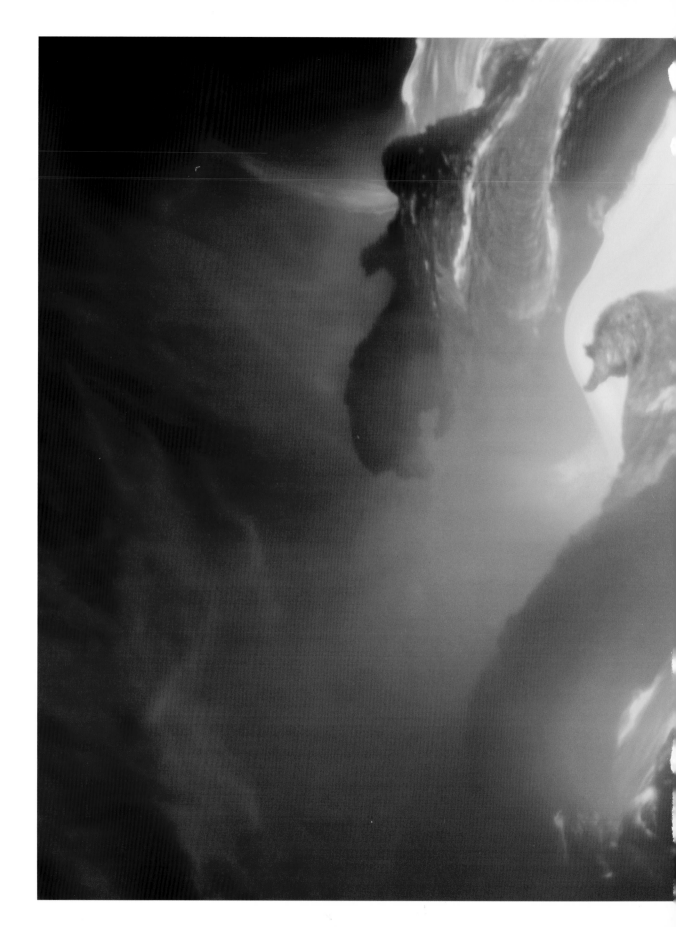

Molten and menacing one moment; cold and hard the next. The ever-changing life cycle of lava can be experienced on a Big Island visit.

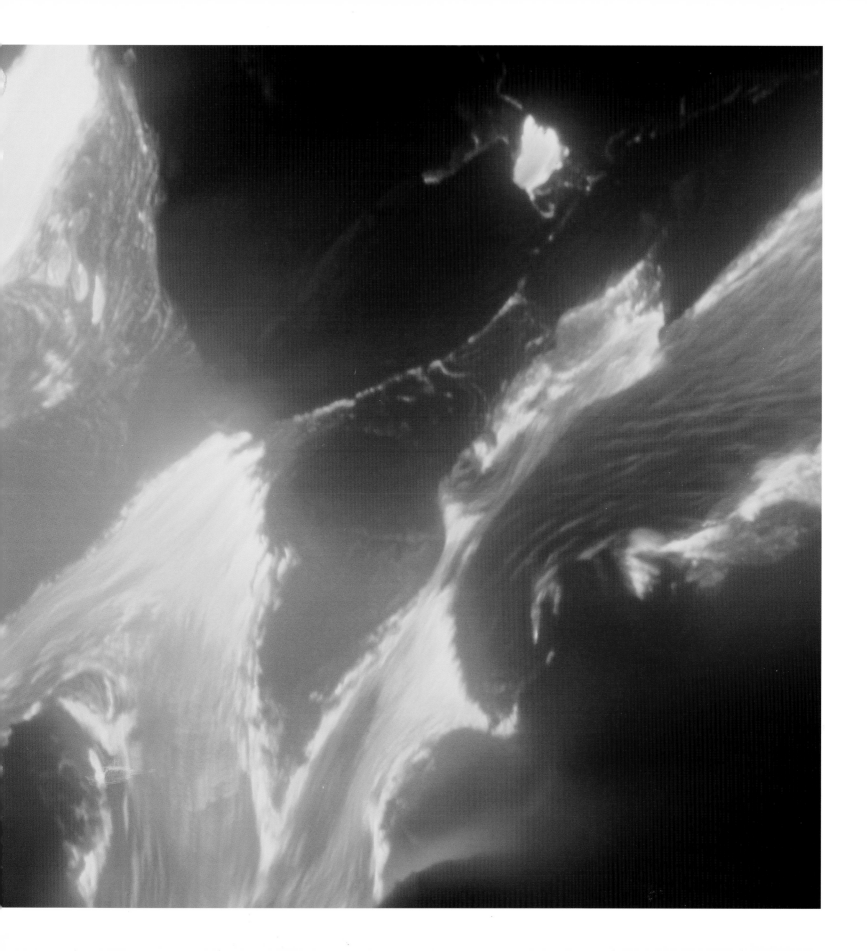

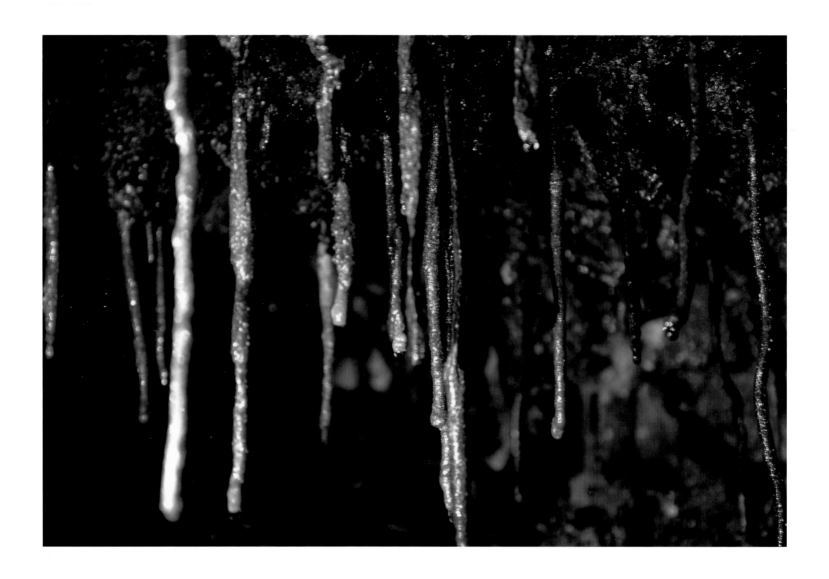

◥ *Lava tubes sometimes contain lava stalactites. Unlike mineral stalactites found on the mainland, these probably formed in a matter of hours or days at the end of the lava tube's fiery life.*

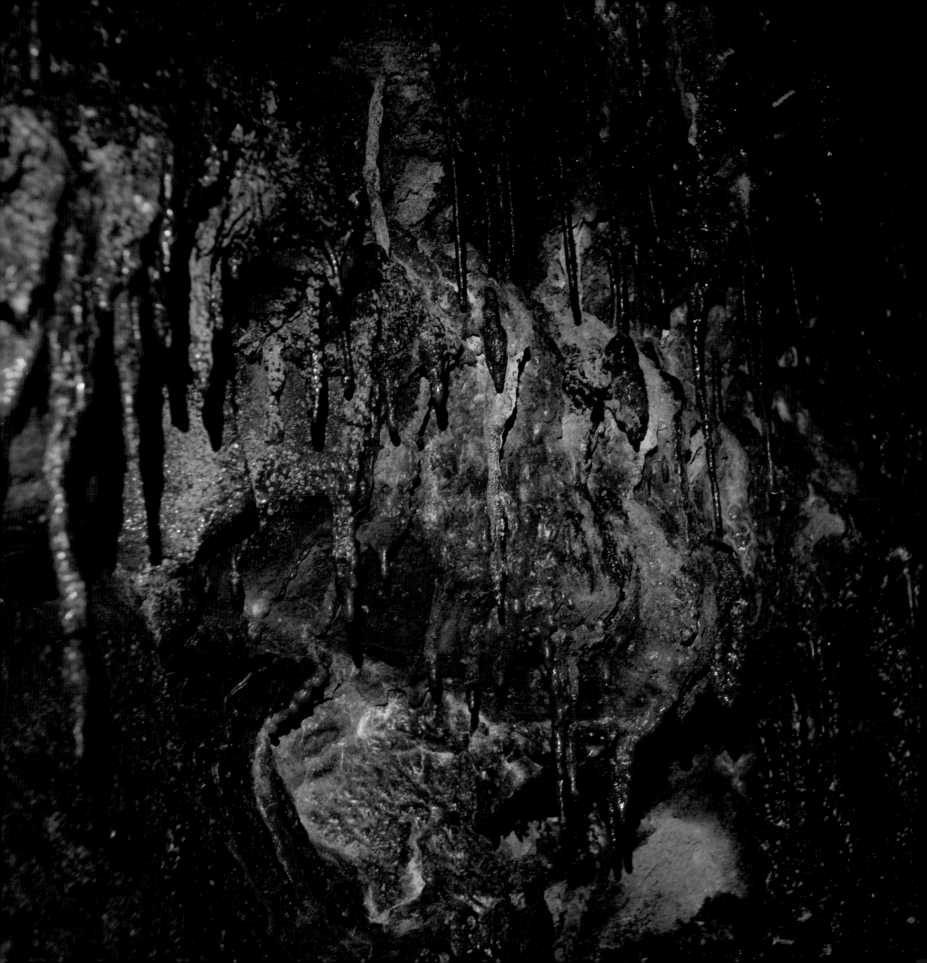

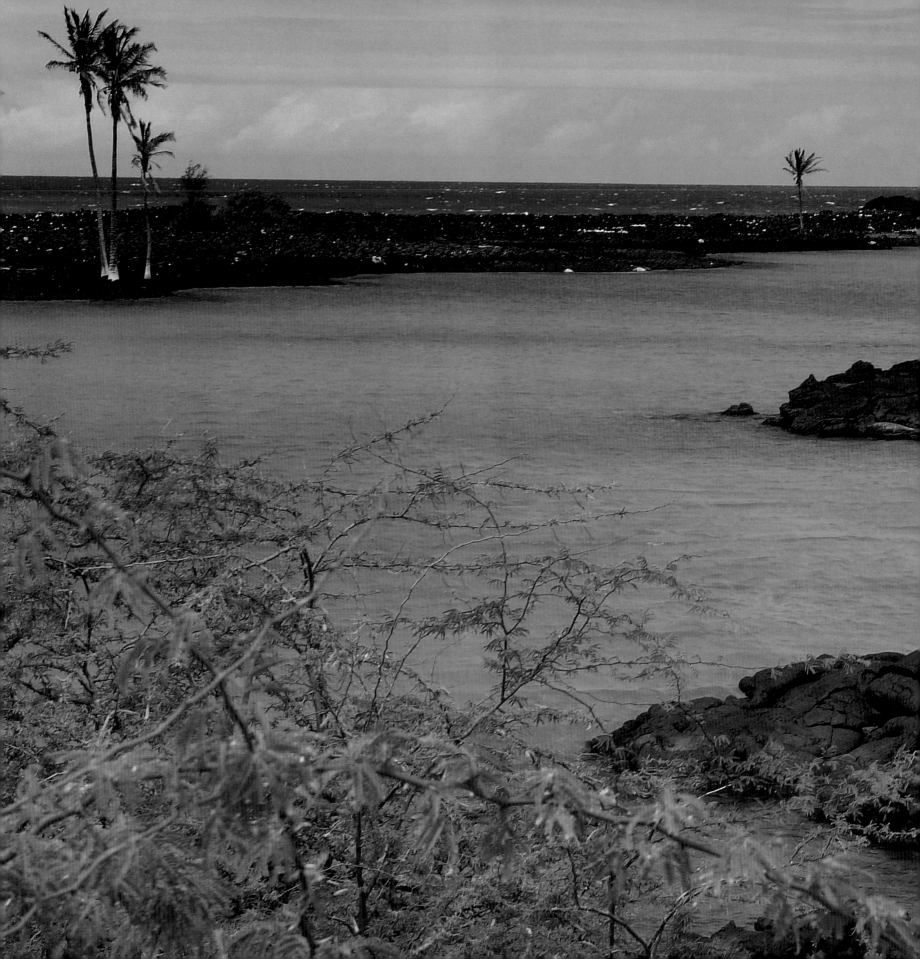

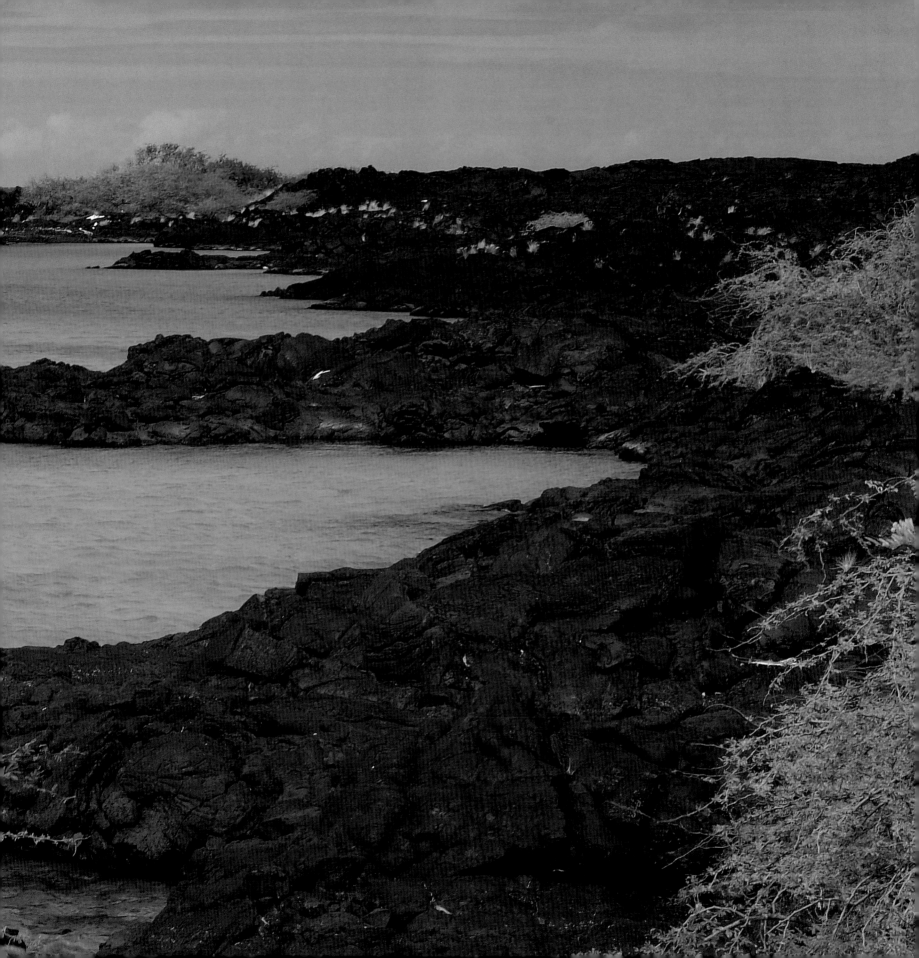

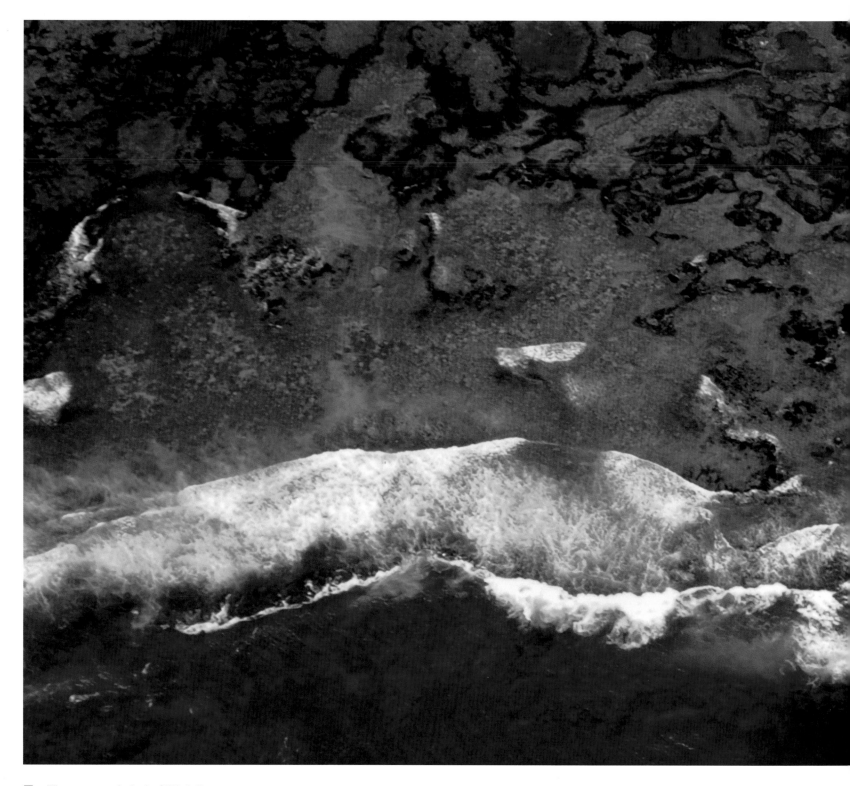

▼ *The waters at the back of Kiholo Bay
are so calm and protected that the lighter
spring water that seeps into it floats on top,
often forming what looks like a pane of glass
a foot or so below the surface. It's a perfect
line of demarcation between the colder
freshwater and the warmer seawater.*

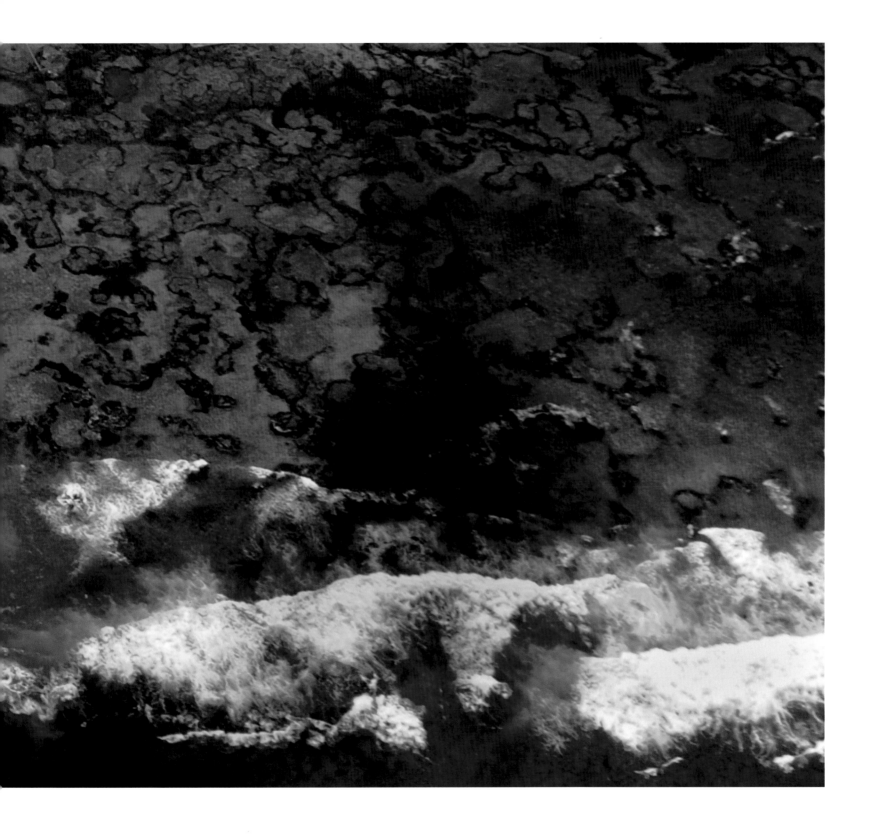

▼ *The interconnected tidepools of Kapoho make a great place to try out your new snorkel gear.*

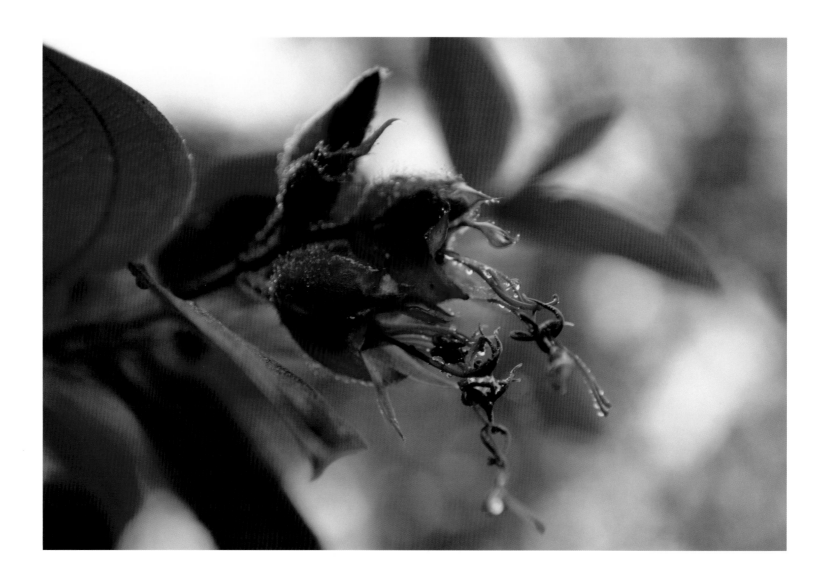

◥ *There aren't many places in the world where snowy peaks and blooming flowers live side by side.*

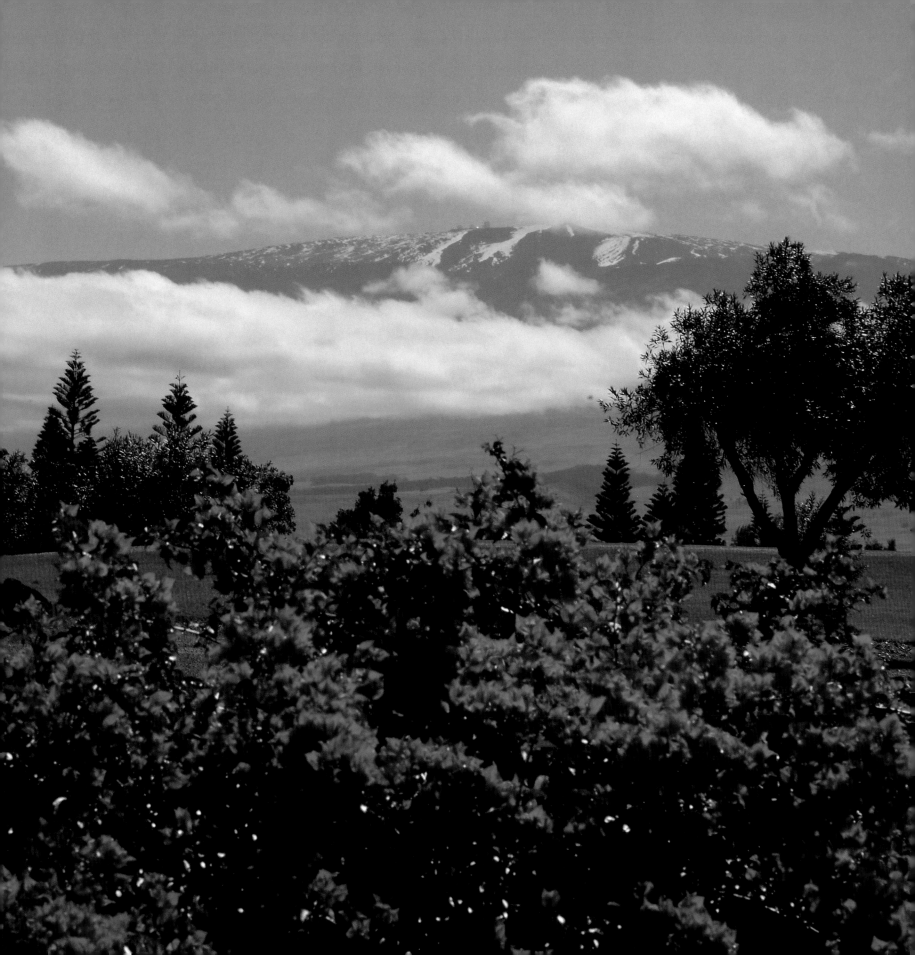

▼ *Giant skies behind Kona's Hulalai mountain.*

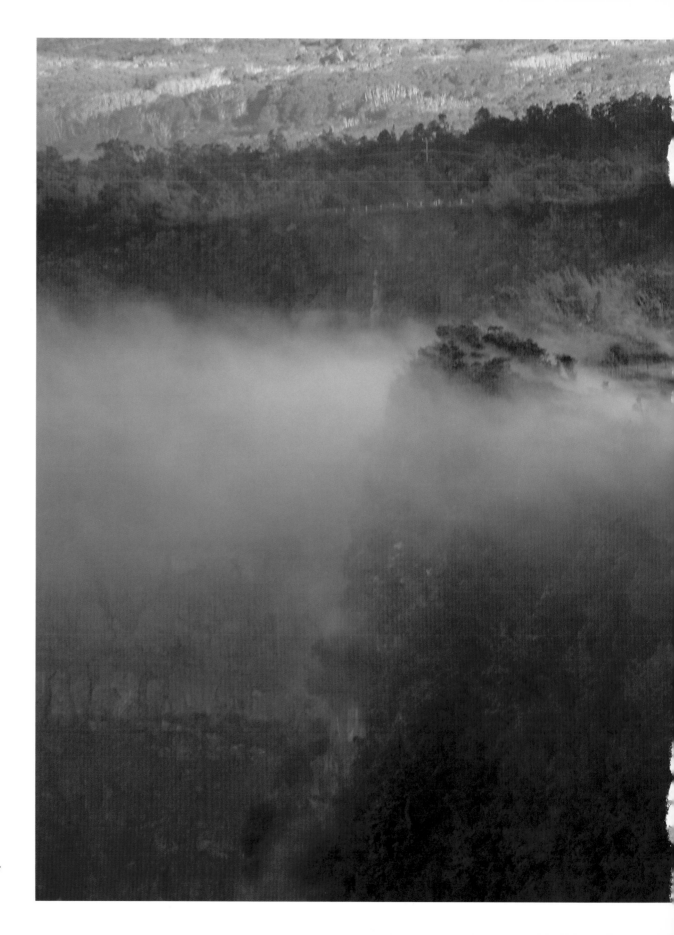

◣ *Like barely contained rage, steam leaks from the crater's edge at Halemaumau, testifying to the fire that brews below.*

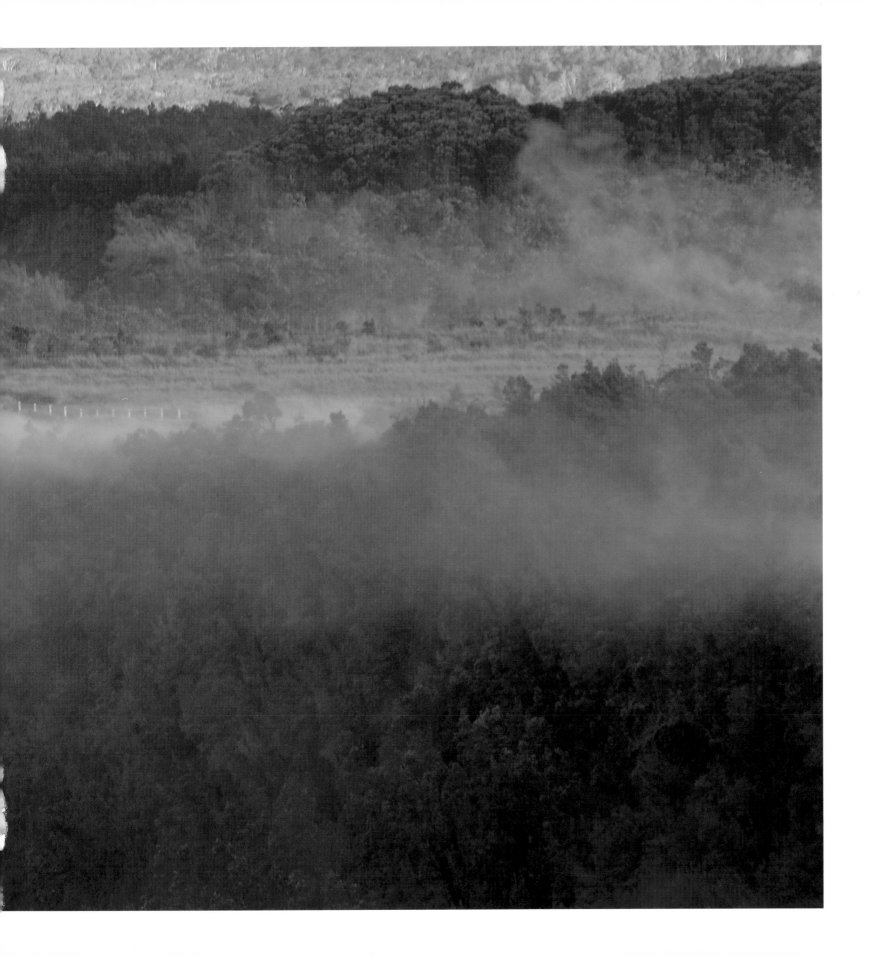

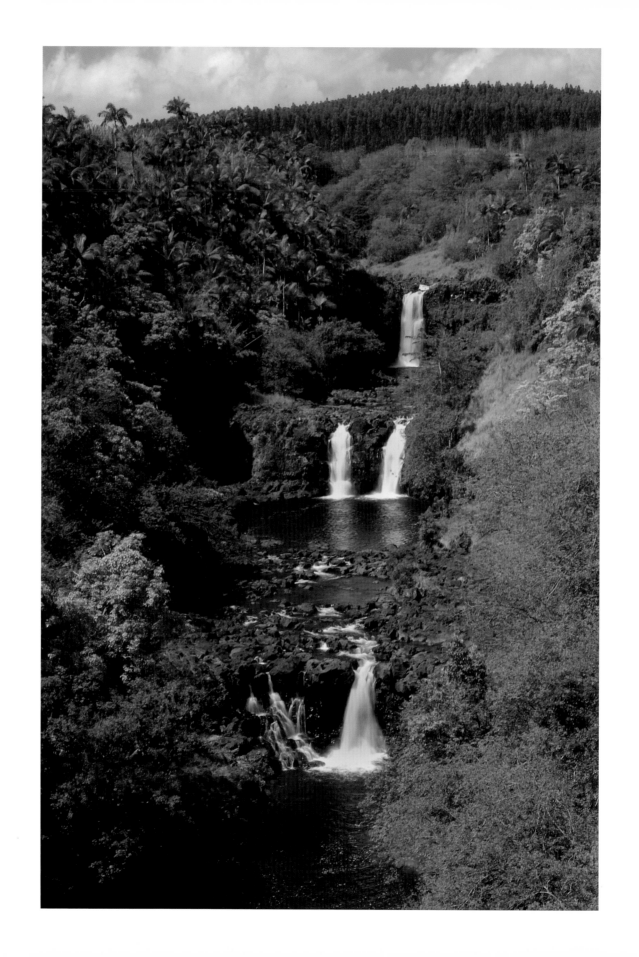

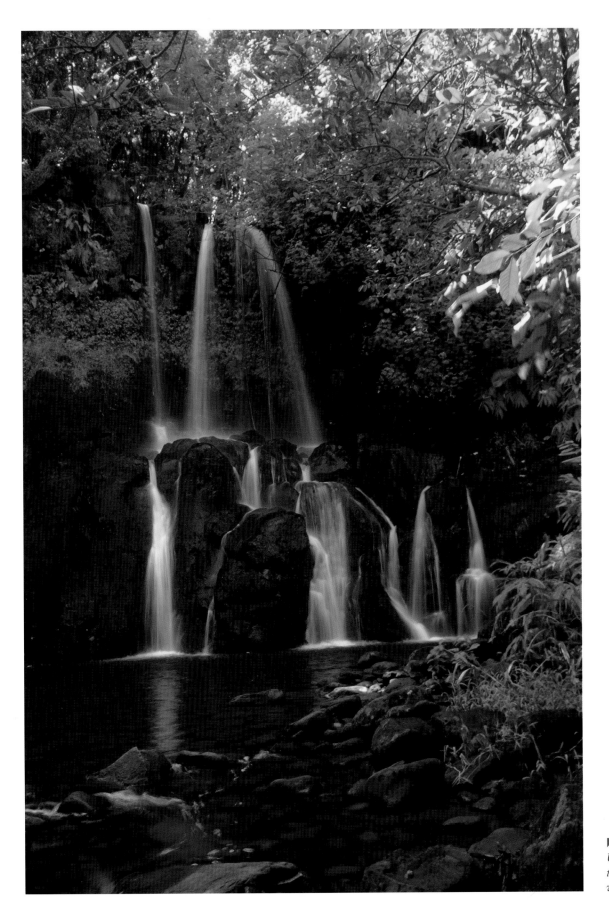

▼ *Whether massive, like Umauma Falls (at left) or tiny, like this one on the Hakalau Stream, what's not to love about waterfalls?*

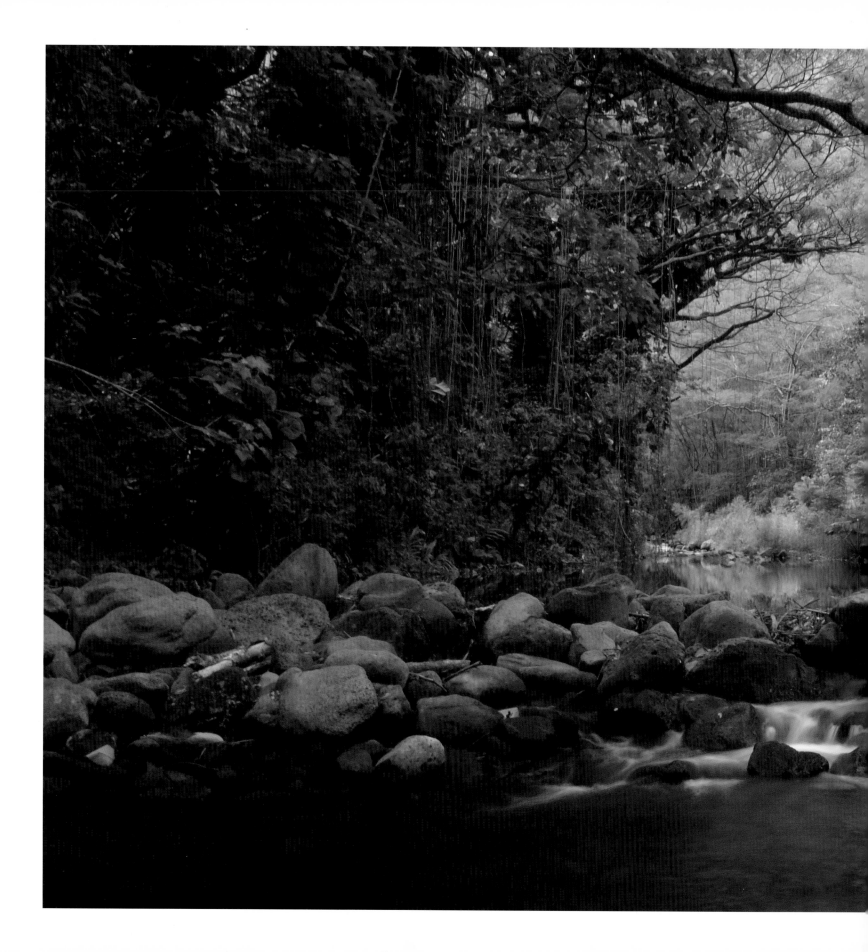

▼ *This is actually the road in Waipoʻi Valley. You'll need to drive across the river if it's not flowing too high.*

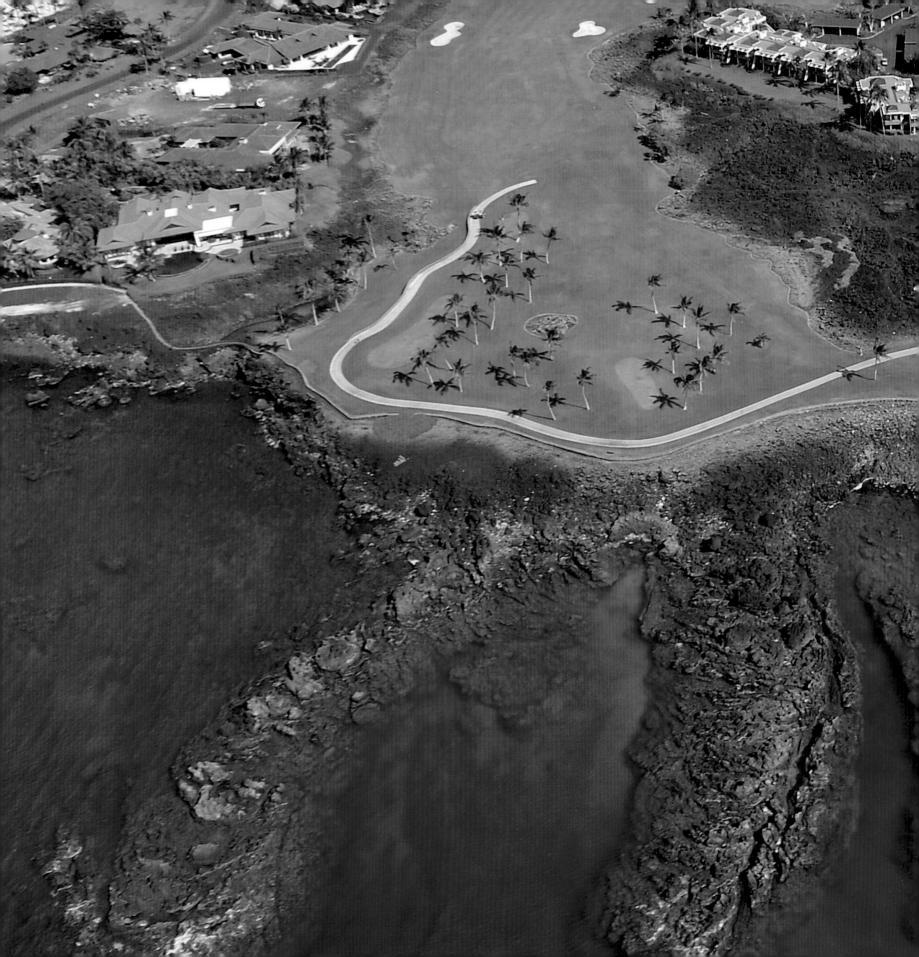

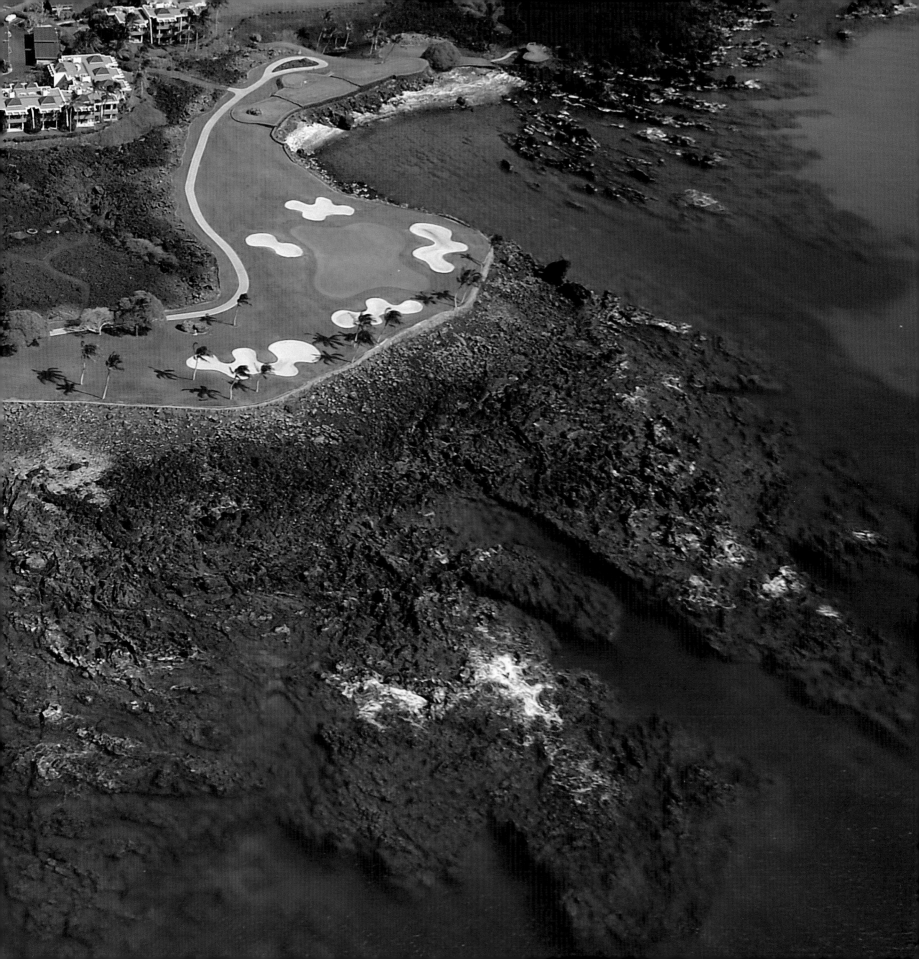

Though the golfing at Mauna Lani is grand, the reefs offshore are even grander.

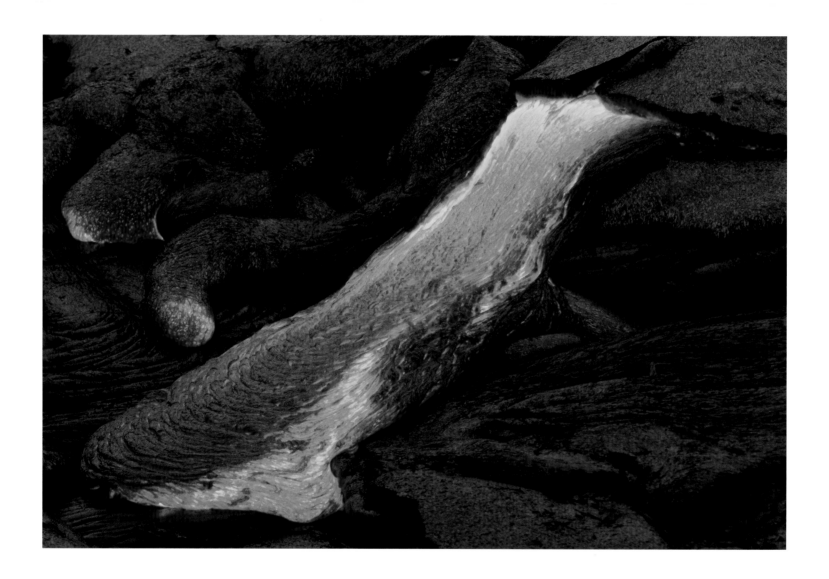

Ropy pahoehoe lava starts to pool like thick cake batter.

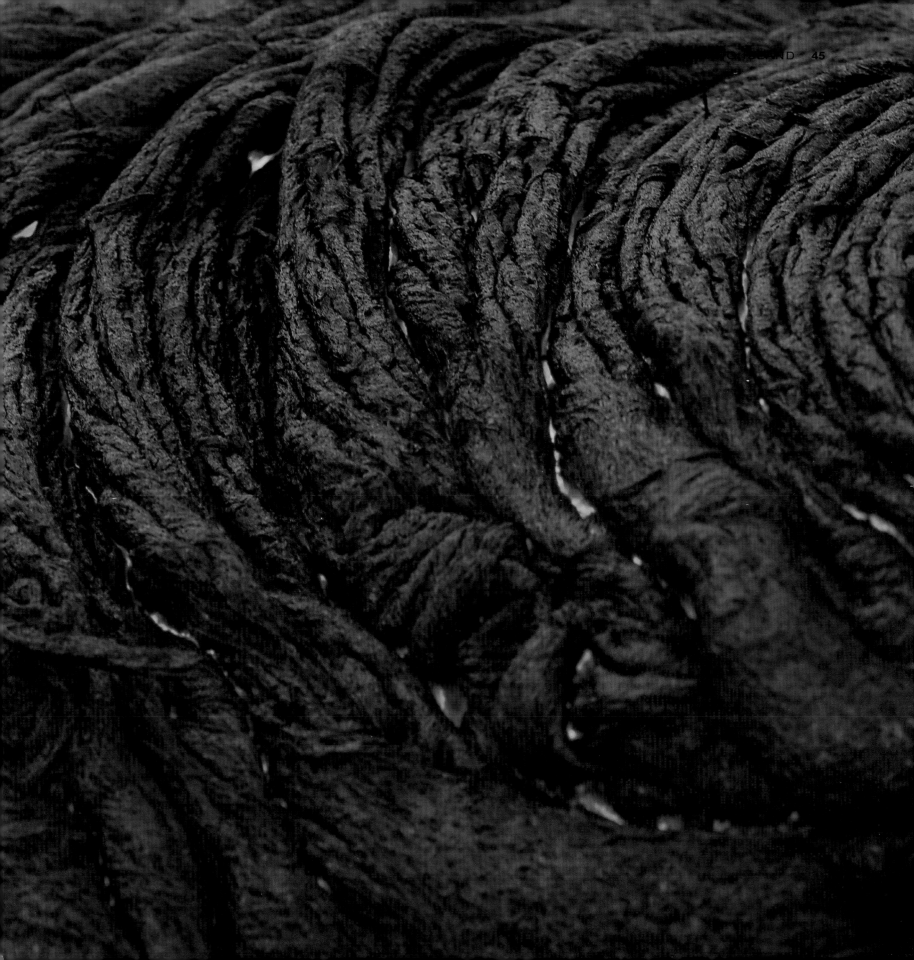

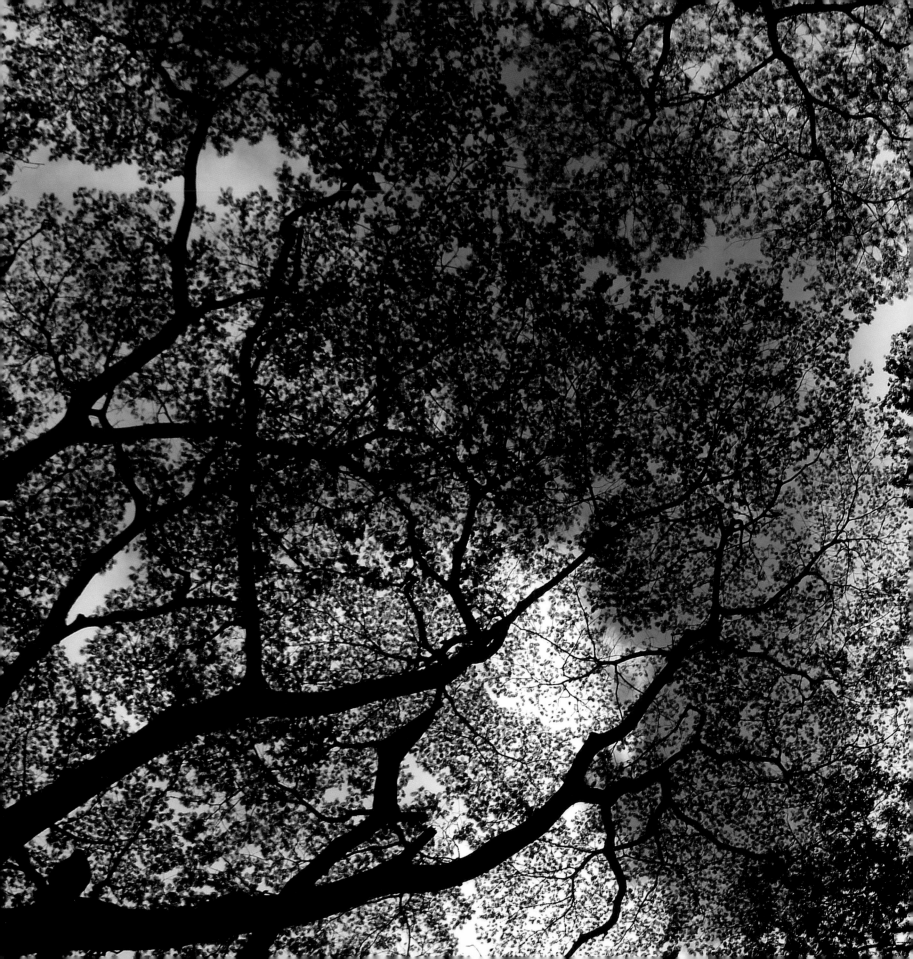

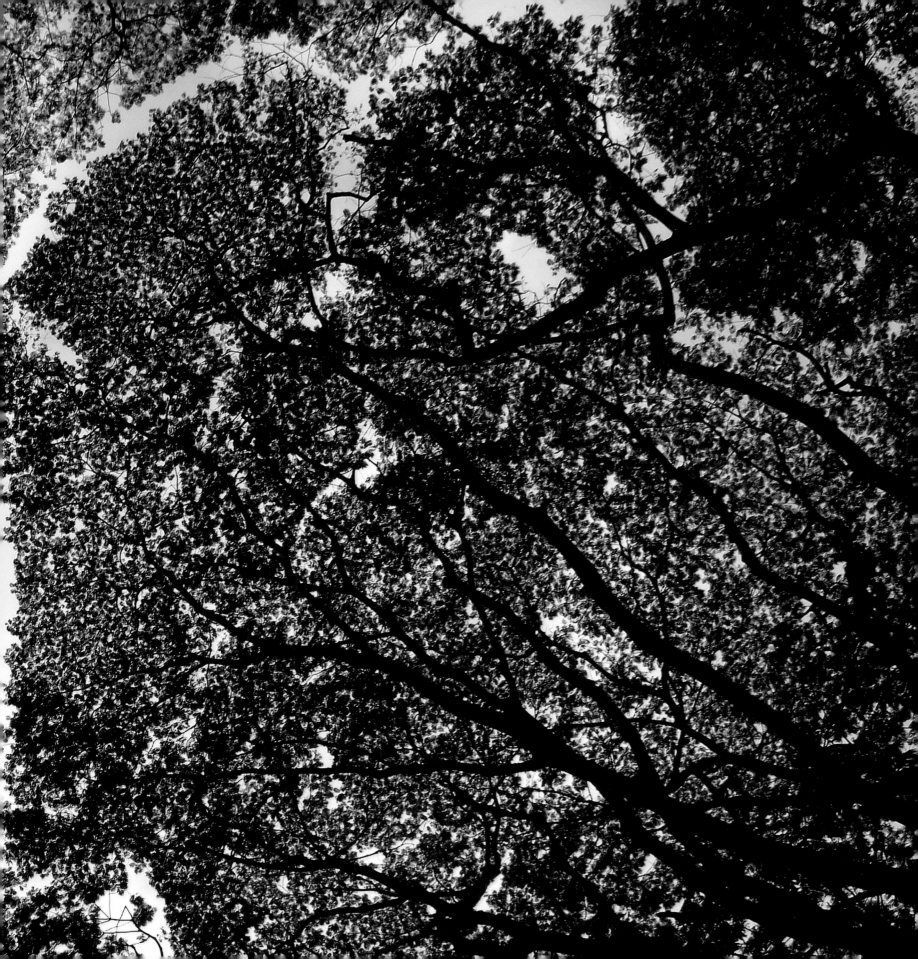

▼ *Stately monkeypod trees form a beautiful protective canopy.*

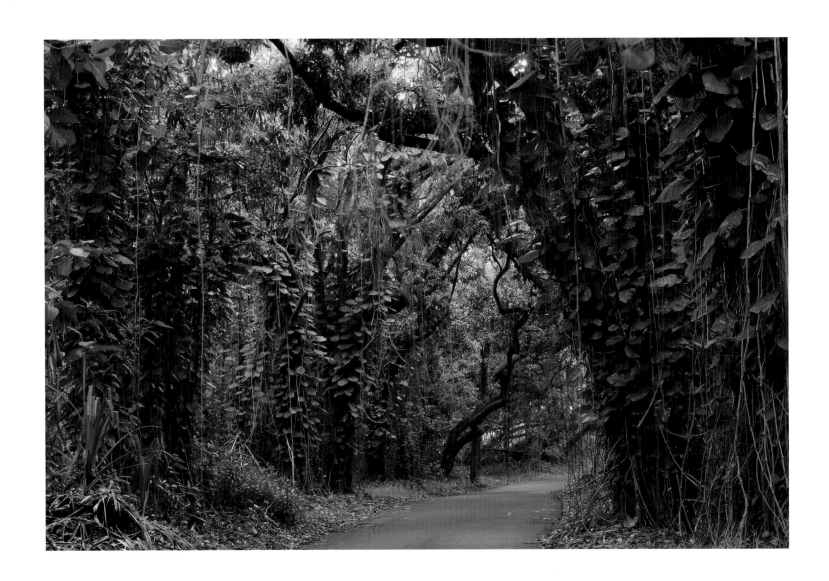

◣ *The Puna road at the left and the freshwater percolating to the surface at Honokohau both have their own protective canopies.*

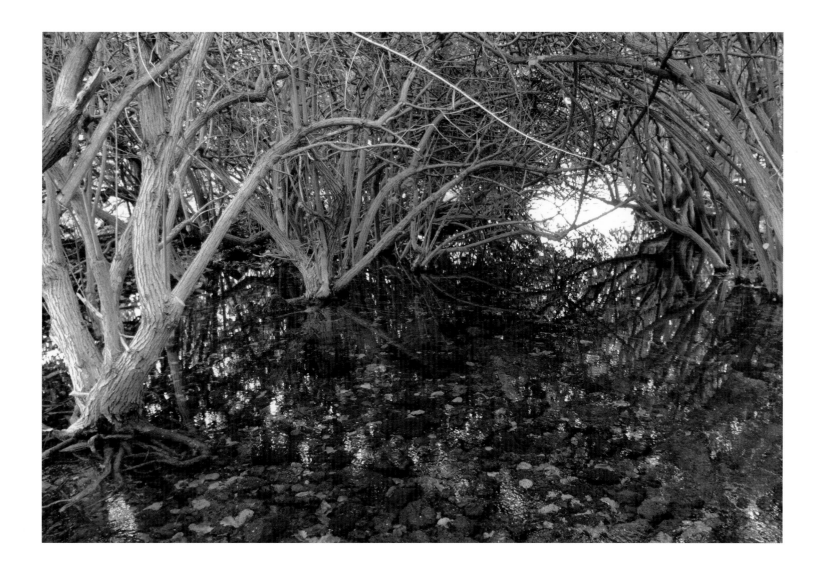

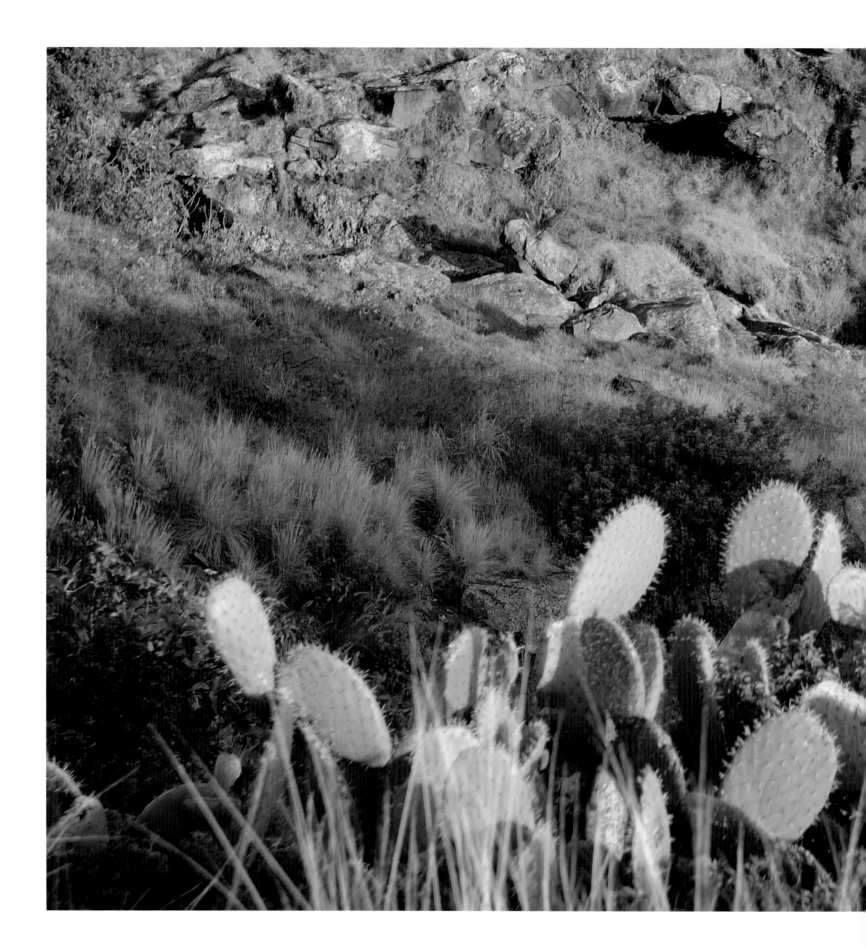

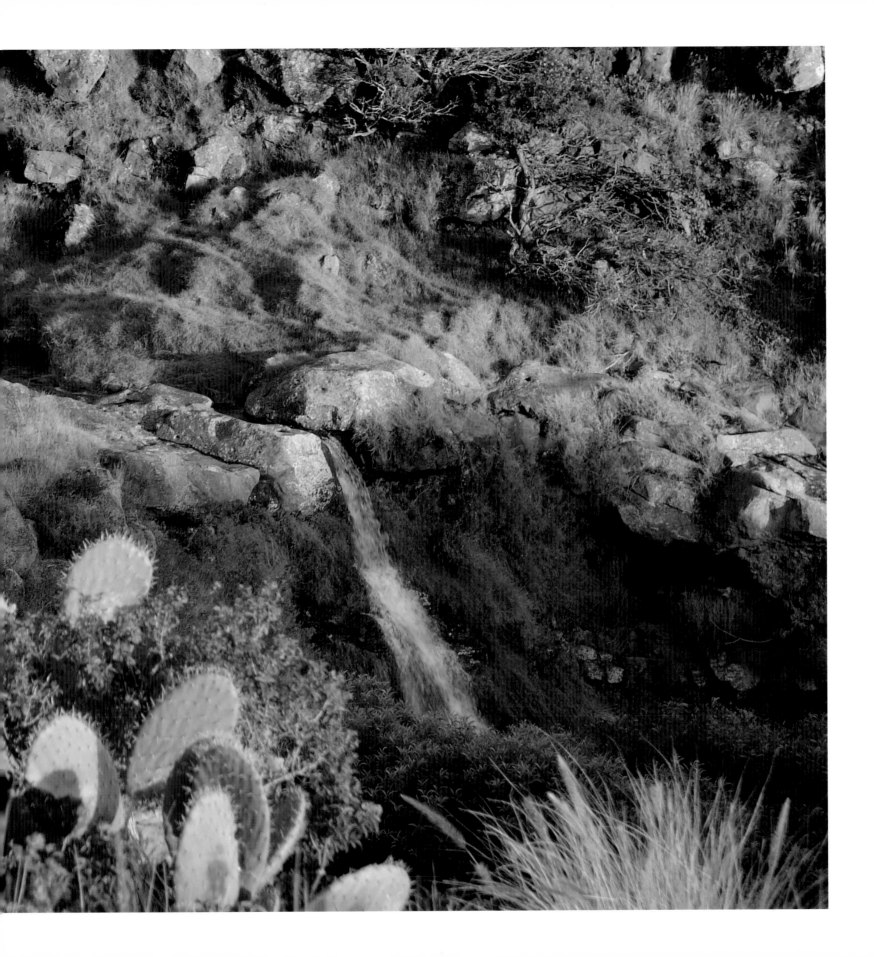

Cactus and waterfalls make a perfect Kohala Mountain moment.

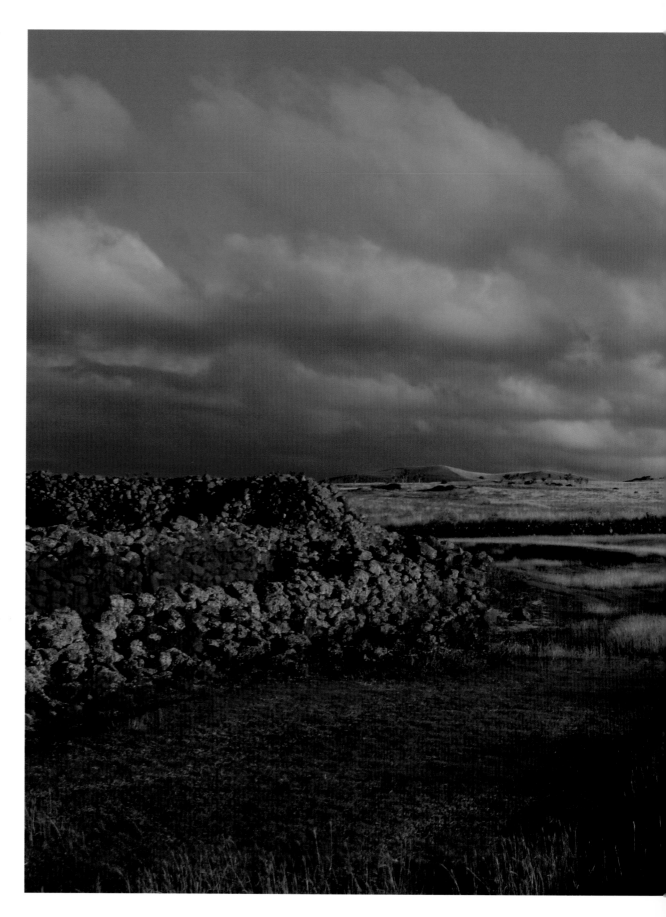

Though it looks peaceful and serene, Mo'okini Heiau's history is anything but pleasant. Here over 10,000 Hawaiians were sacrificed to their gods.

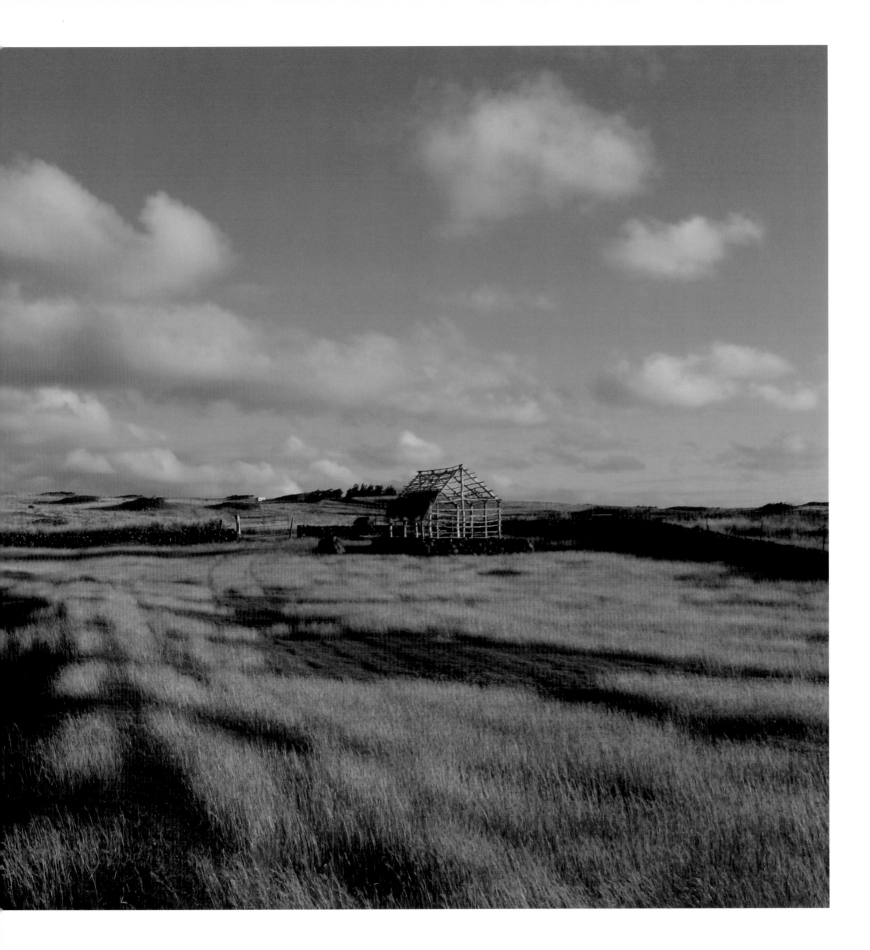

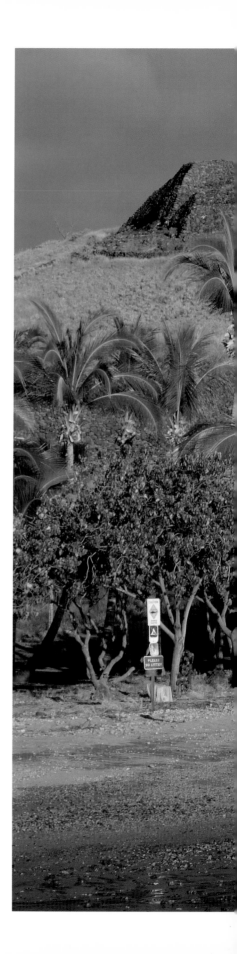

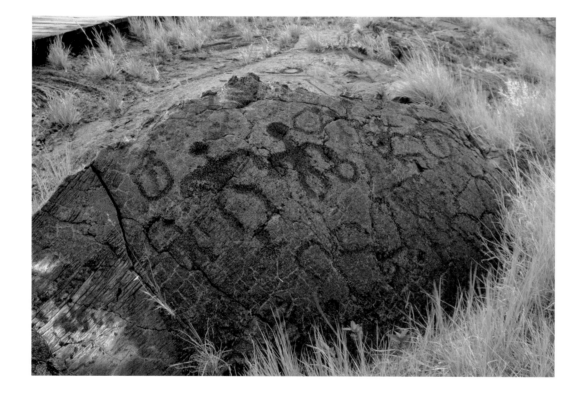

◥ *Pu'ukohola Heiau on the right had only one sacrifice of note. King Kamehameha's rival was lured here by the king in the hope of peace, then sacrificed to christen the newly built heiau. Above, petroglyphs from ancient times harken to a more peaceful era.*

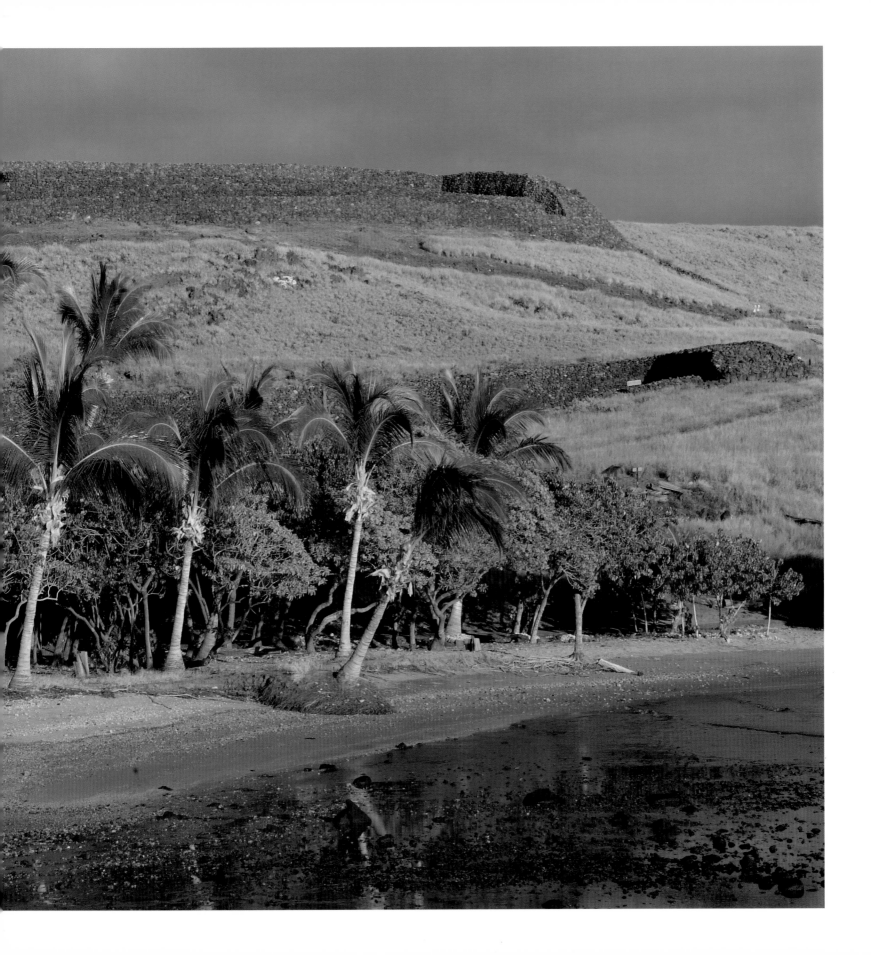

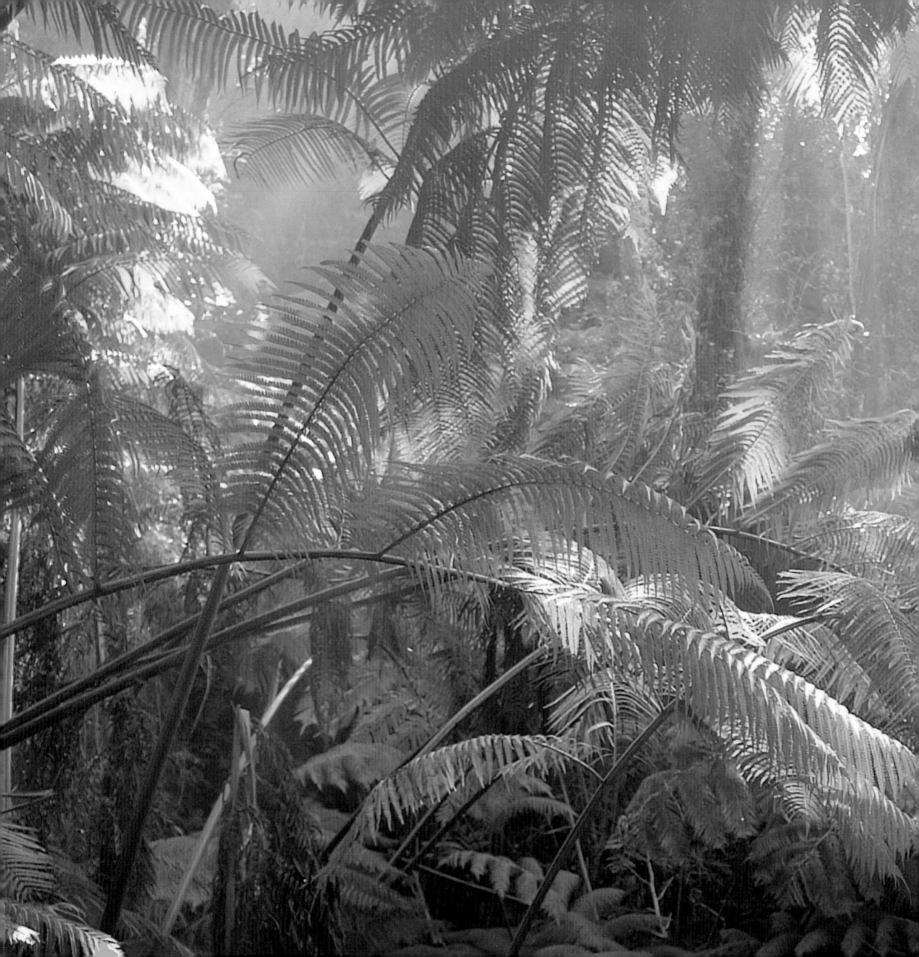

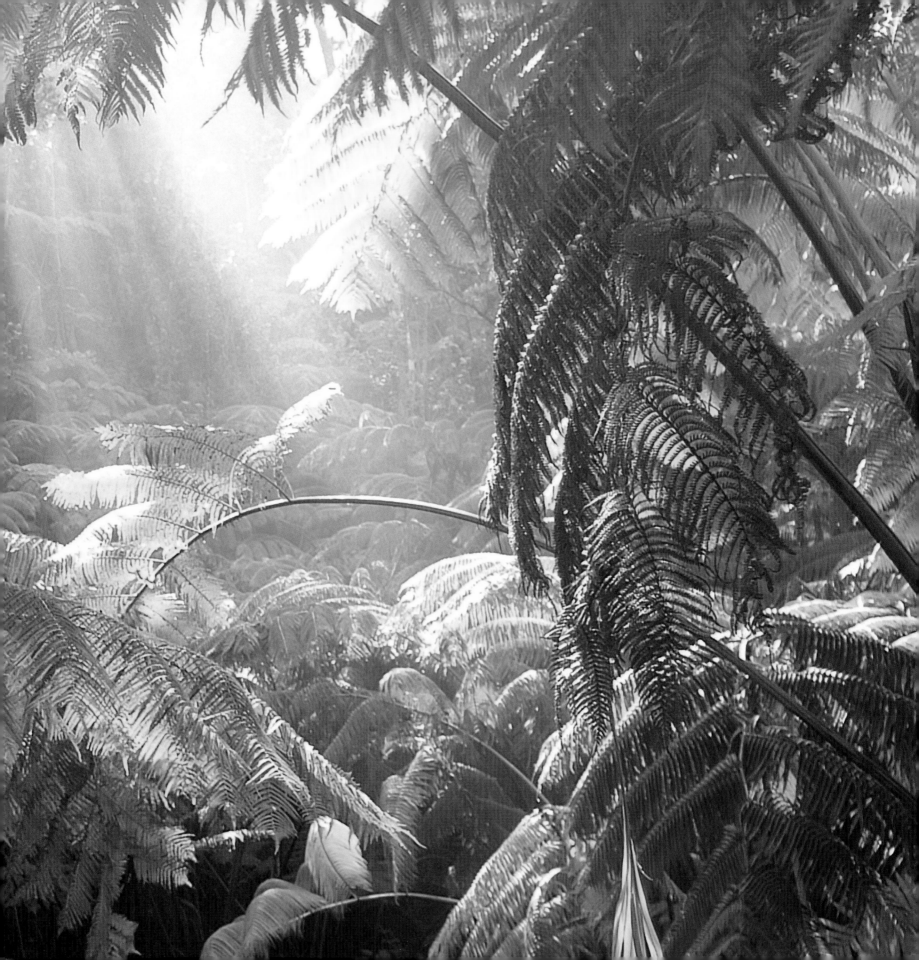

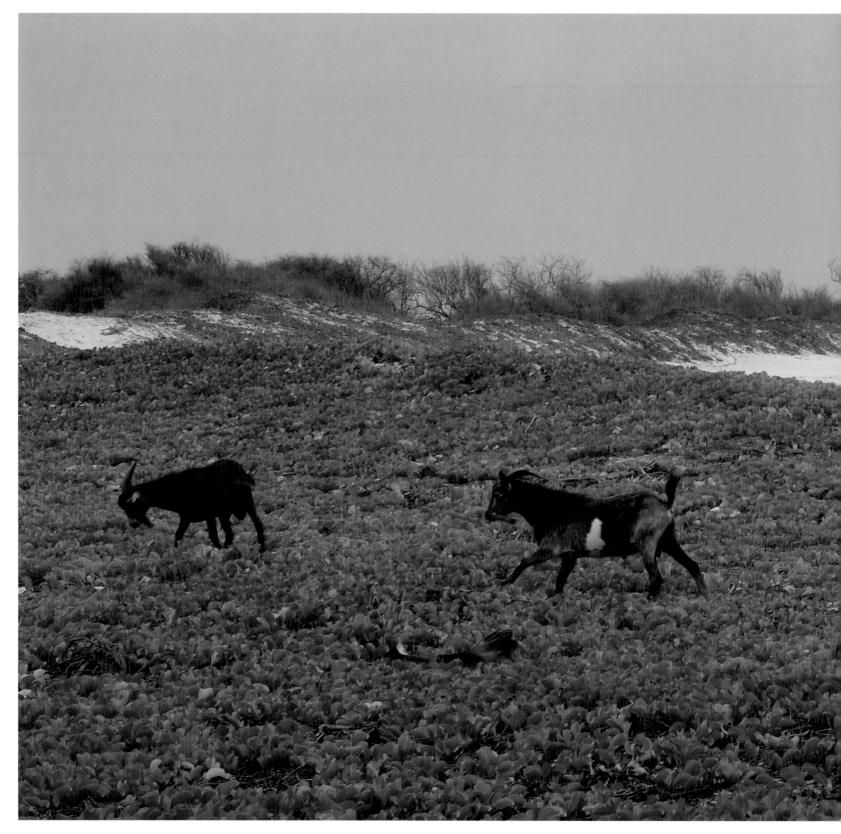

▼ *Like a gift from heaven,*
light filters through the jungle
at Kilauea.

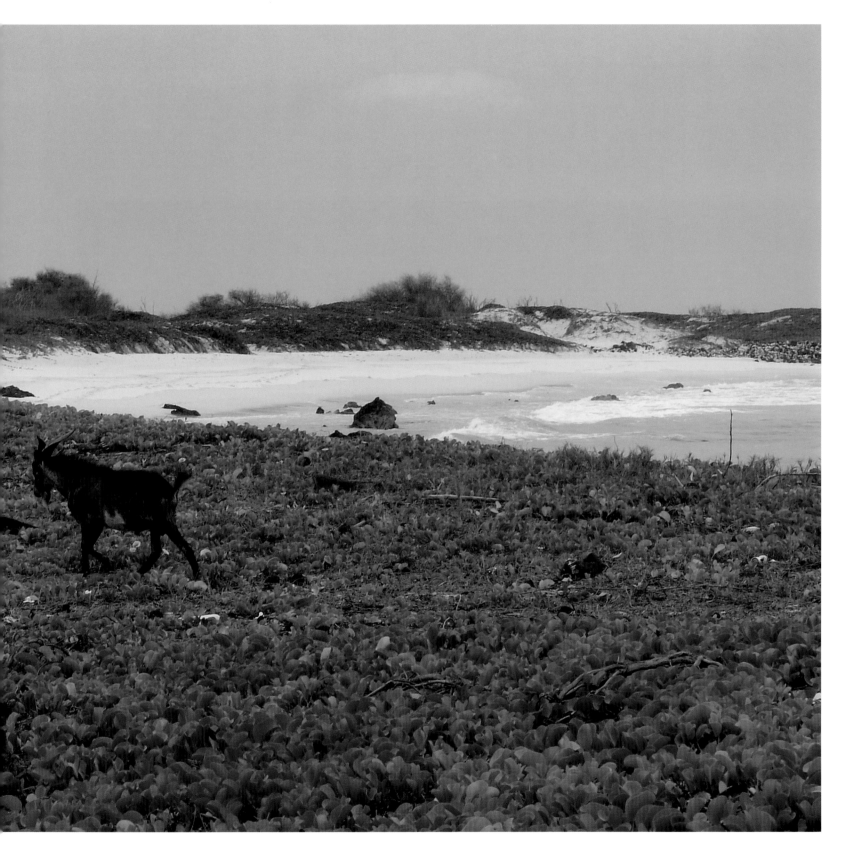

▼ *Sunbathing with wild goats—only on the Big Island*

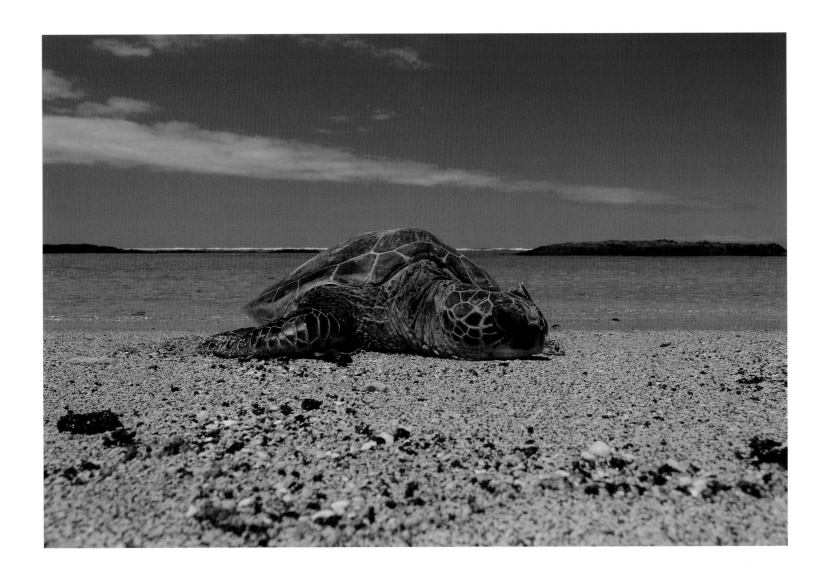

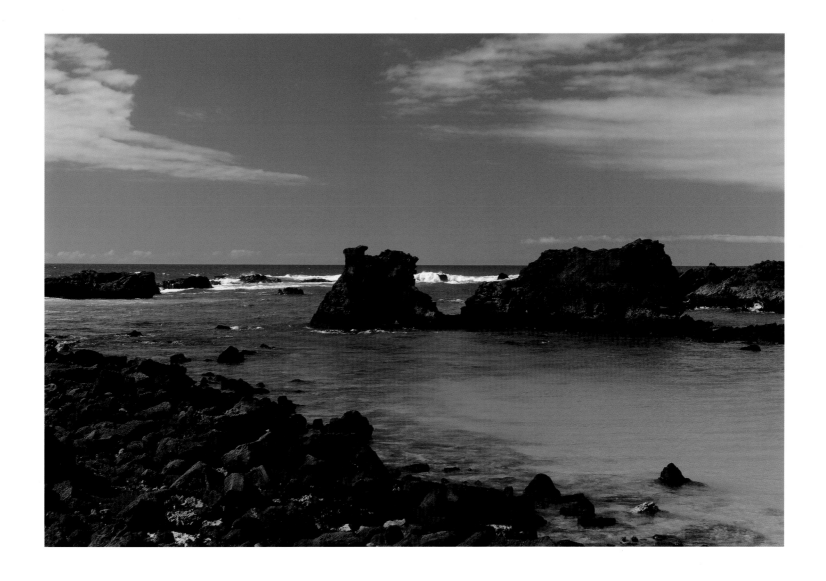

▼ *A sea turtle (at left) sunning on a beach is as much a part of the local landscape as the lava at Kikaua Beach (above).*

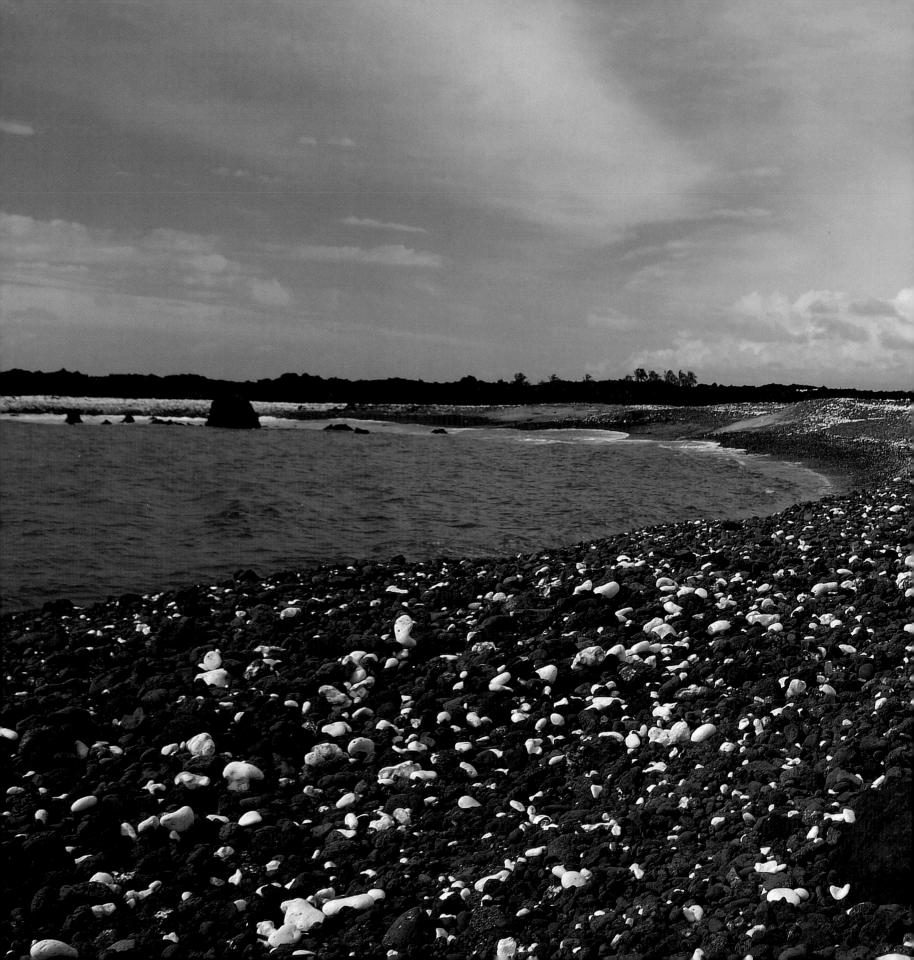

Despite numerous resorts, vast stretches of the Kohala shoreline are still untouched and isolated. Ideal places to stroll and enjoy the solitude.

The perfectly protected back of Kiholo Bay.

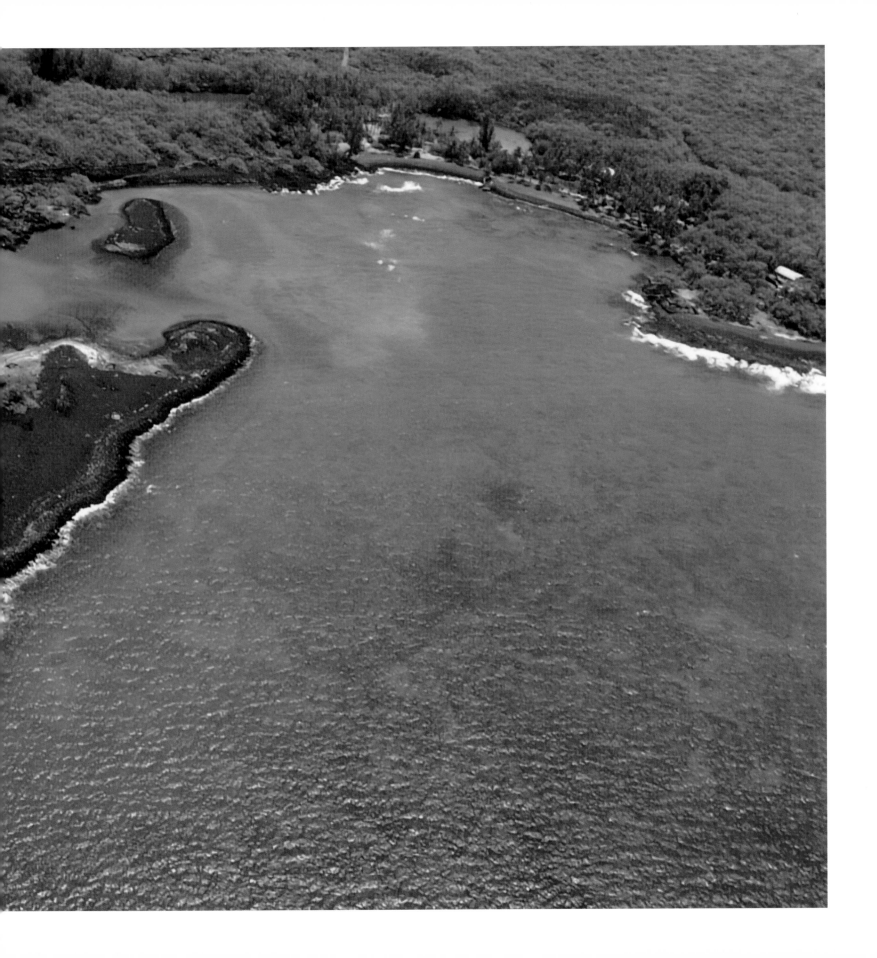

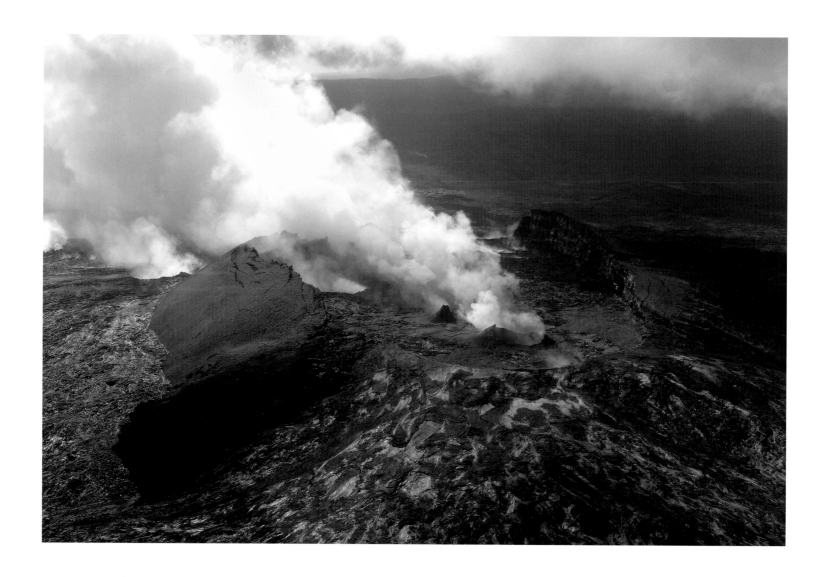

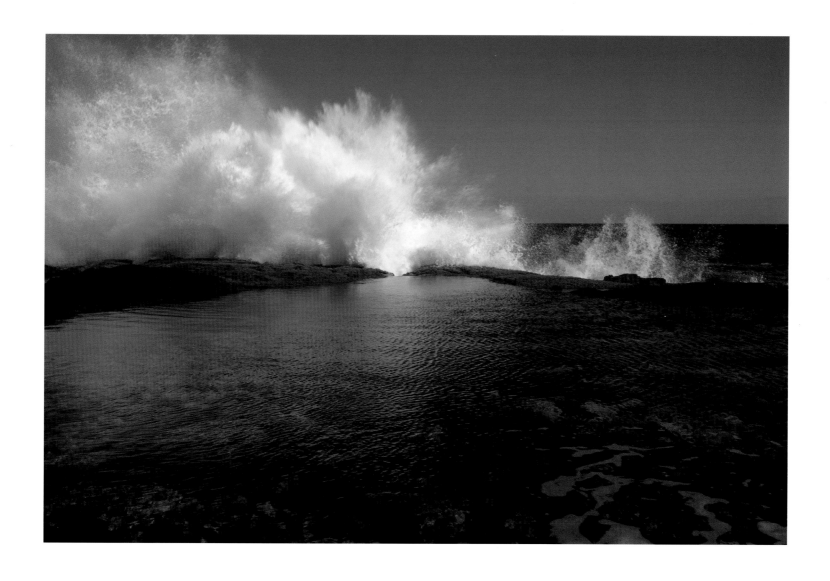

▼ *Eruptions of fire and eruptions of the sea. Both have power. Both need to be respected.*

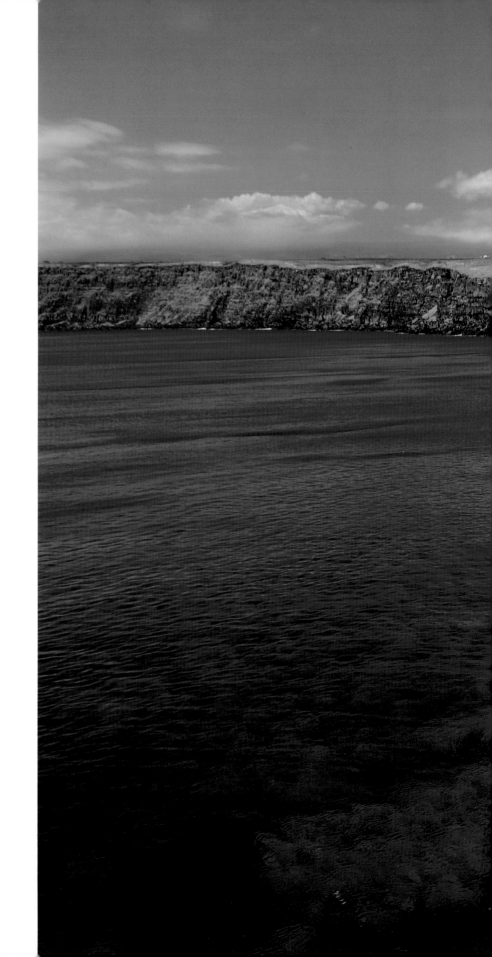

◥ *The end of Broken Road near South Point brings you to sheltered waters.*

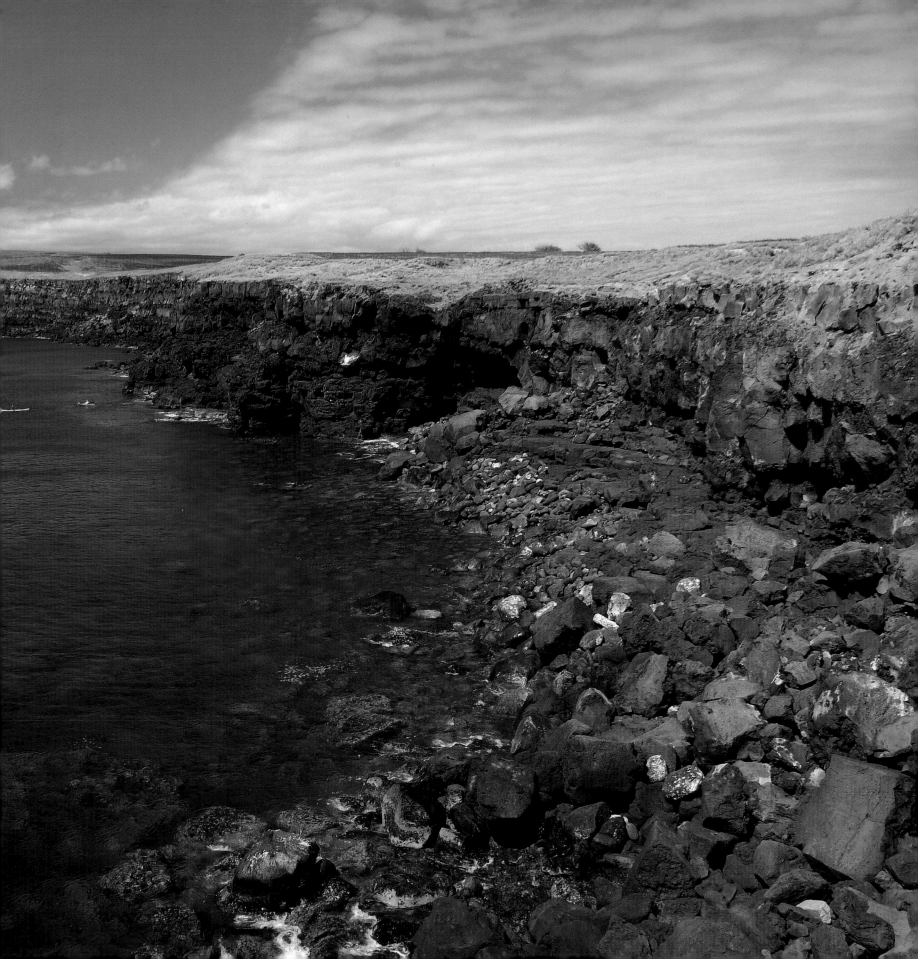

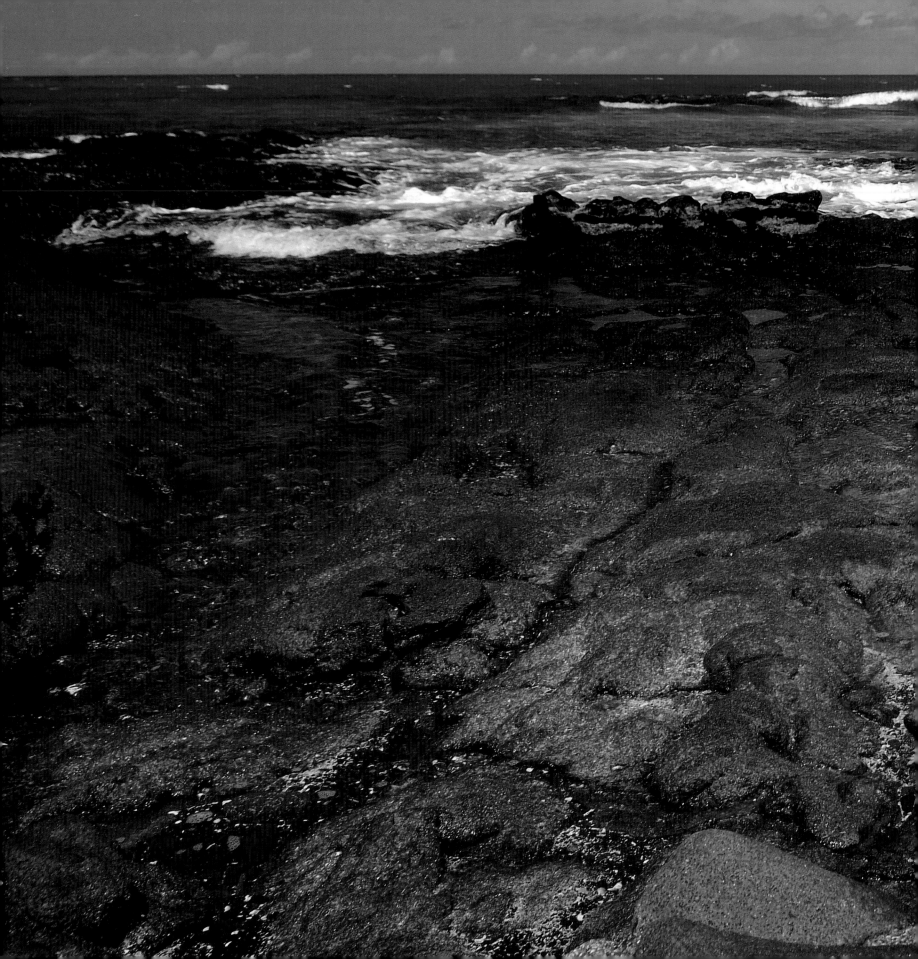

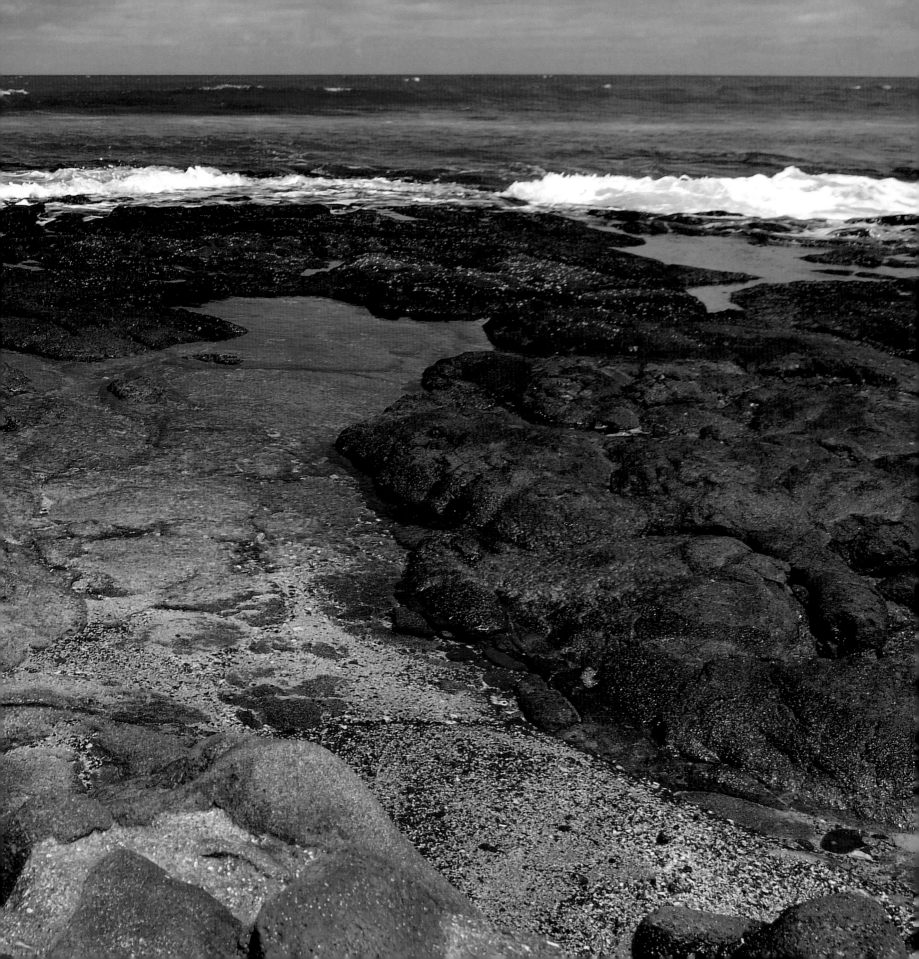

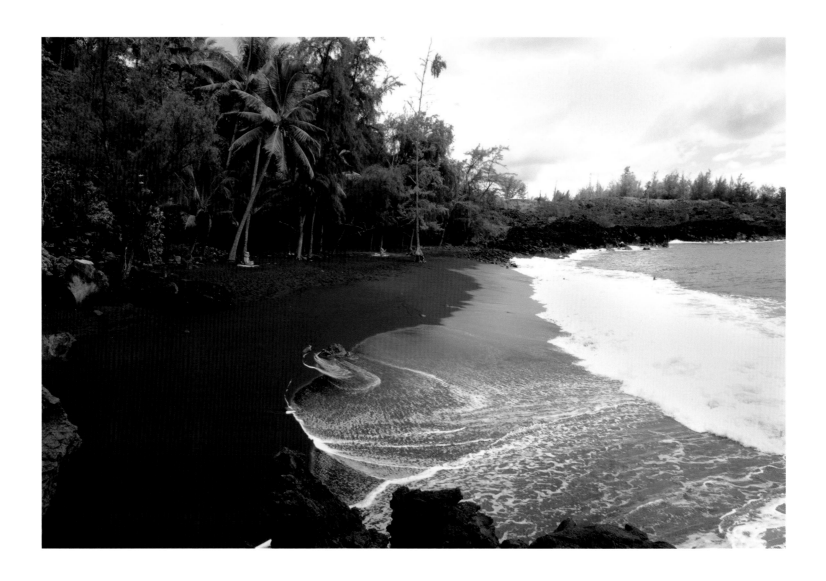

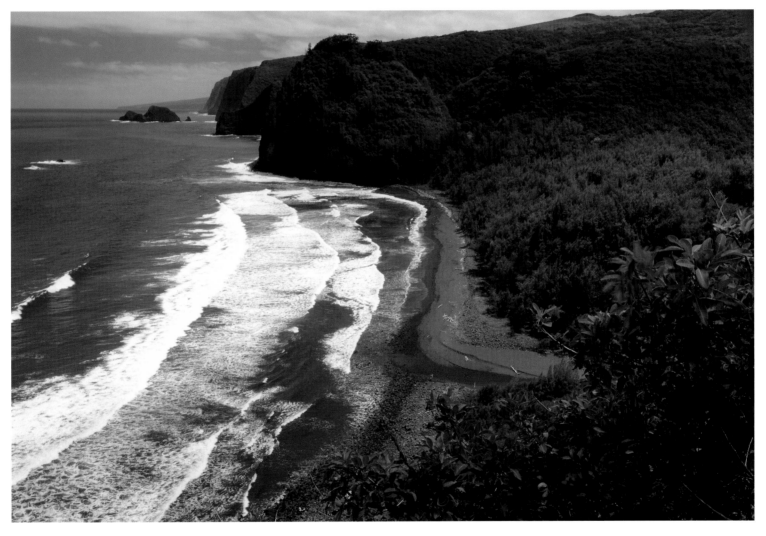

▼ *There's more than one way to form a black sand beach. The one on the left was created in a matter of weeks when lava poured into the ocean and shattered as the cold water quenched it. Pololu Valley on the right, however, took thousands of years as river water patiently chipped flecks of lava from the riverbed and piled the debris on the shore.*

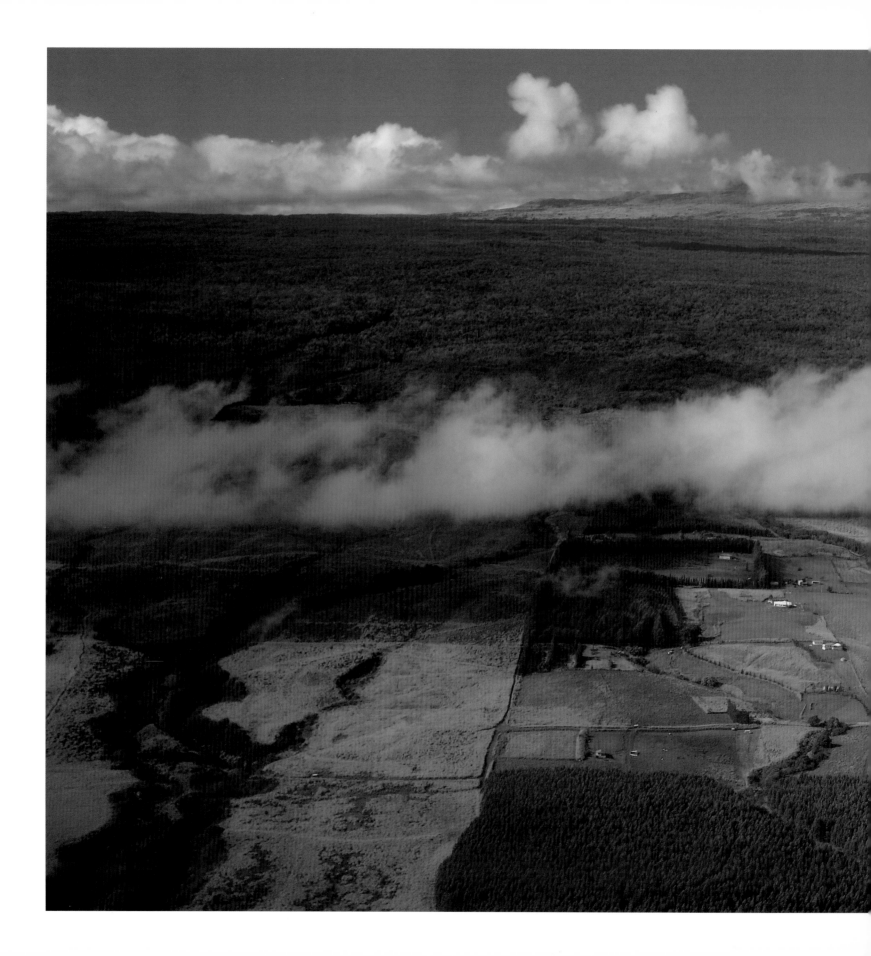

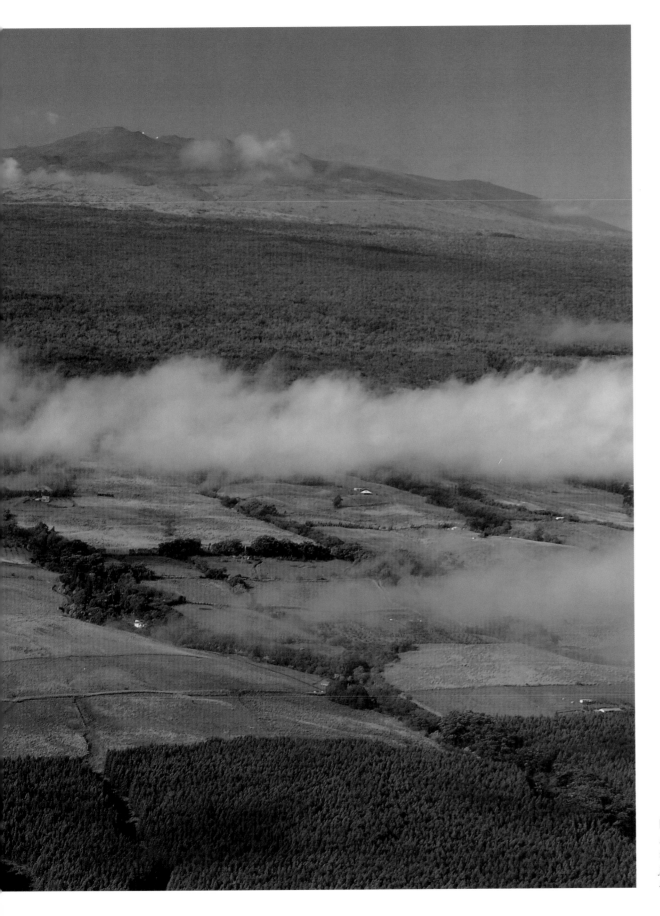

▼ *Gentle slopes can be deceiving. It's hard to believe that this unrelenting hill marches 13,769 feet from the sea to Mauna Kea's summit.*

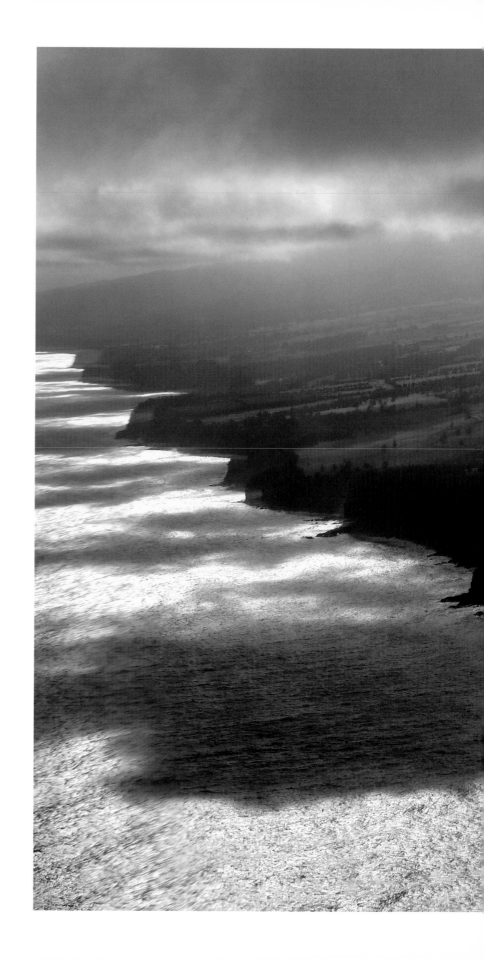

◥ *Storm clouds threaten the Hamakua Coast.*

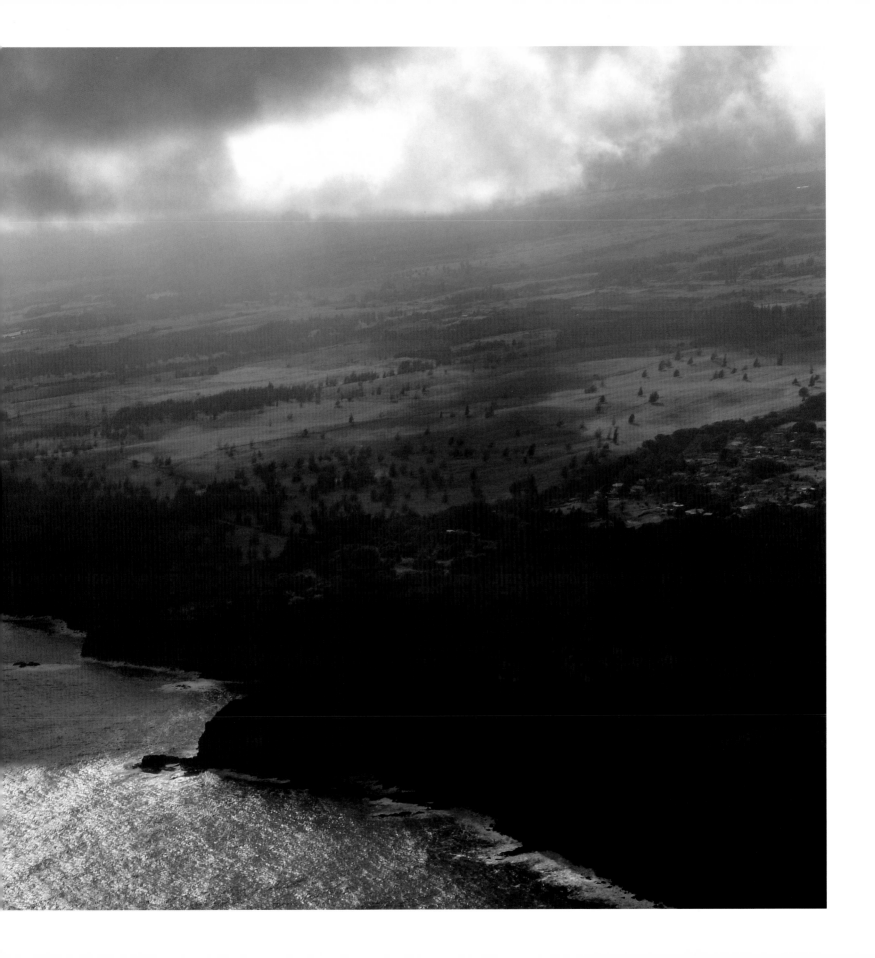

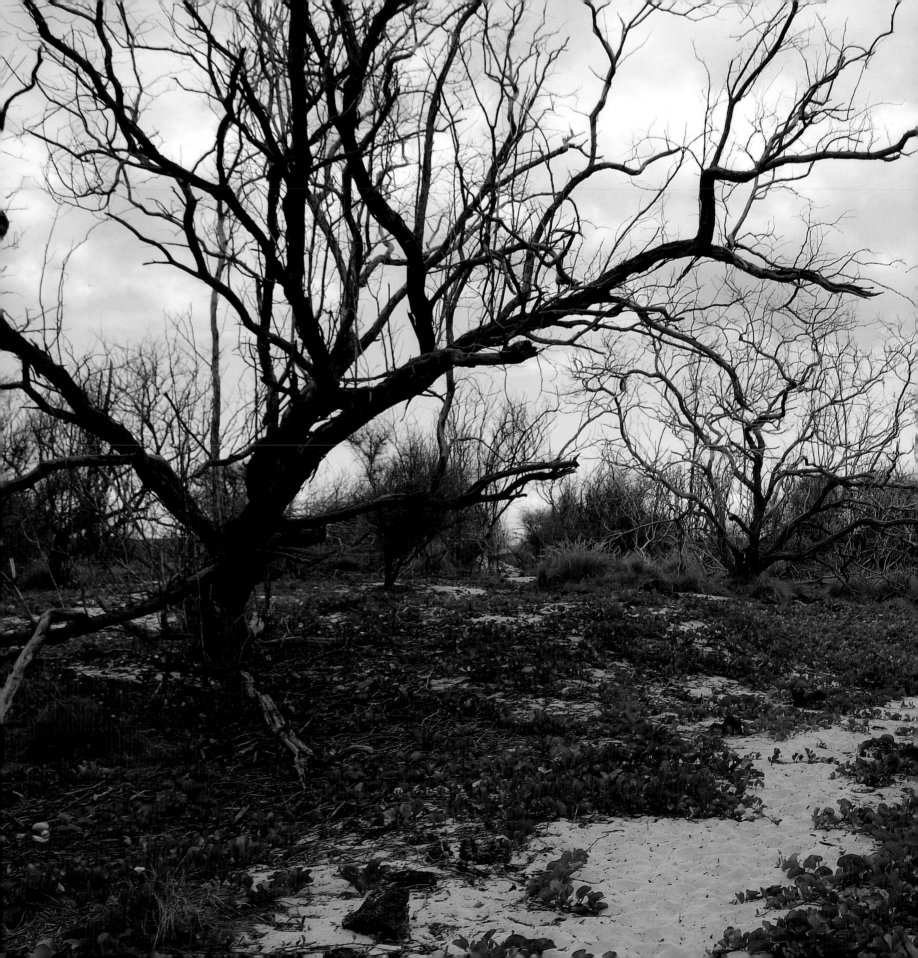

▼ *This was a sandy beach until a lava flow came and separated it from the ocean.*

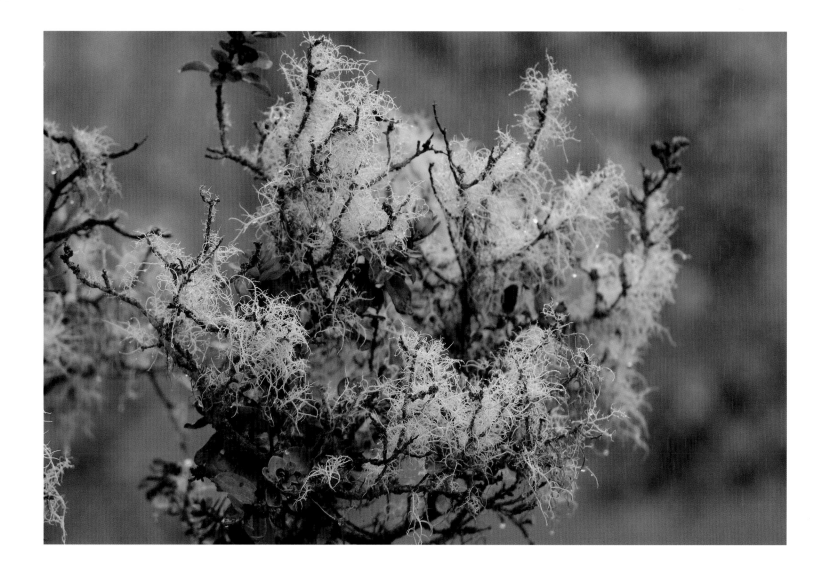

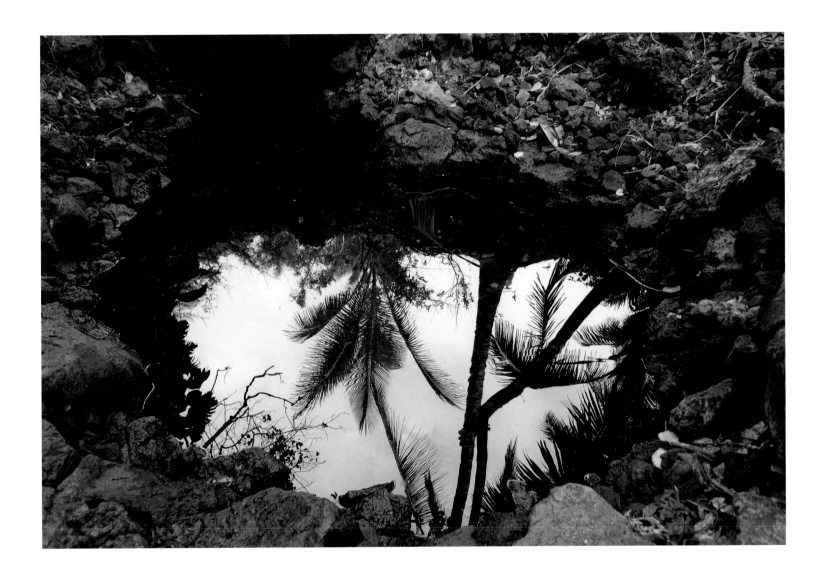

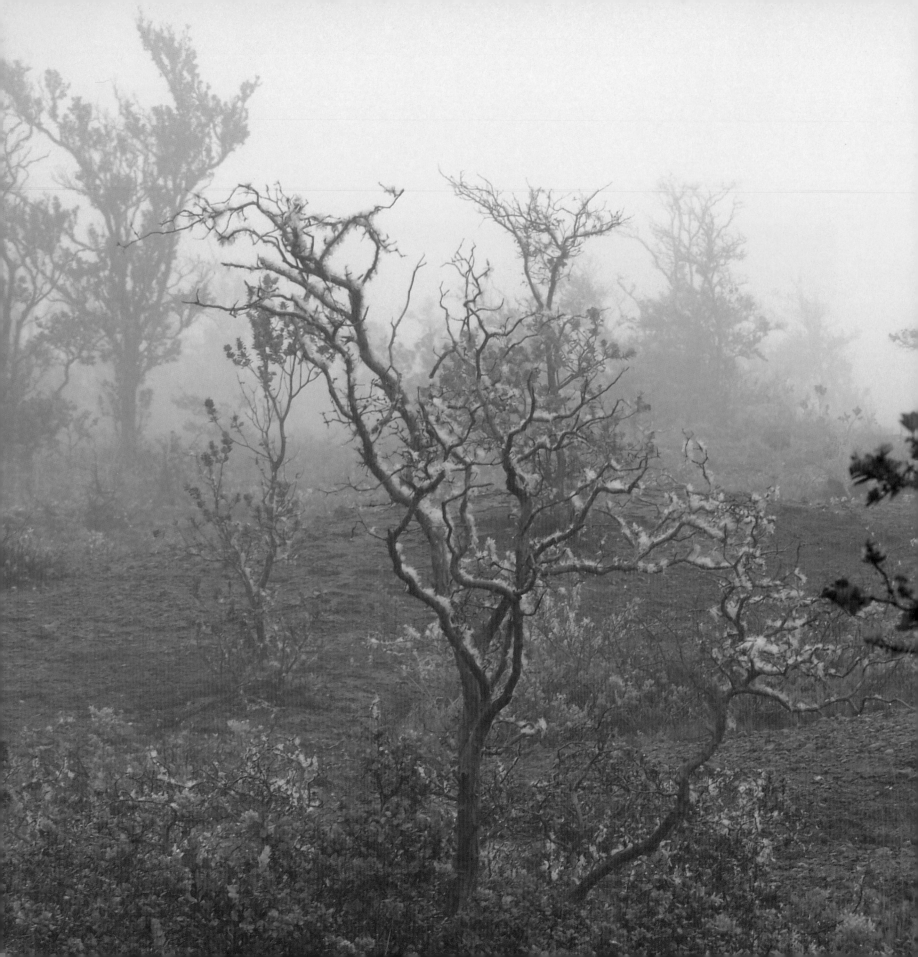

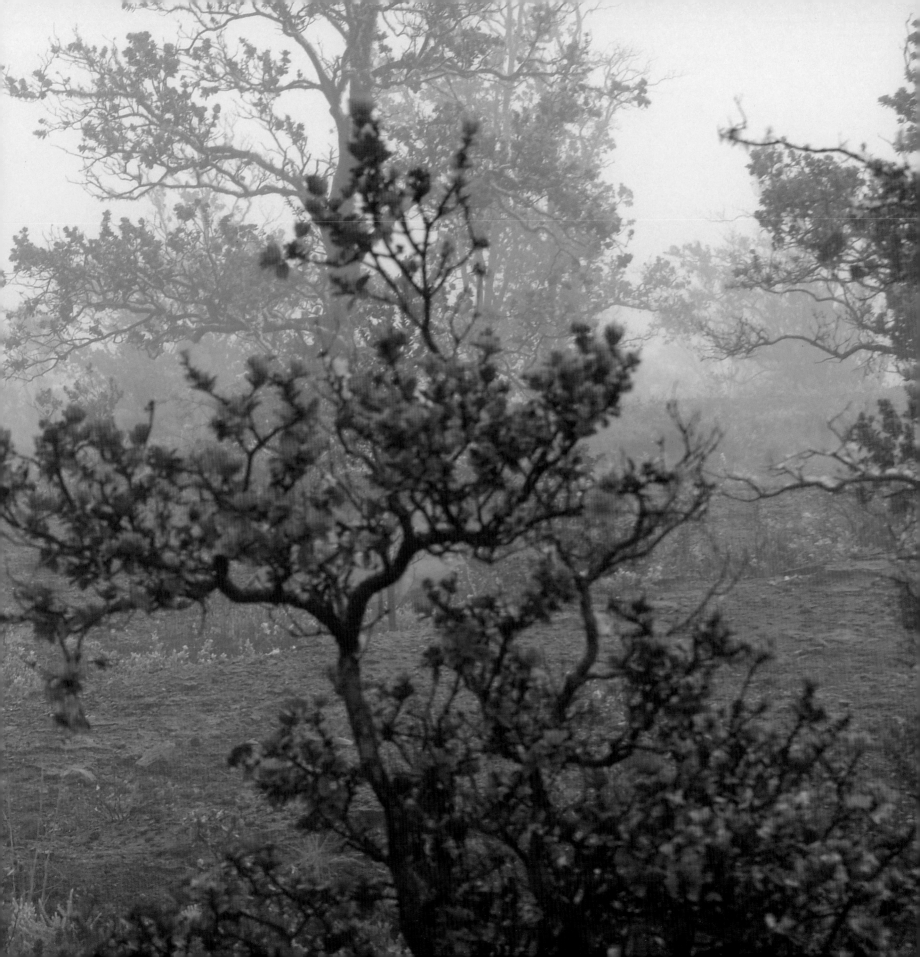

▼ *Mist and fog envelop and nurture the new life that springs from relatively recent lava flows.*

◣ *Waves, illuminated by the very lava the ocean is attacking, begin dismantling the land before it even cools.*

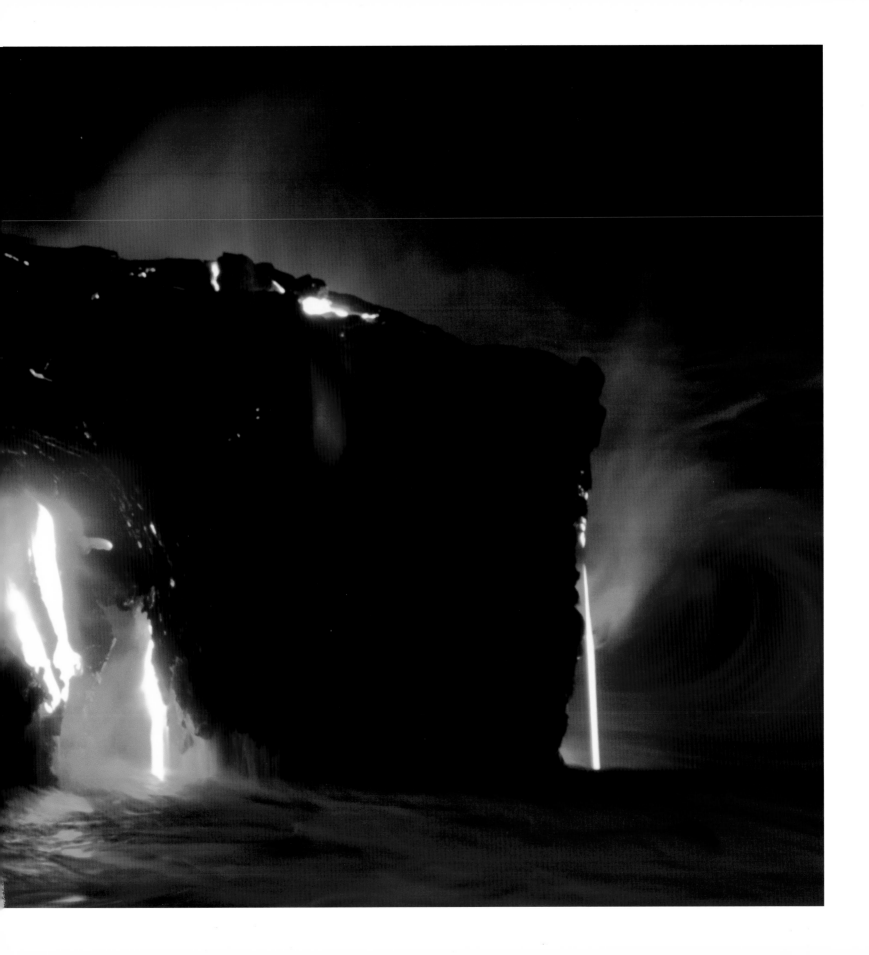

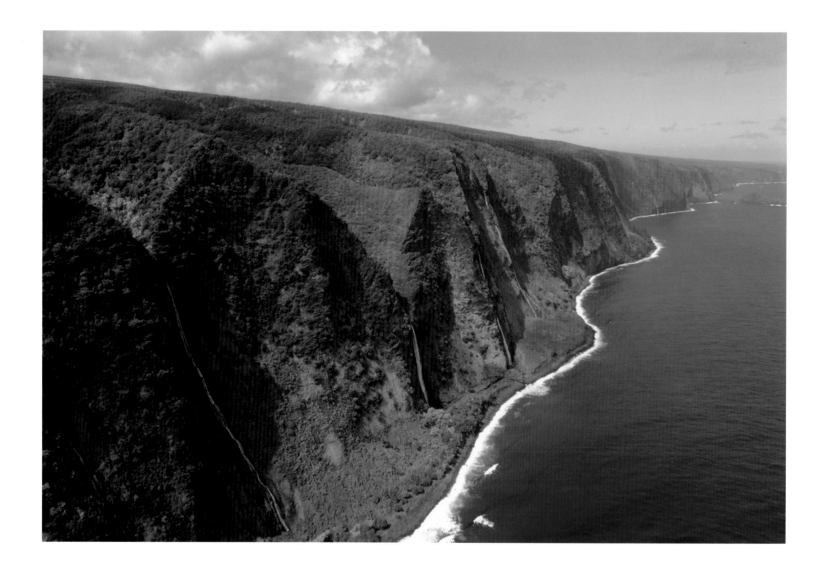

◥ *The recipe for waterfalls only calls for two ingredients: lots of rain and lots of sudden elevation changes. Rainbow Falls on the right and the many falls of the Hamakua Coast are proof that the Big Island has what it takes.*

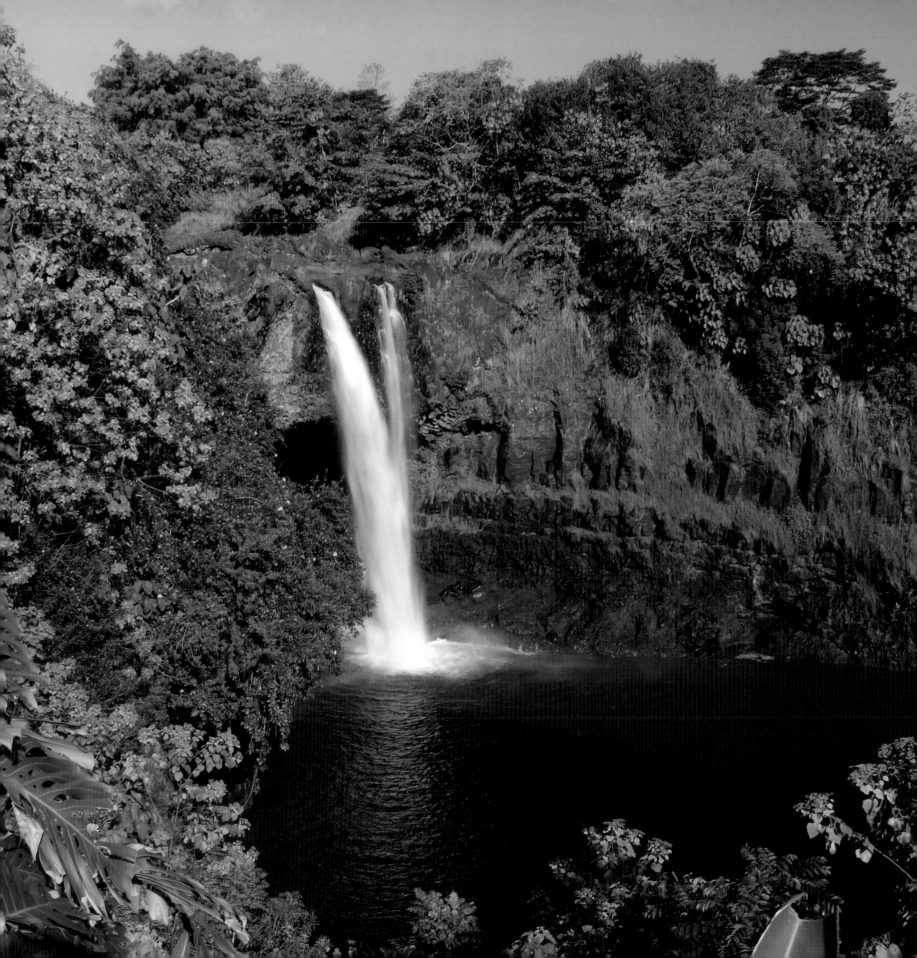

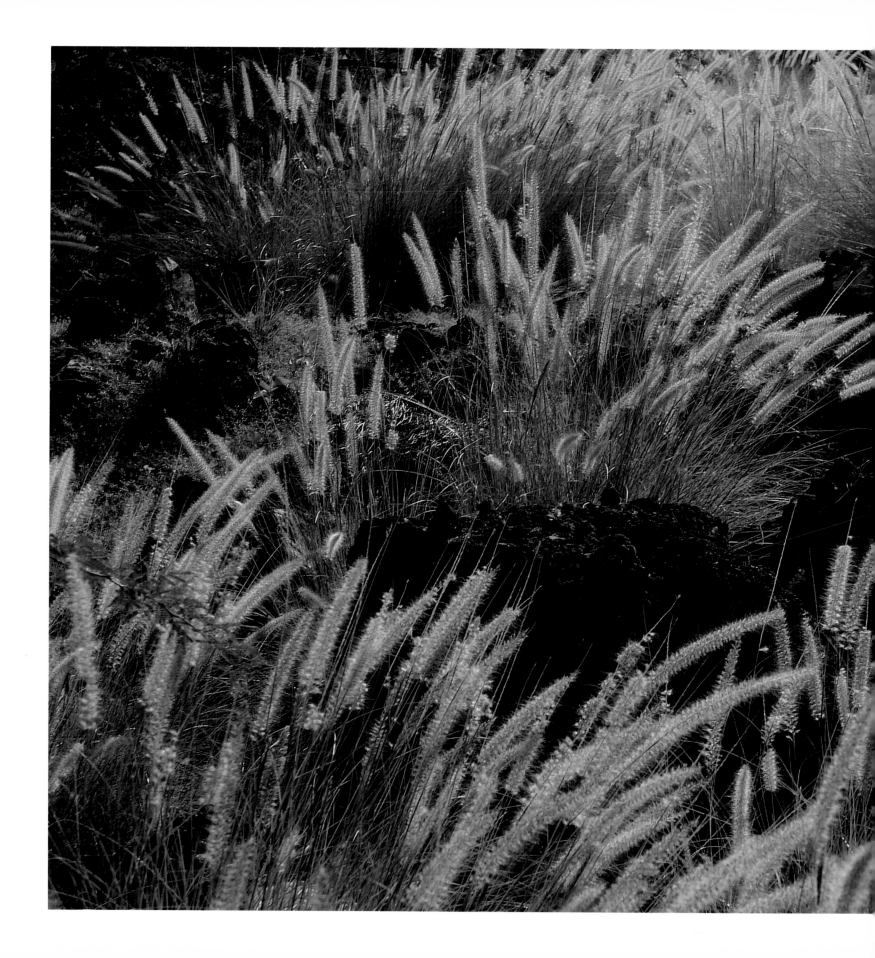

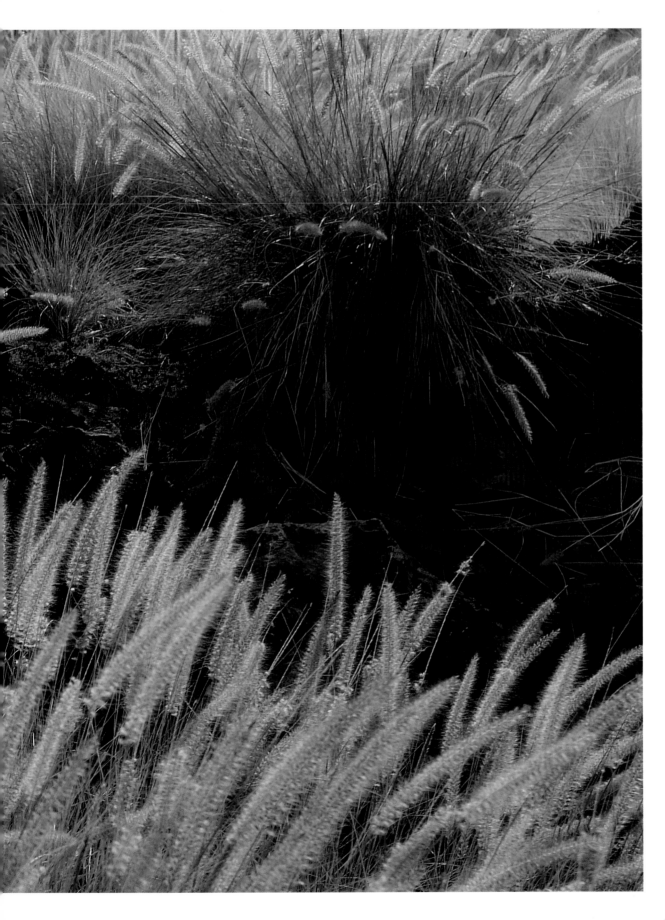

▼ *Grasses produce seedlings for the next generation of life in the dry, harsh lava deserts of Kohala.*

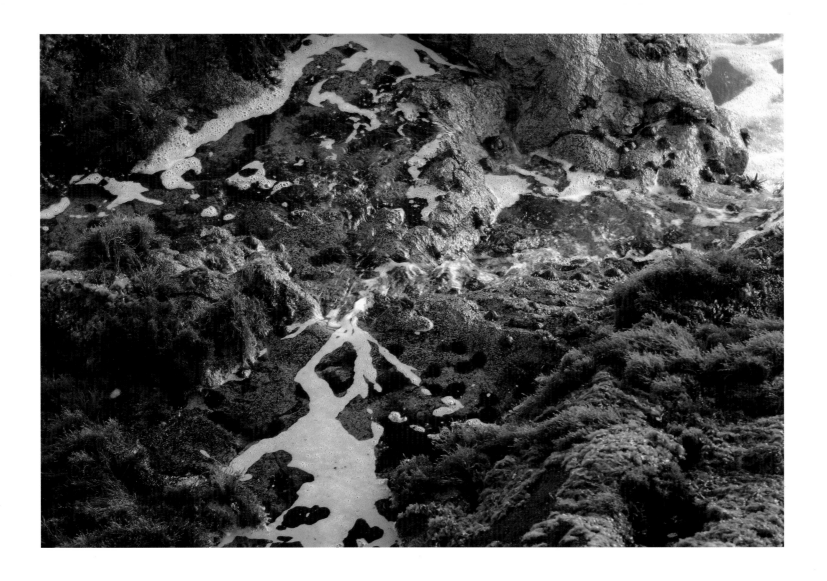

◥ *From the foamy shoreline to the top of Mauna Kea over two miles high, life always finds a way.*

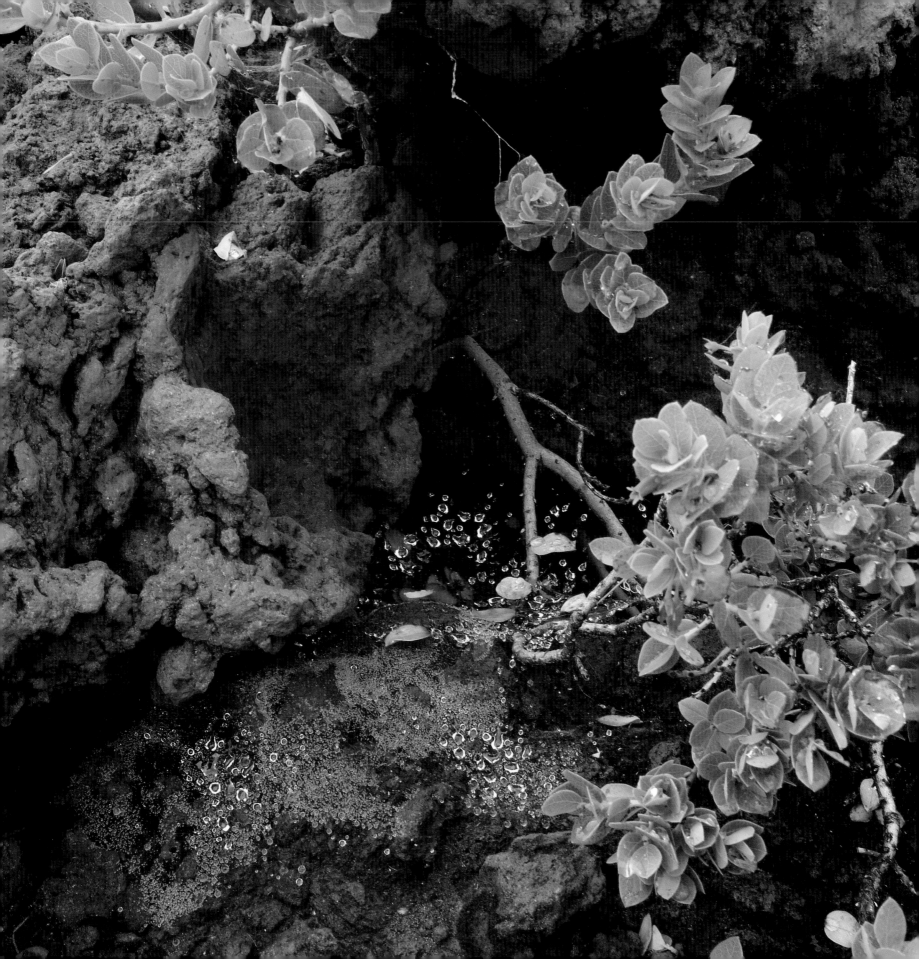

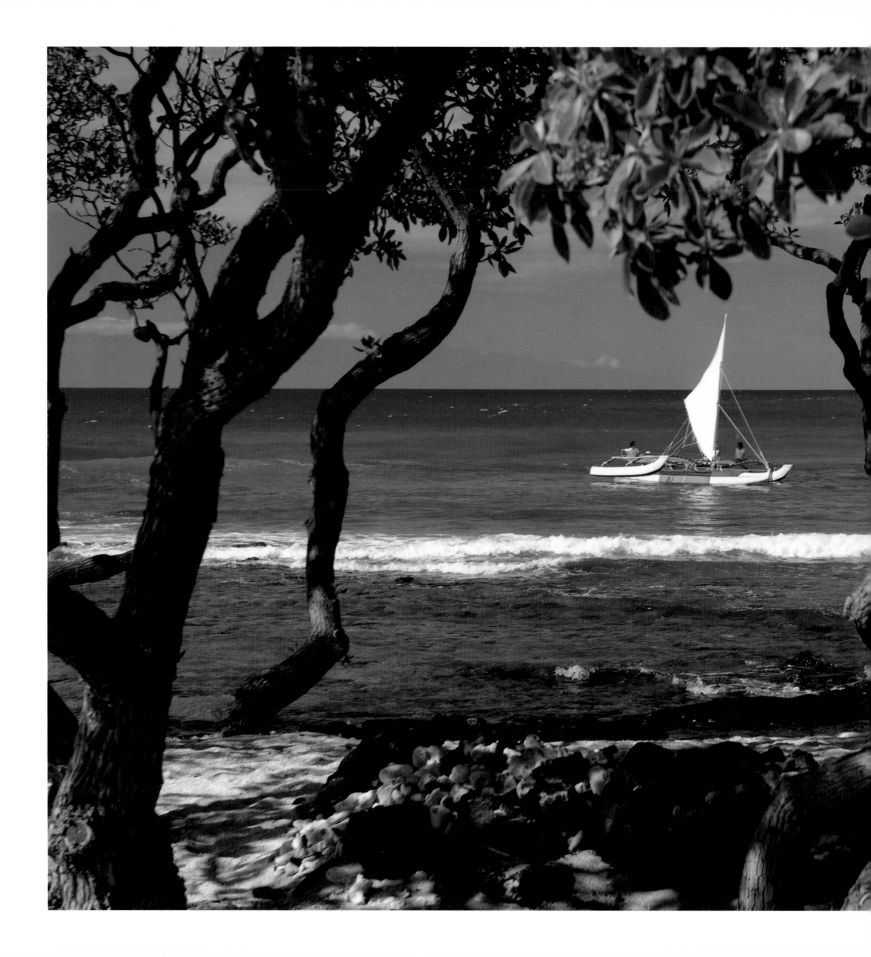

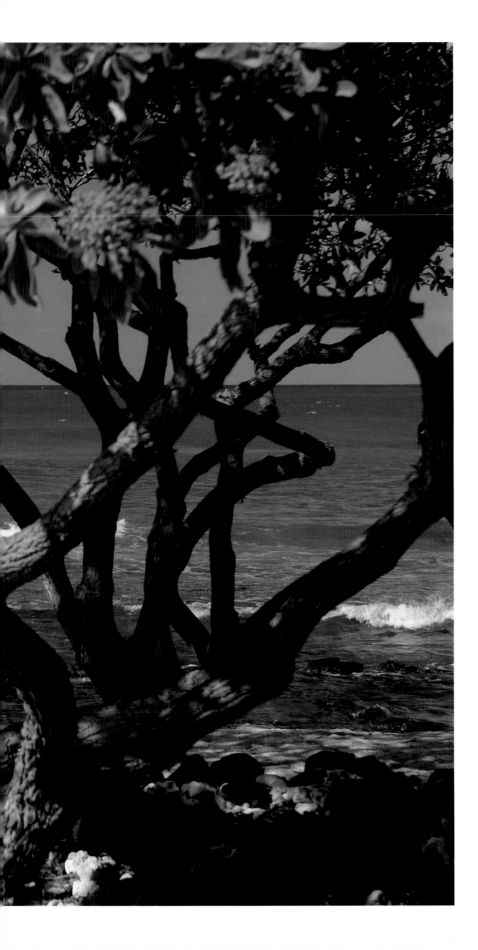

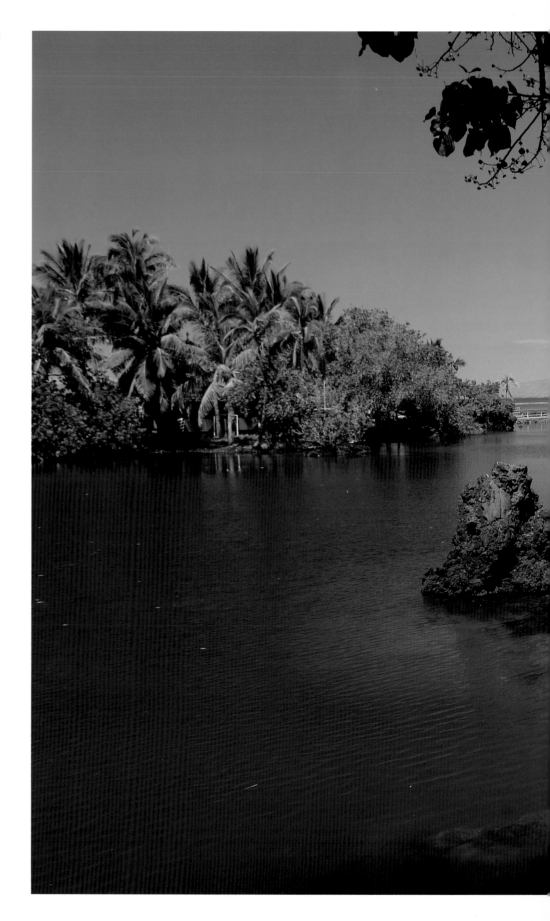

◥ *The west side of the Big Island has no permanent streams. Rain usually seeps into the lava. Sometimes, at places such as at the Mauna Lani, the water percolates back out of the ground, forming fresh or brackish ponds.*

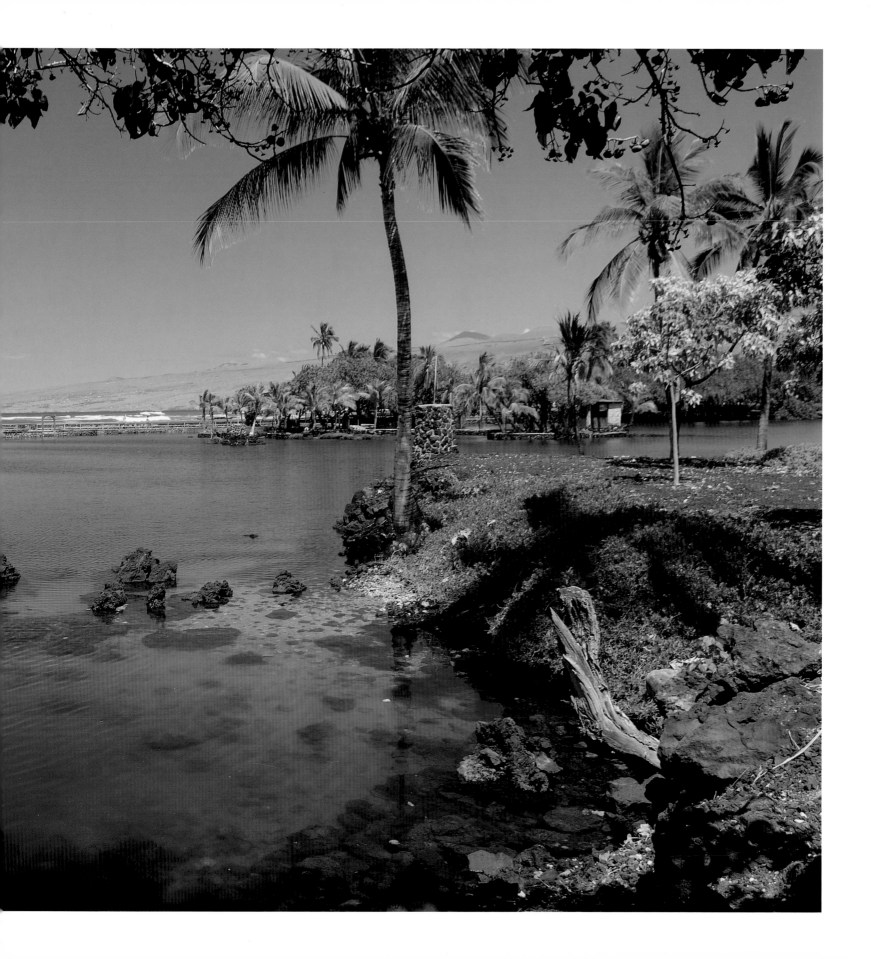

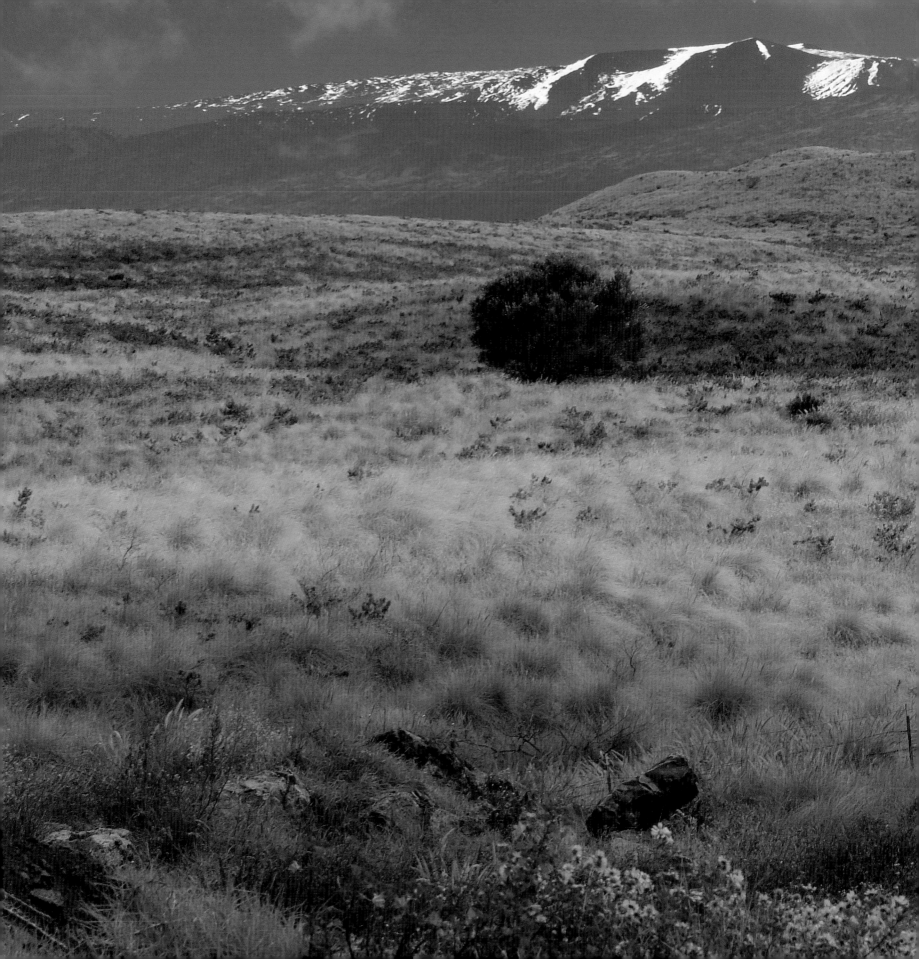

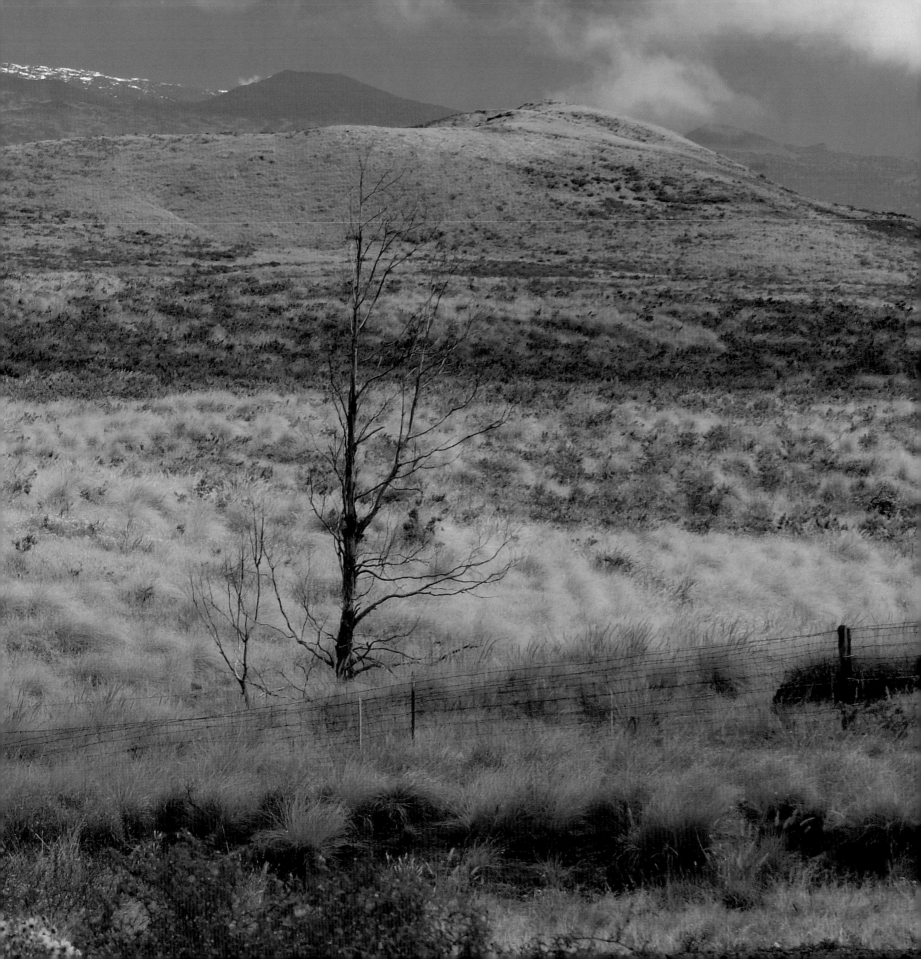

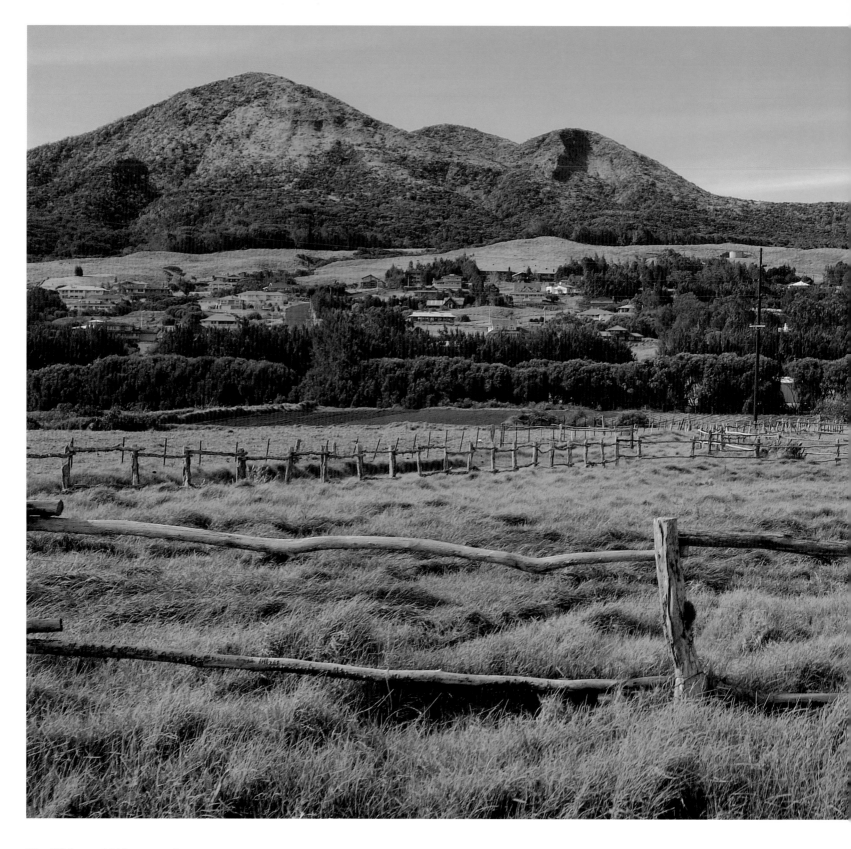

▼ *With over 4,000 square miles of land, wide-open spaces are still easy to find on the Big Island.*

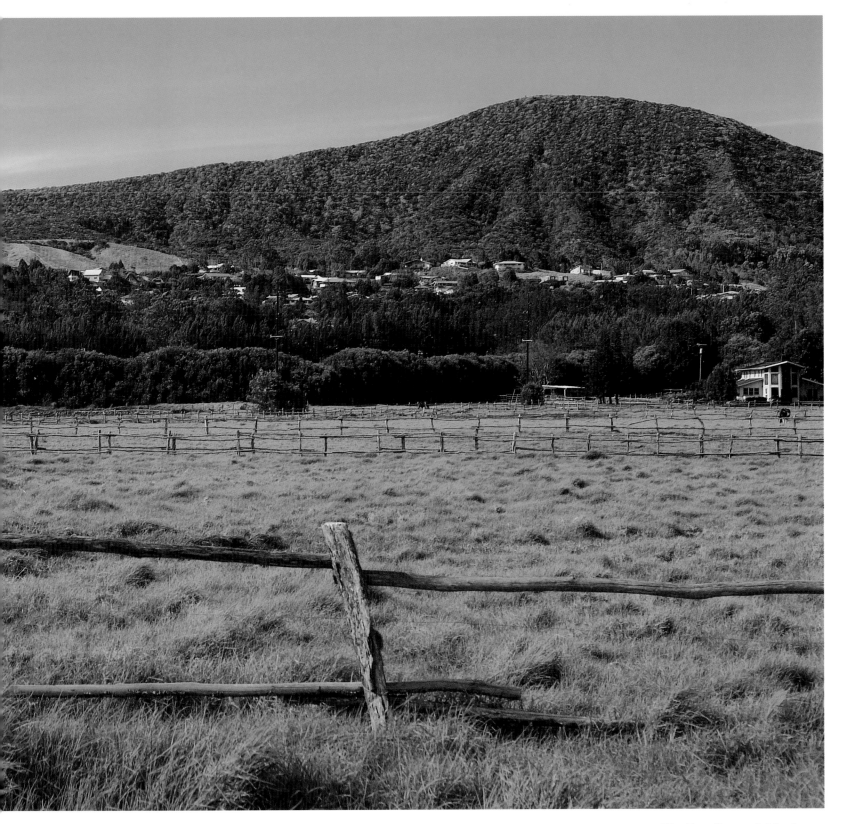

▼ *To really get a feel for the cowboy town of Waimea, you need to step back and view it from Parker Ranch, here on Mana Road.*

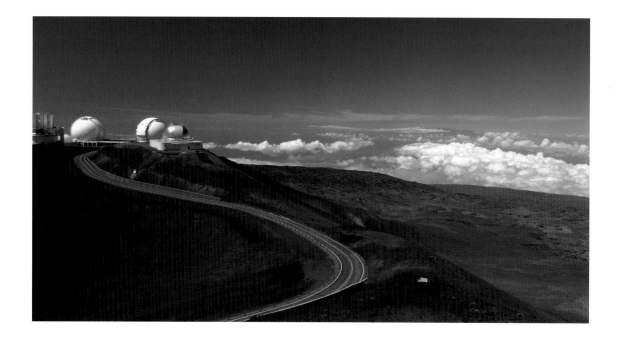

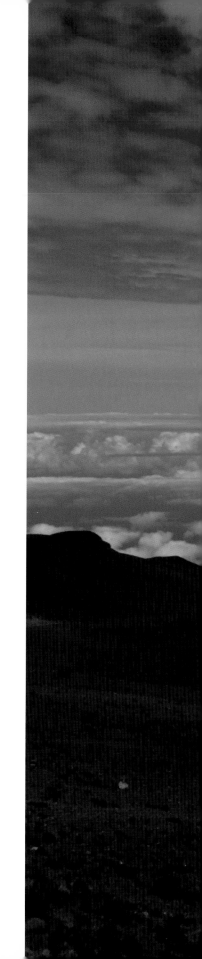

◥ *With clouds below you, the summit of Mauna Kea can take on moonscape properties.*

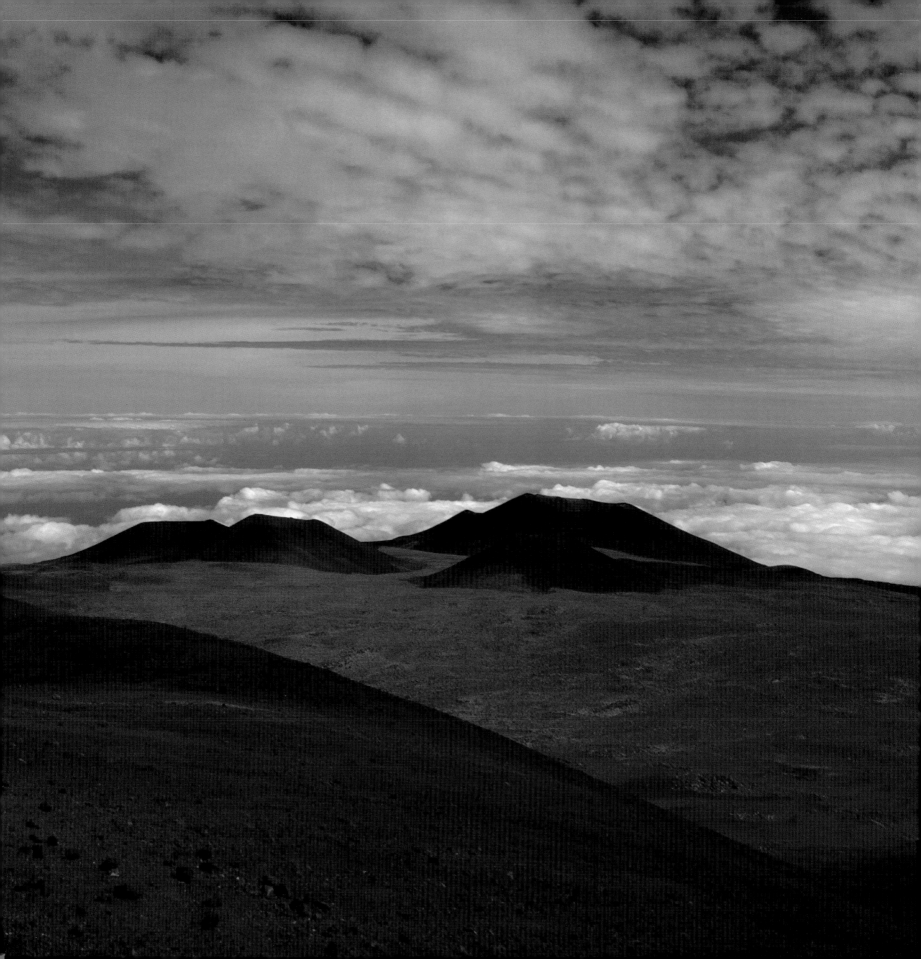

▼ *The forest floor teems with life in the form of moss and lichen.*

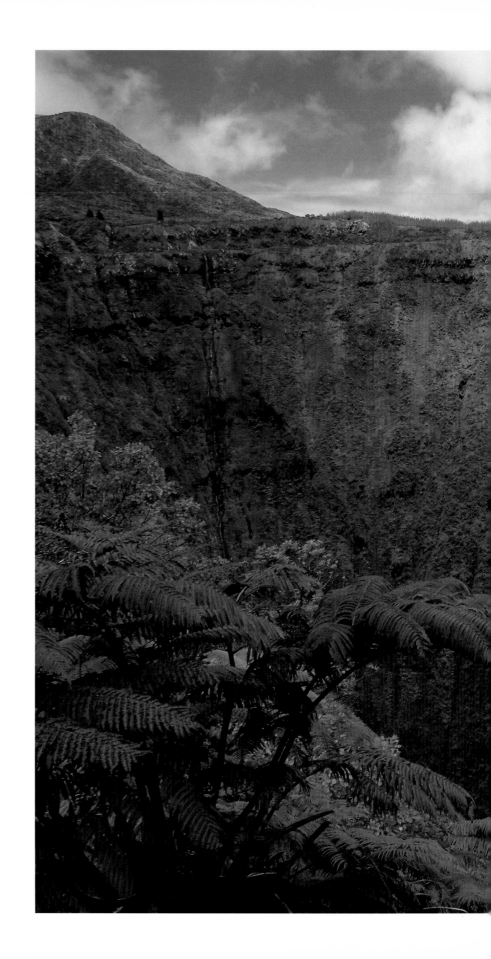

◥ *The back of Waipio Valley ends suddenly, with 2,000-foot walls carpeted with green.*

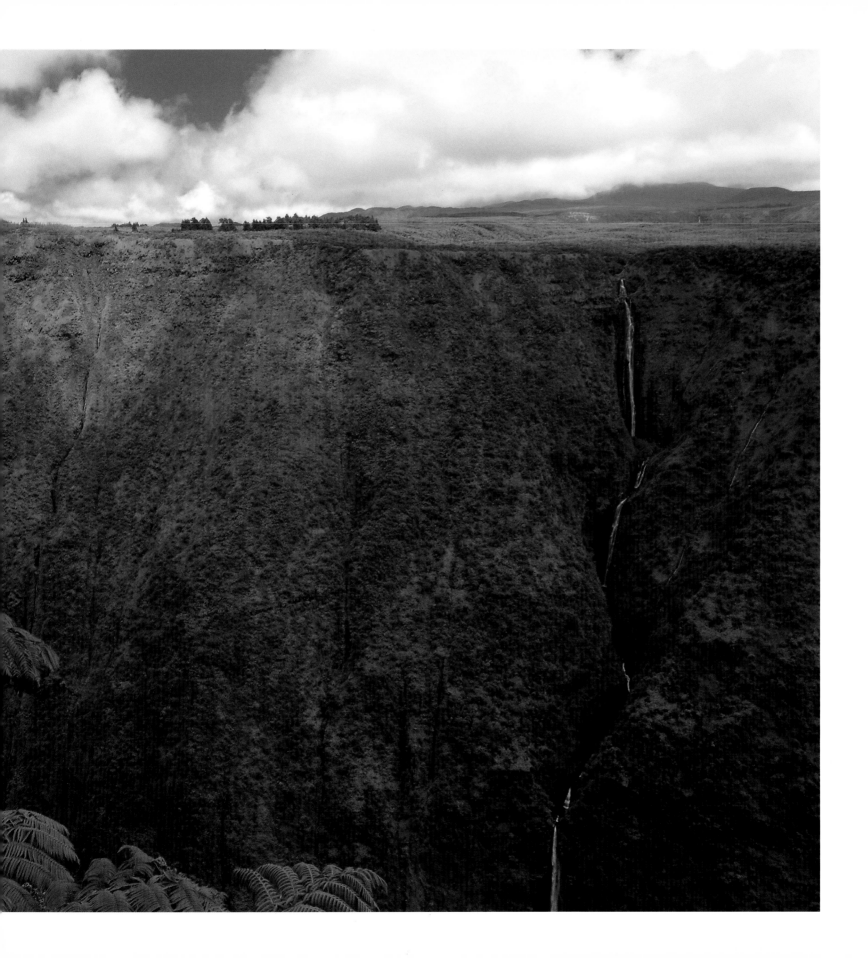

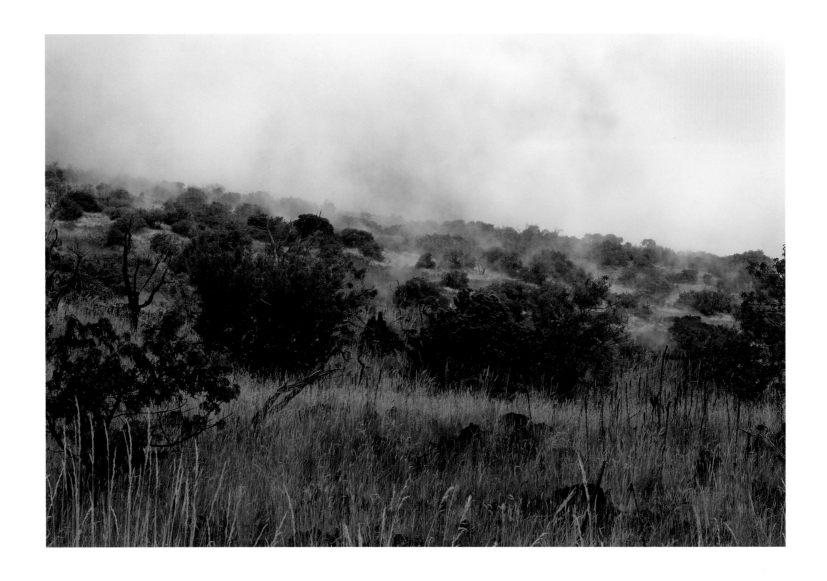

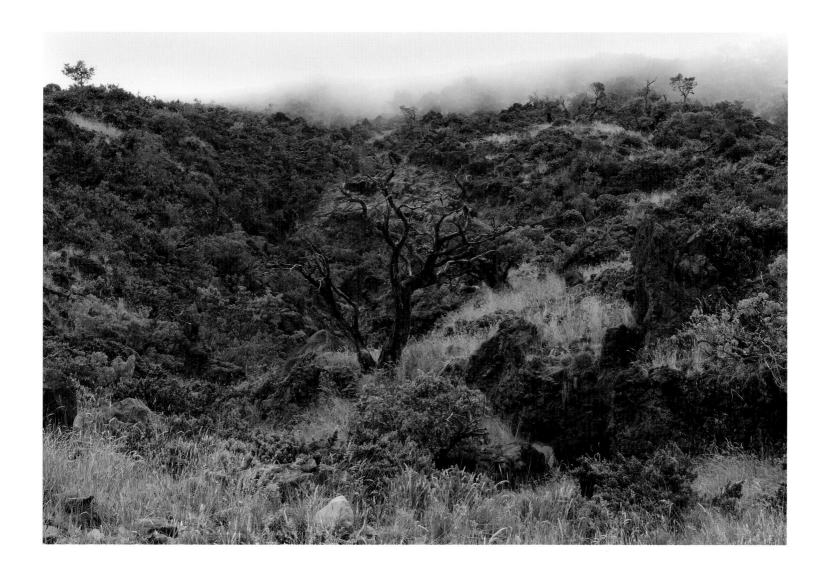

▼ *Looking more like fire on the mountain, clouds are your constant companions when you and your 4WD venture to the back side of Mauna Kea.*

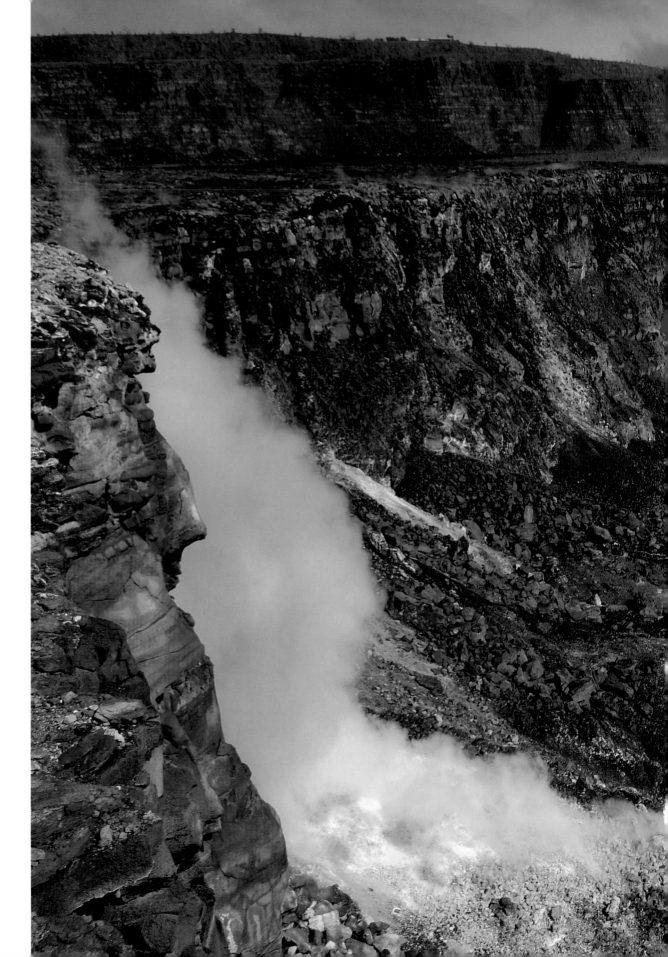

Hellish sulphuric fumes weep out of Halemaumau, Kilauea's scabbed-over wound.

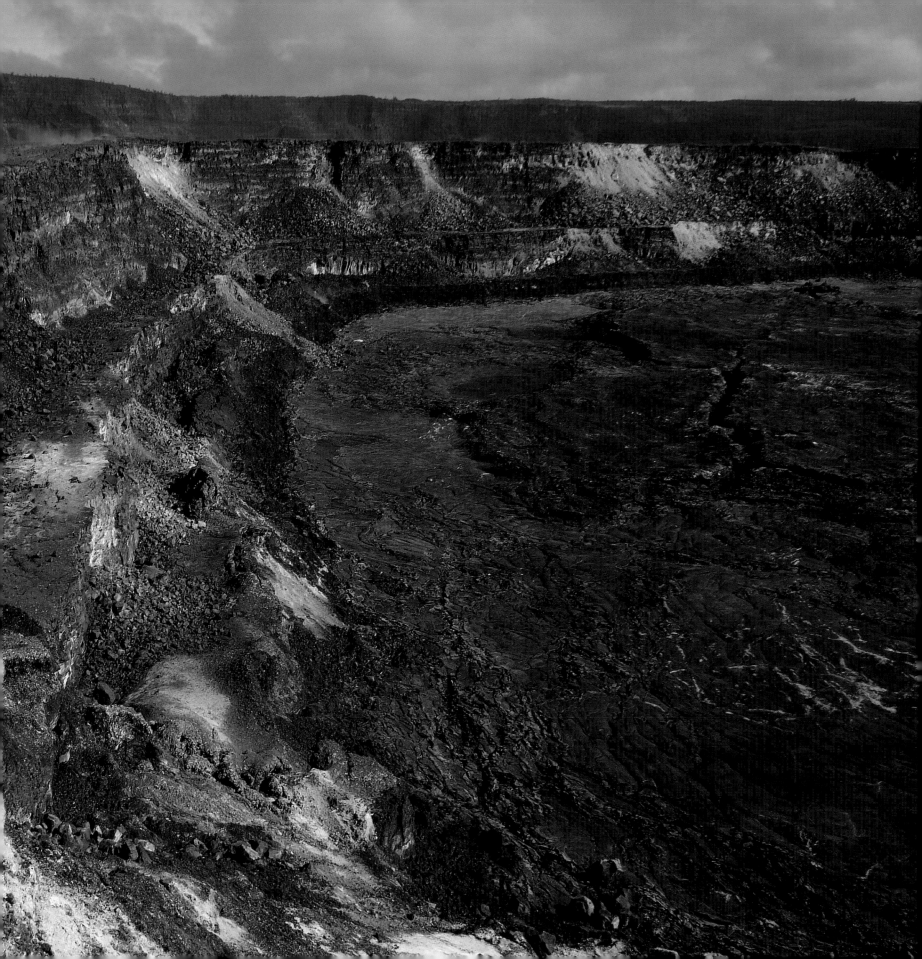

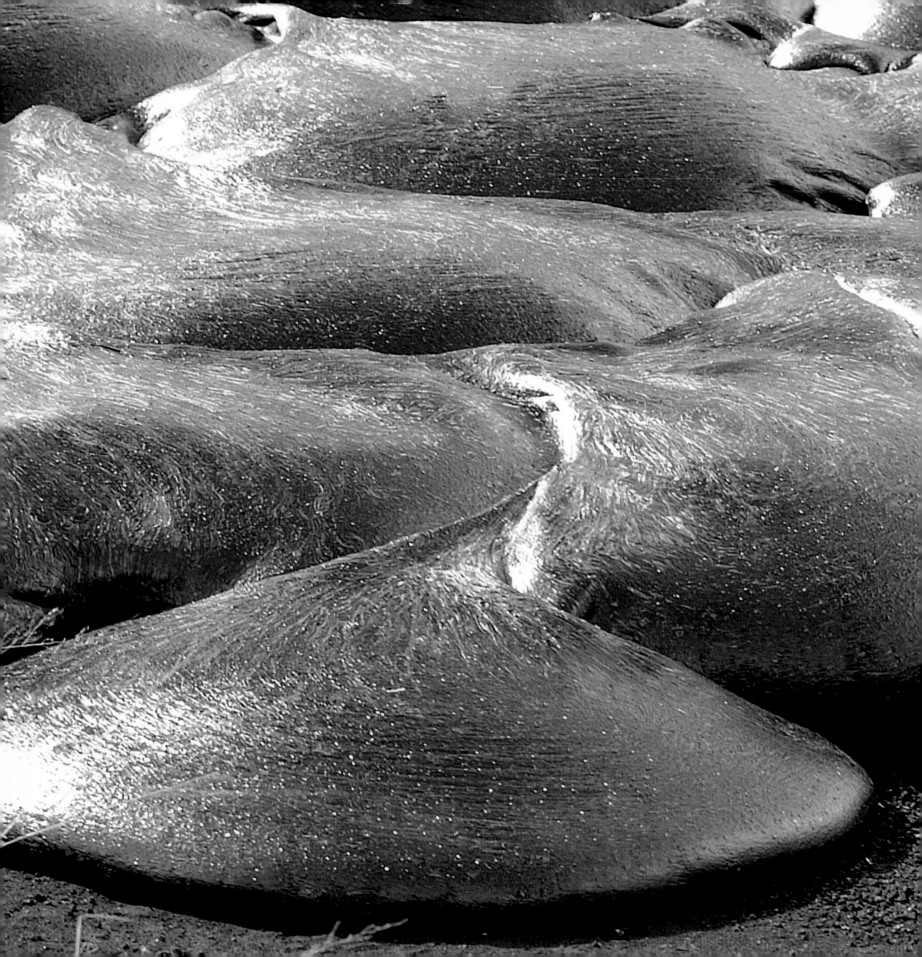

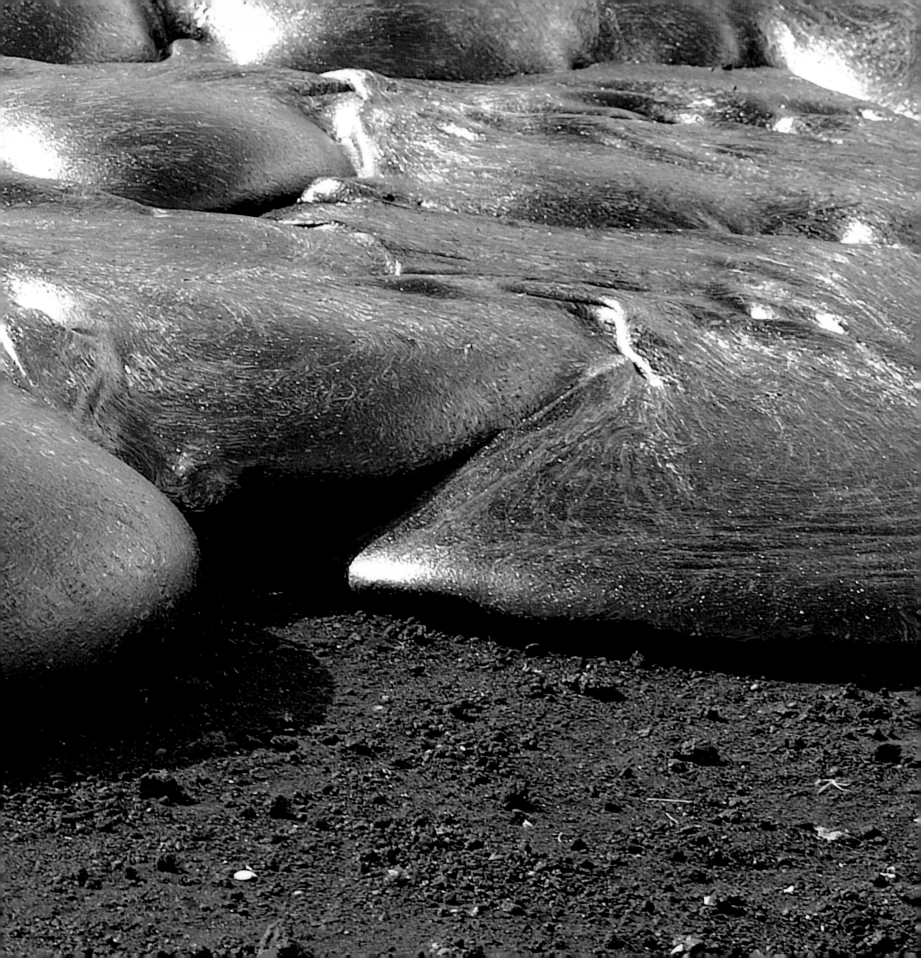

Looking like liquid mercury, lava slowly creeps over the land.

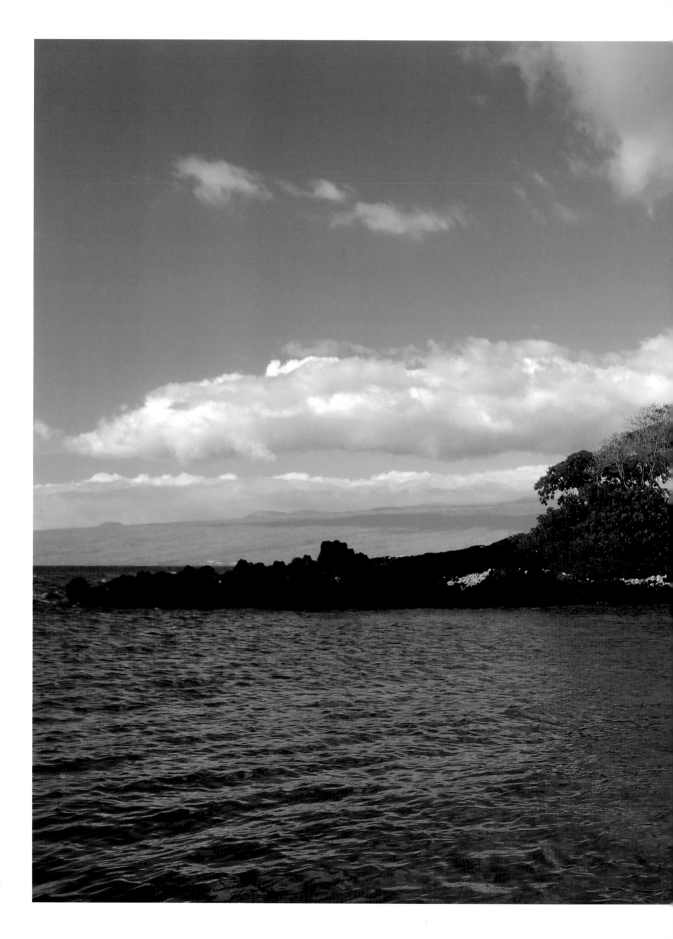

A calm, gentle cove along the Kohala Coast.

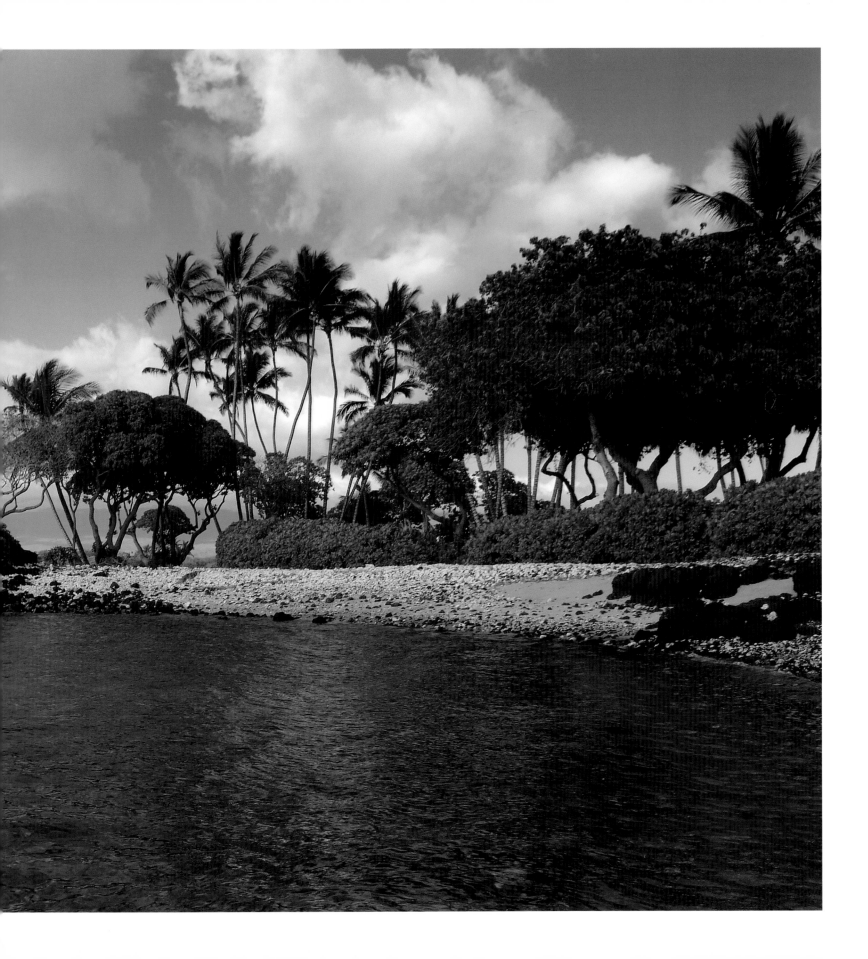

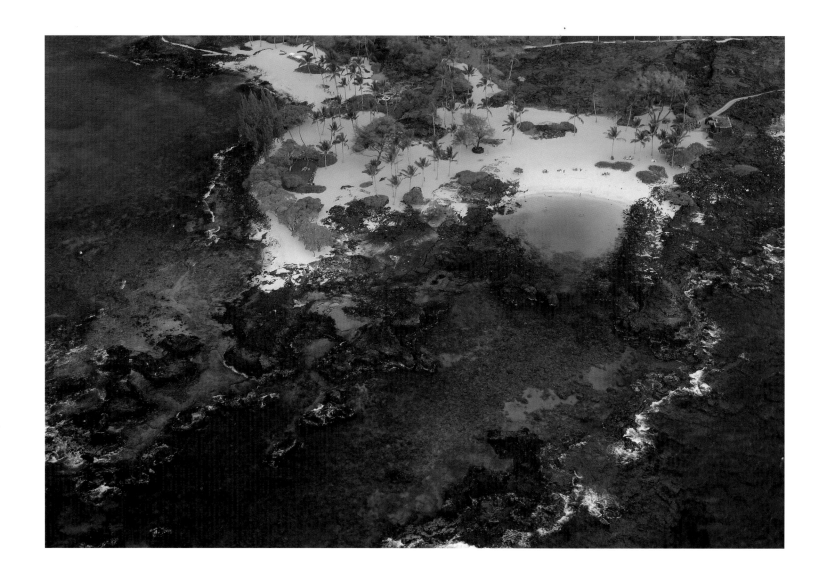

◤ *Ironically, both of the beaches are new. Kikaua Beach (on left) was formed by developers over the course of months. The one on the right was formed by the most recent lava flow and took only days.*

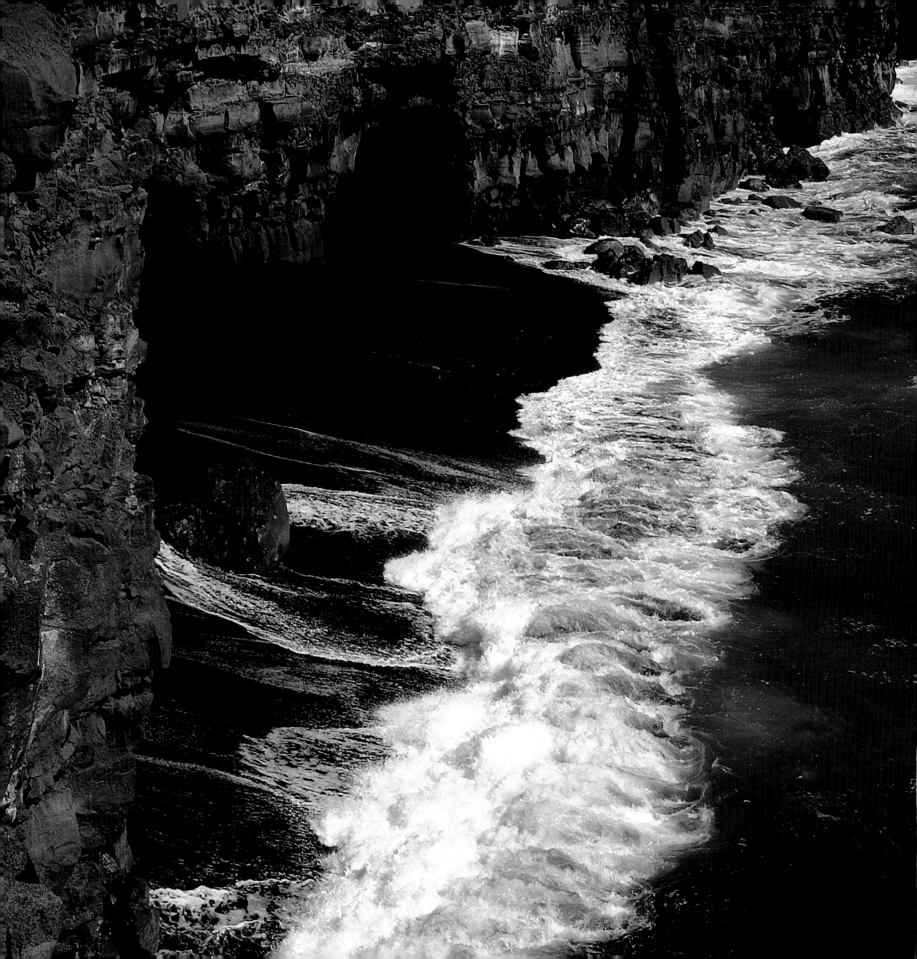

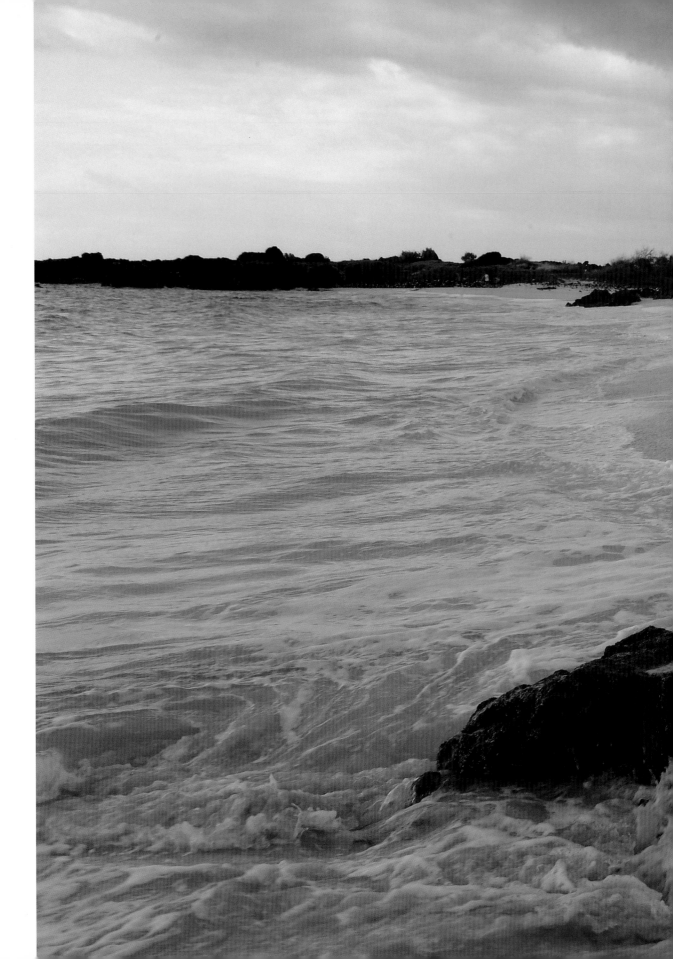

▼ *Even when skies are dreary or threatening, the lava-strewn beaches are always inviting.*

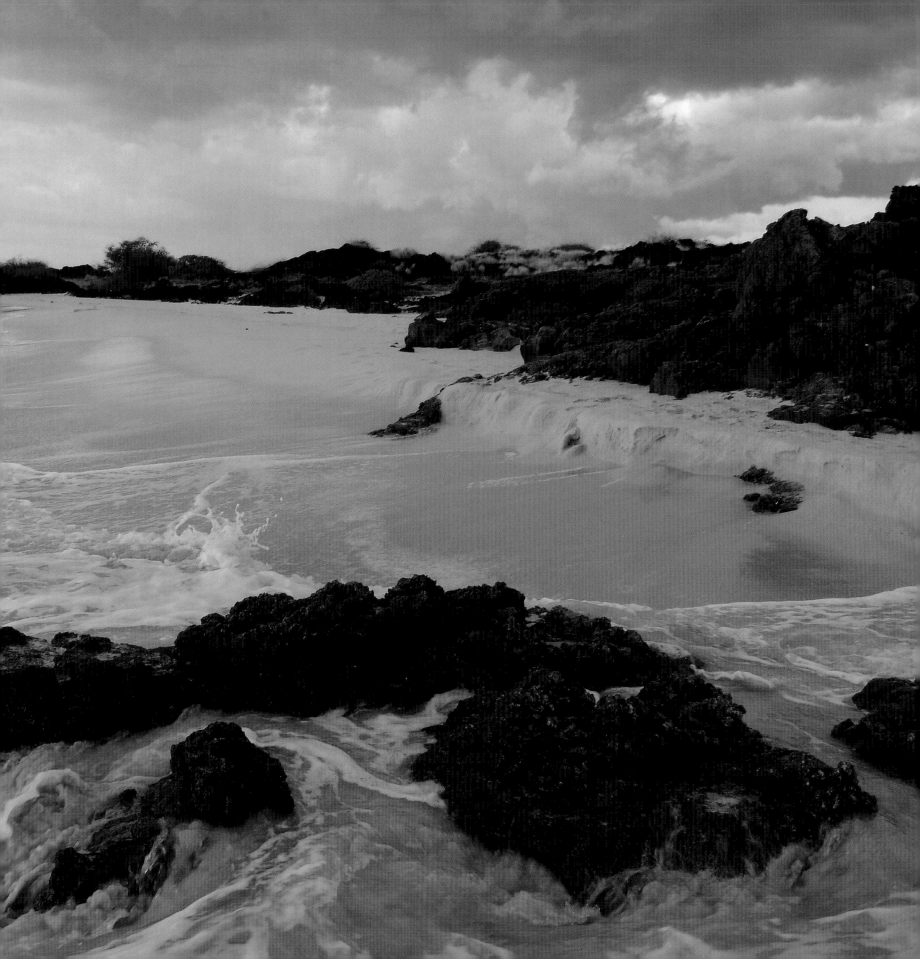

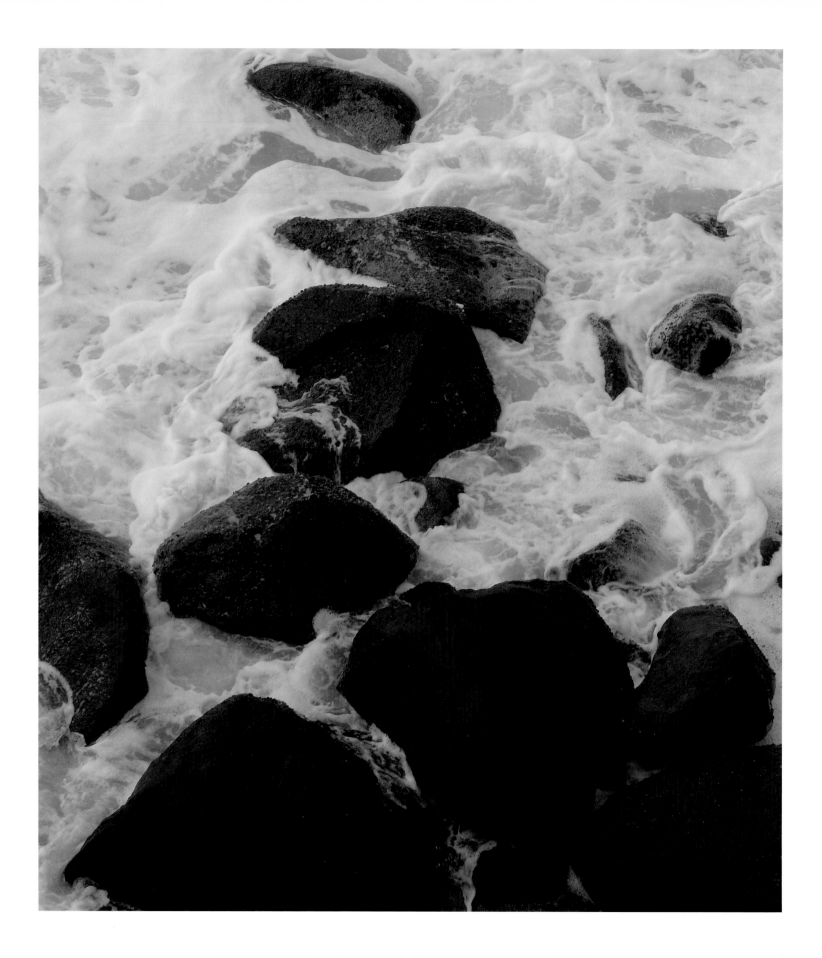

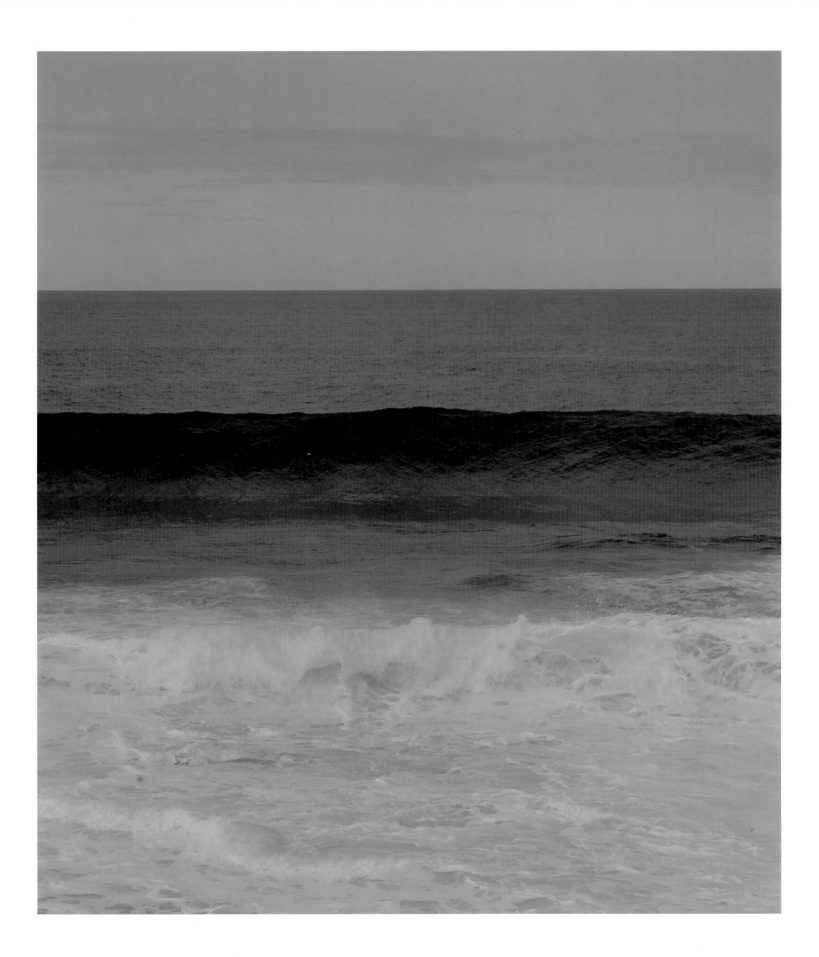

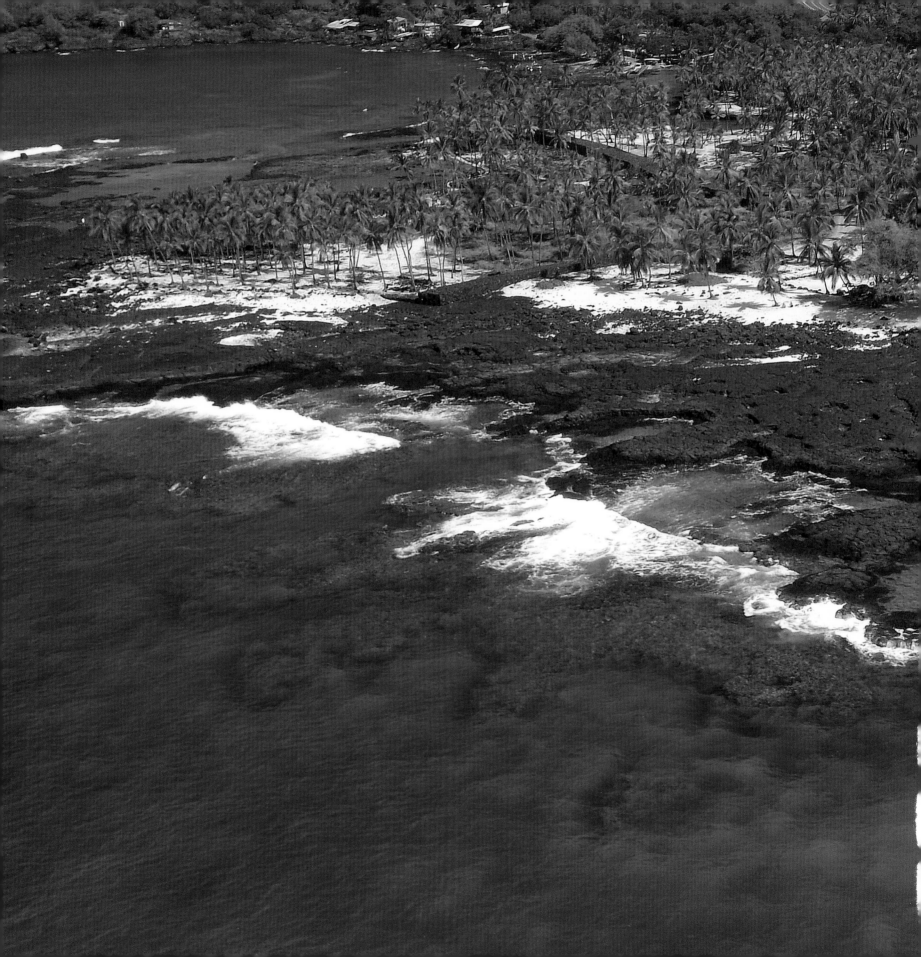

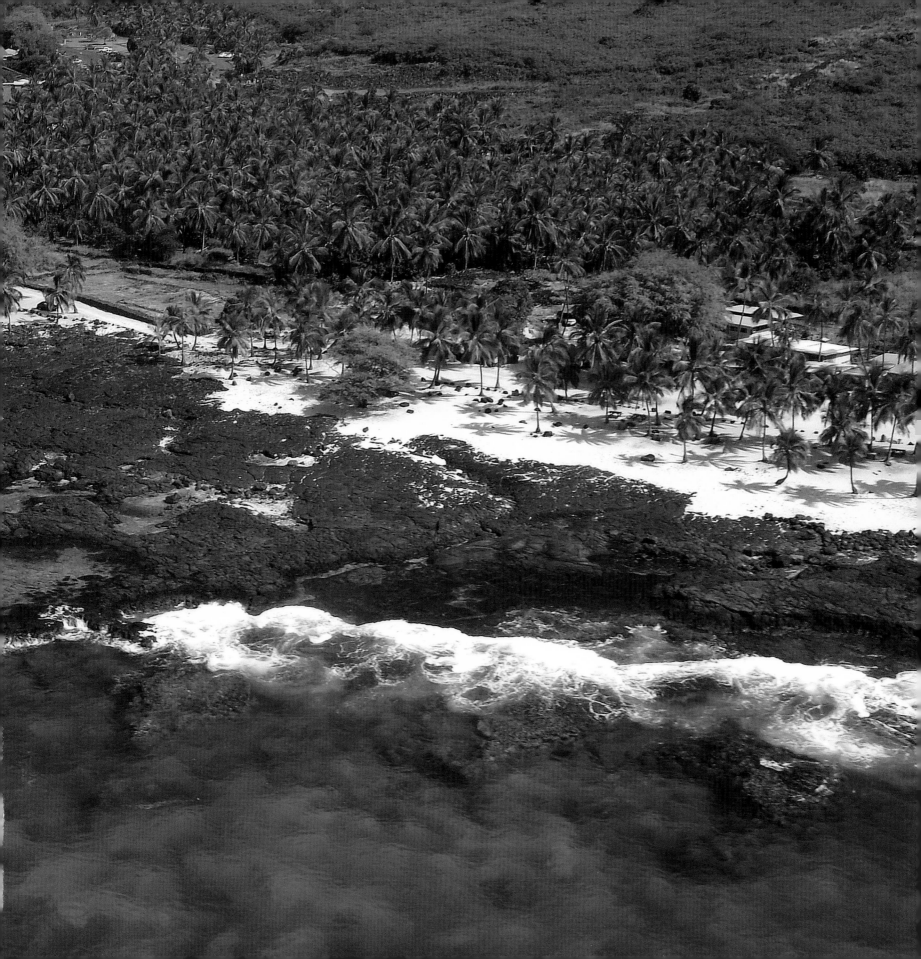

▼ *In ancient times, Hawaiians would flee to this place of refuge, called Pu'u Honua o Honaunau to escape from the consequences of their crimes. Here offenders would perform certain rituals, and their guilt was forgiven.*

◣ *No, it's not Colorado. It's just another side of the Big Island's charm.*

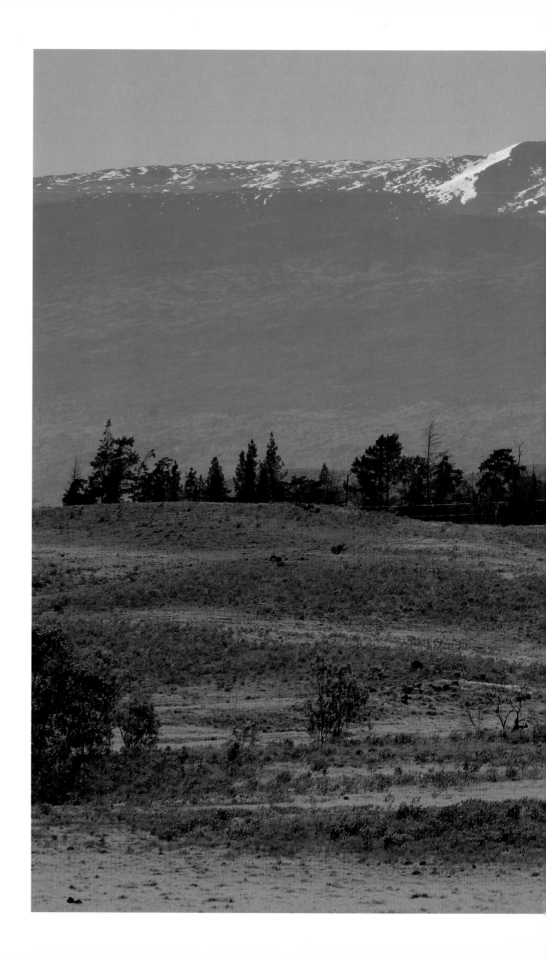

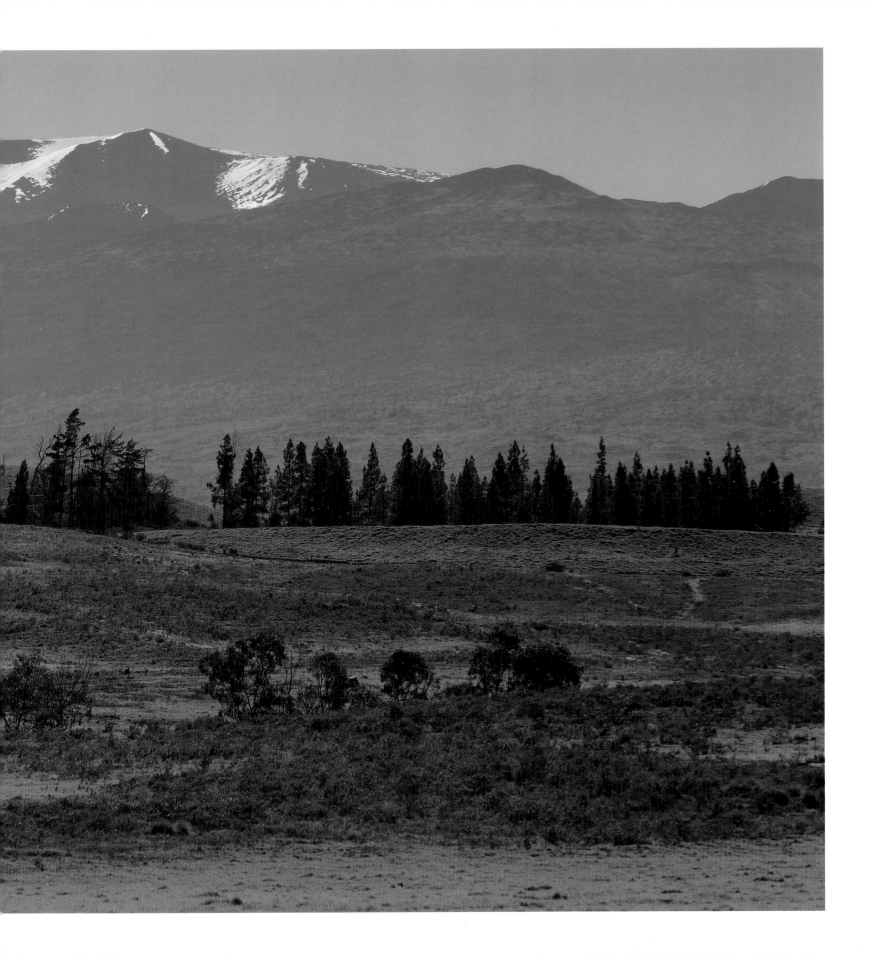

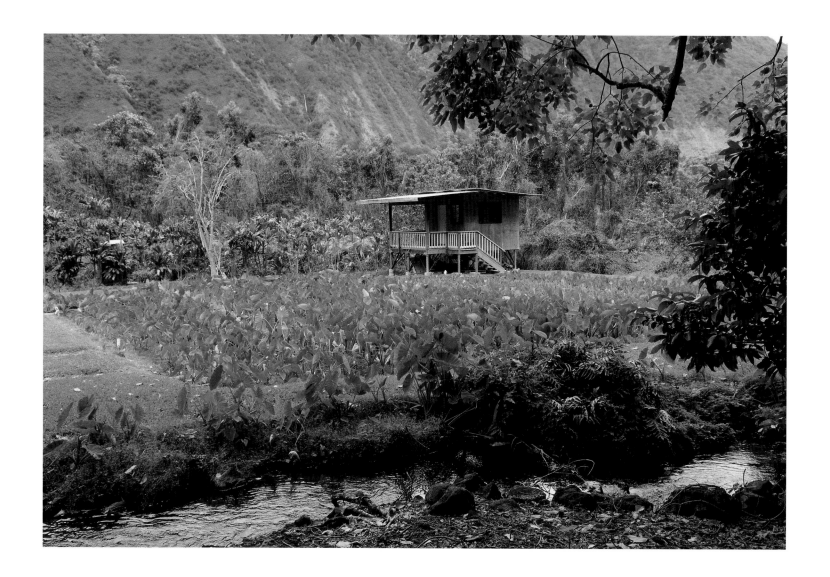

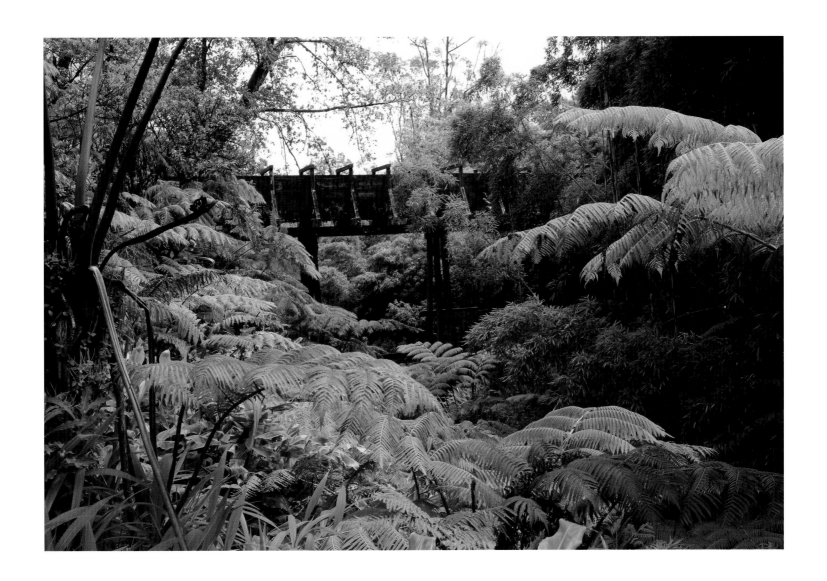

▼ *It's all about the water. Waipio Valley on the left has abundant river water to feed the valley's most important crop: taro. Above the valley, water was diverted in a series of ditches and flumes to feed sugarcane, no longer commercially grown on the Big Island.*

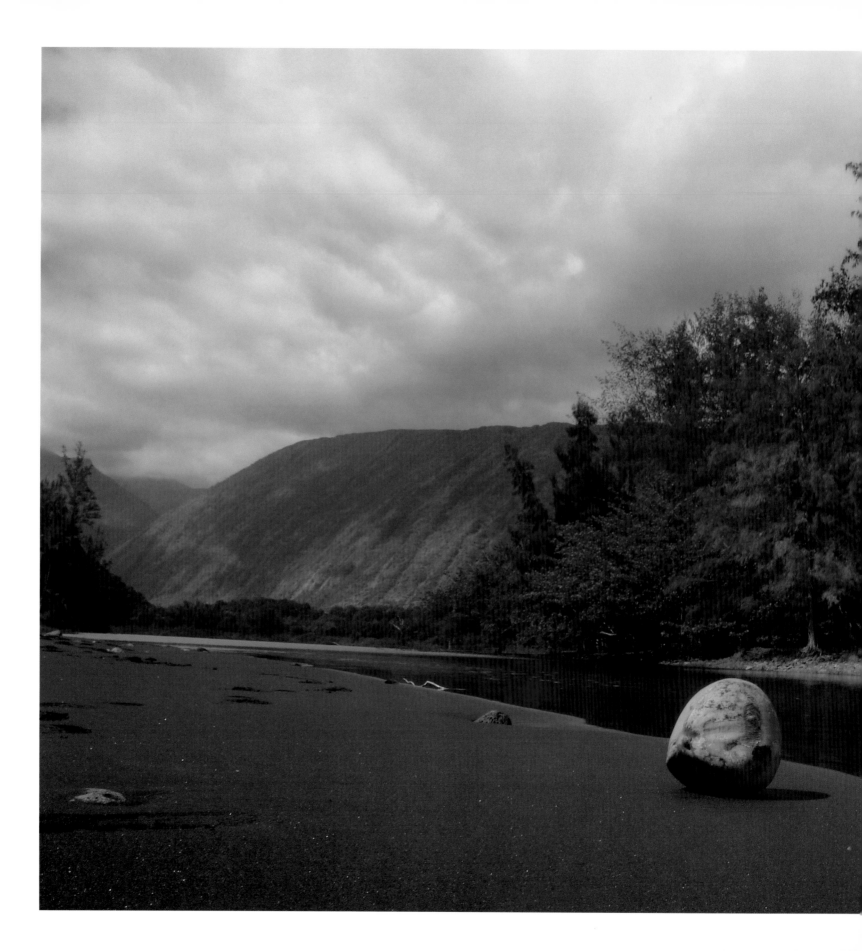

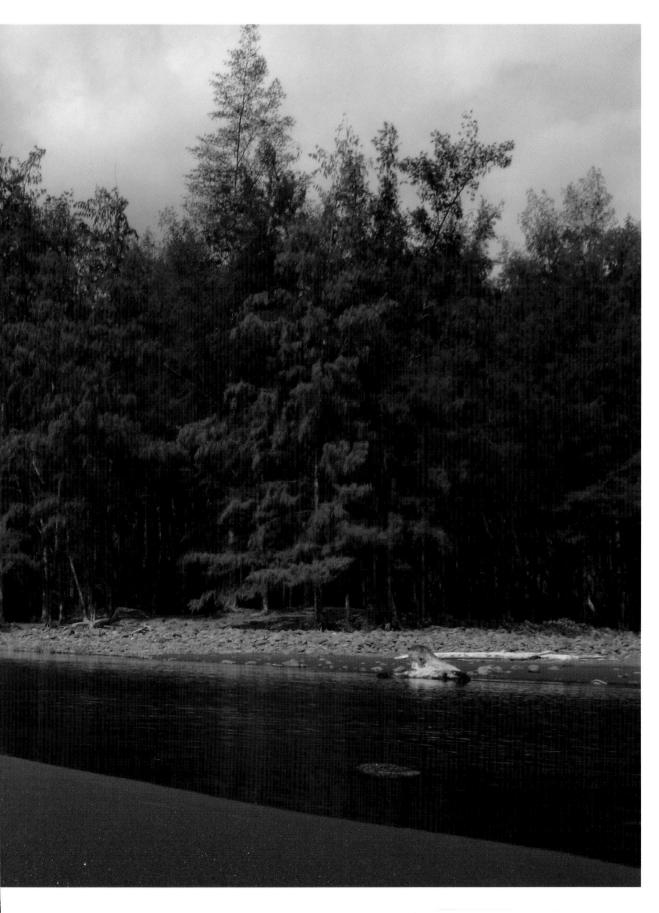

▼ *A lone coconut on a black sand river beach in Waipio.*

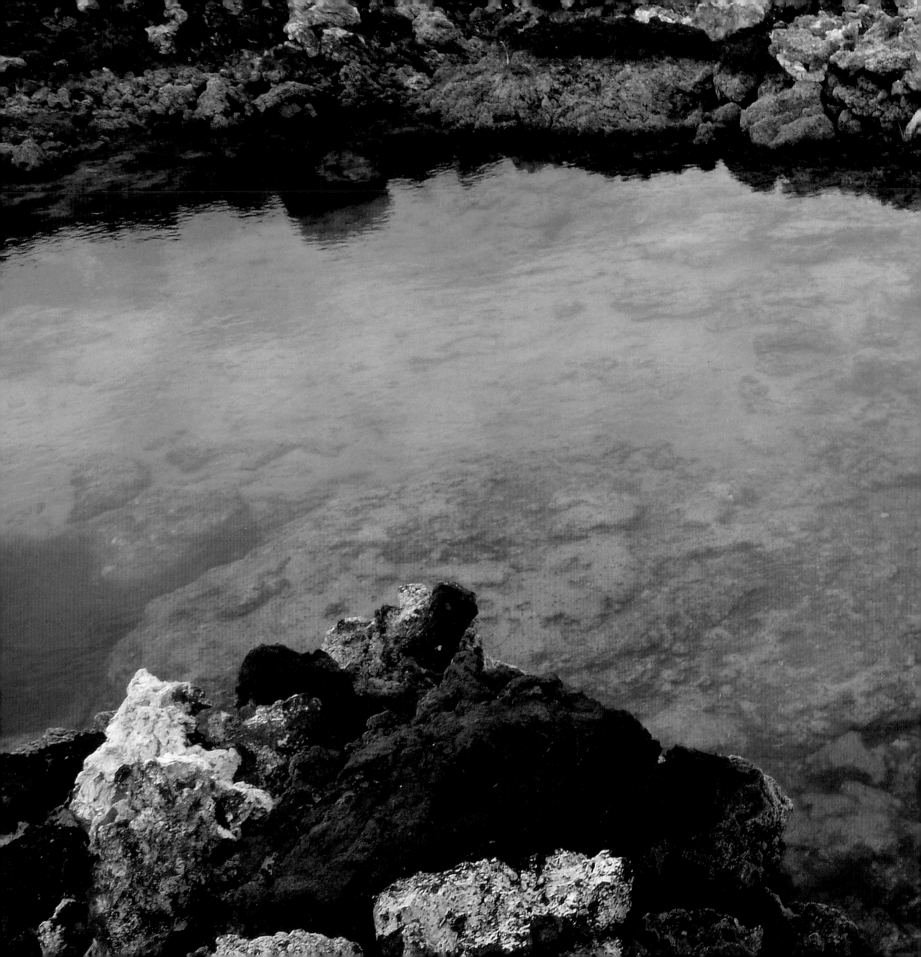

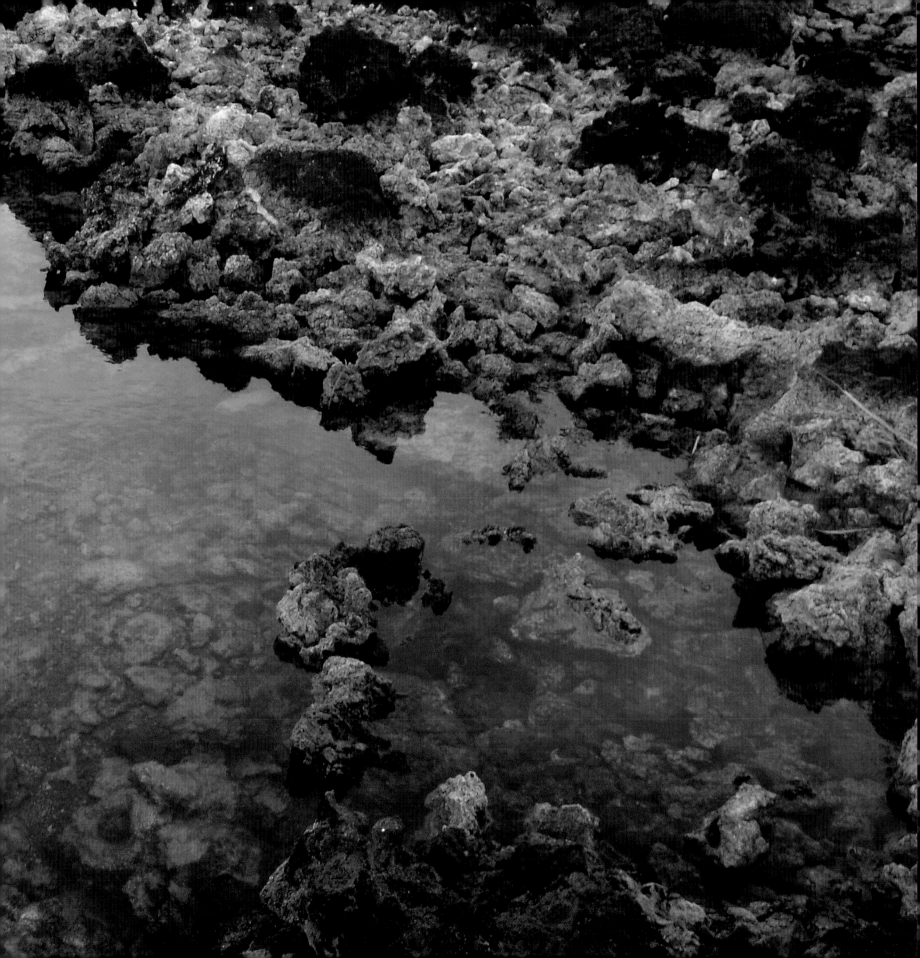

▼ *An ancholine pond forms in the lava field as rainwater disappears into the ground. Gravity takes it as far as it can until it encounters seawater seeping in from the shoreline. Freshwater is lighter than seawater and floats on top, sometimes percolating to the surface.*

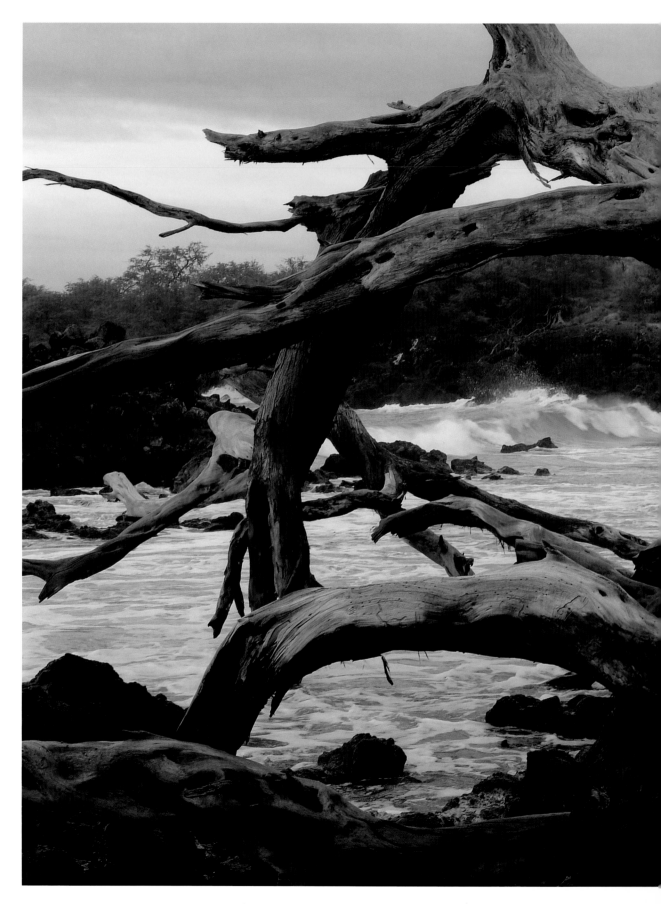

◥ *Massive waves can transport massive driftwood to island beaches.*

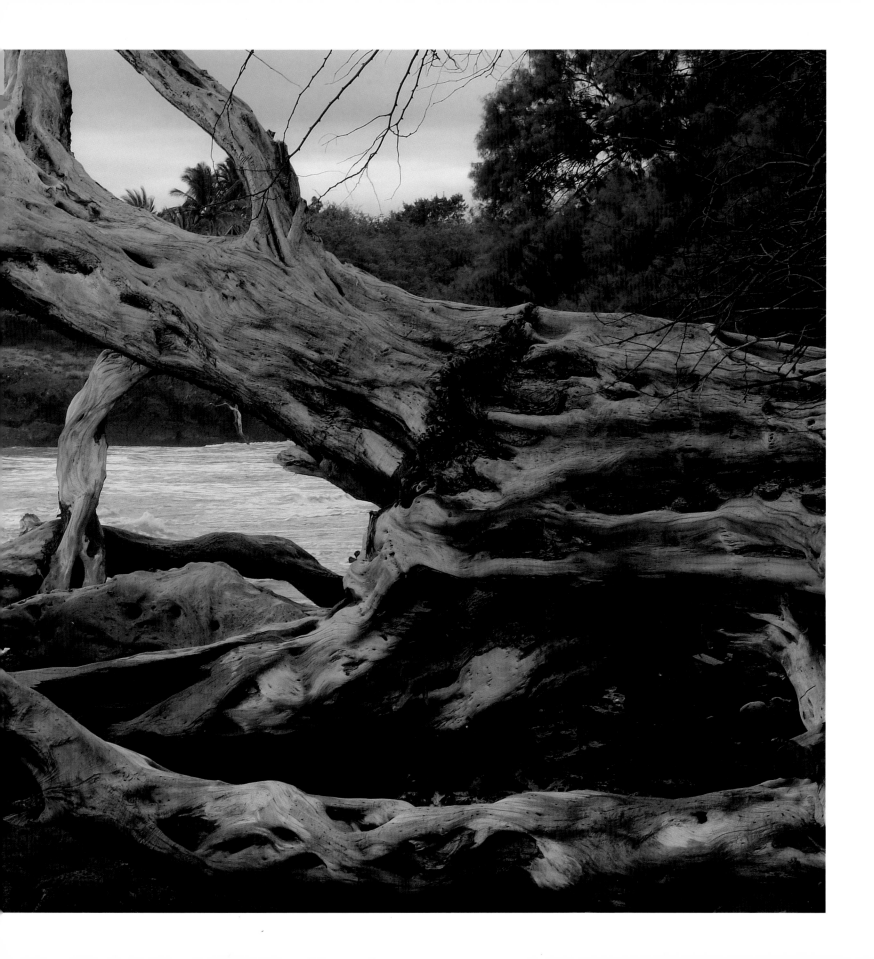

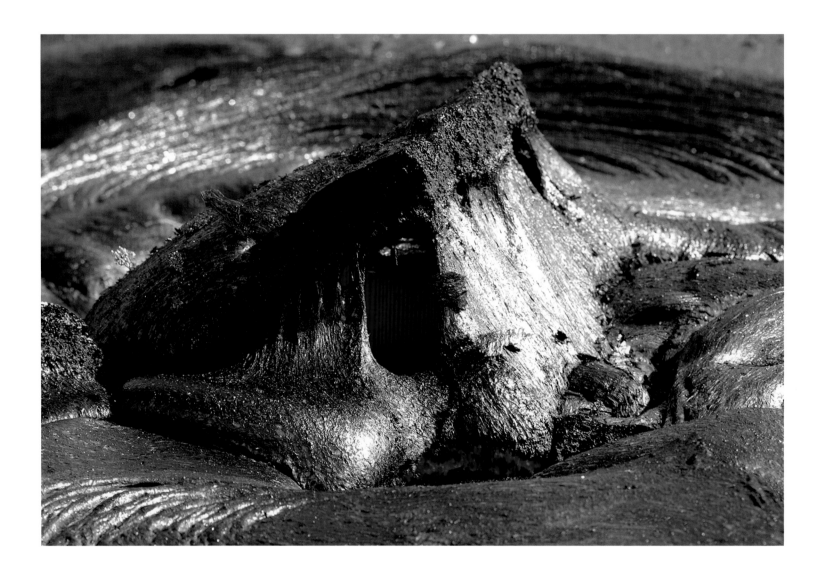

◥ *Sometimes nature pulls back the curtain, allowing you to see what's beneath the surface. At right, the intense heat coming from this rare, vertical skylight blurred our camera as well as our senses.*

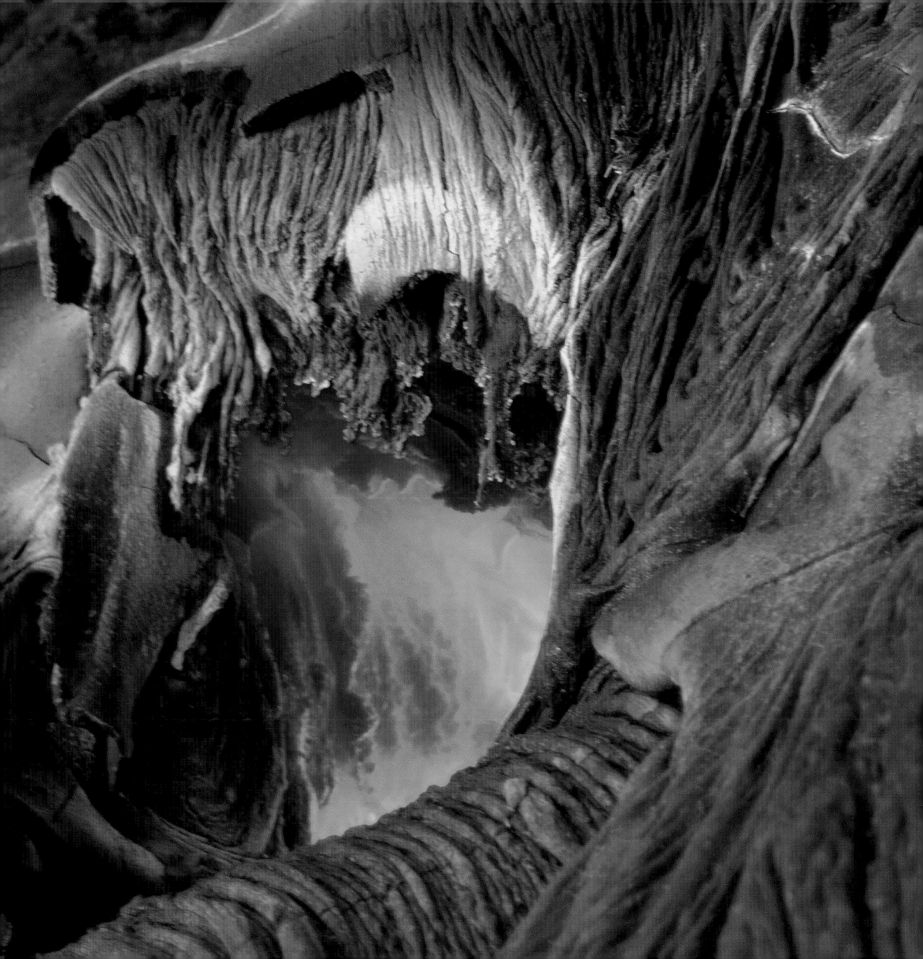

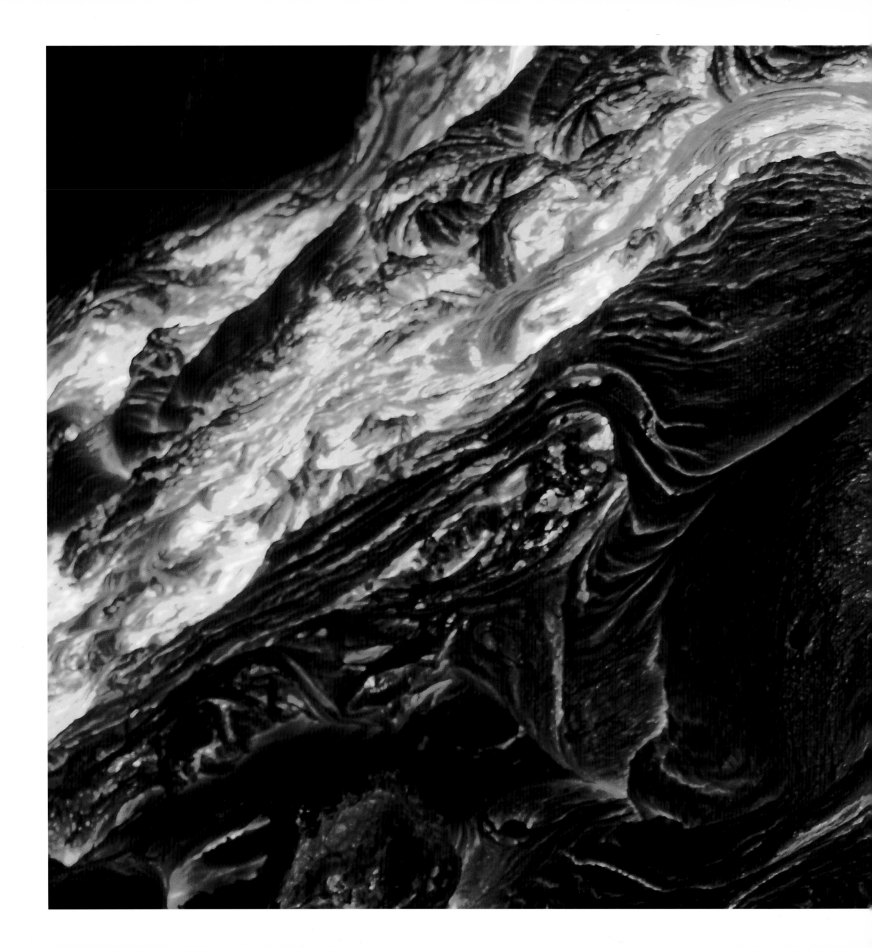

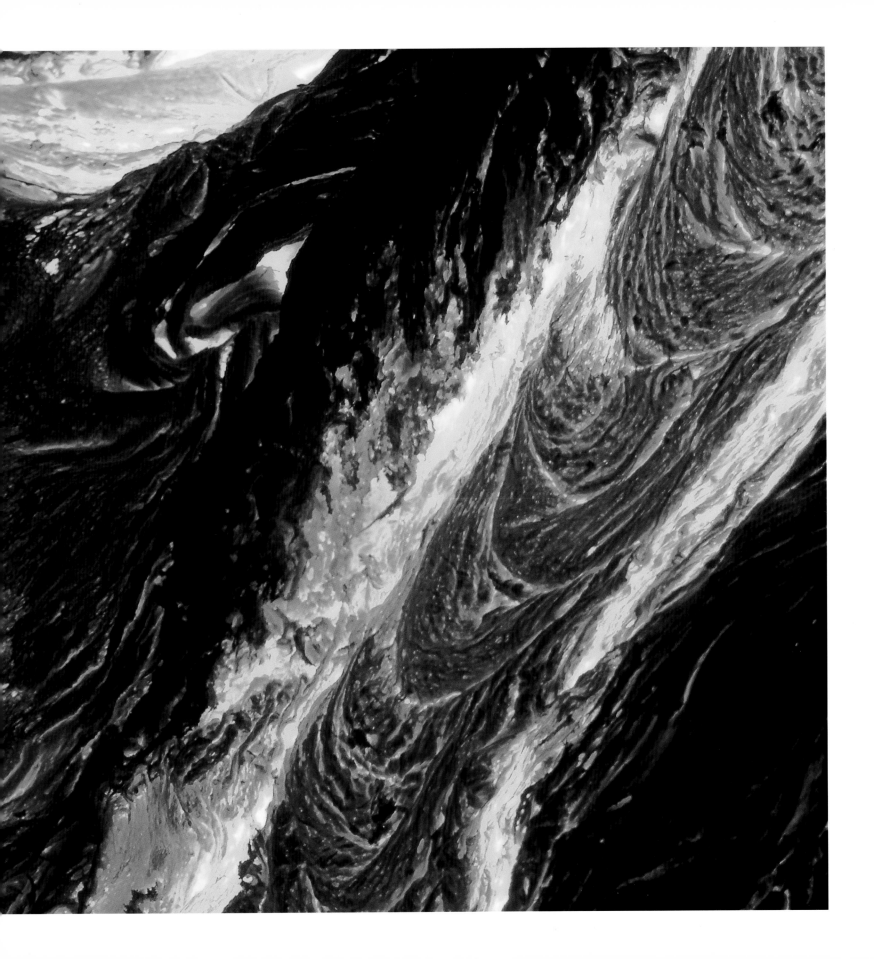

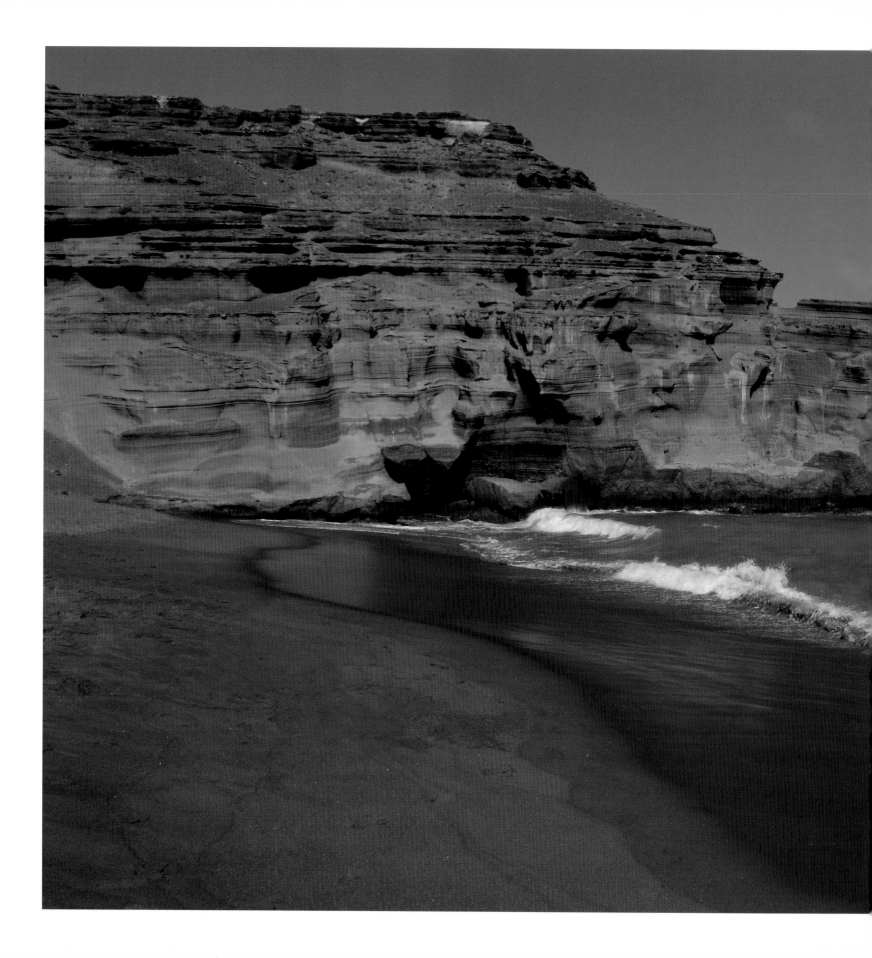

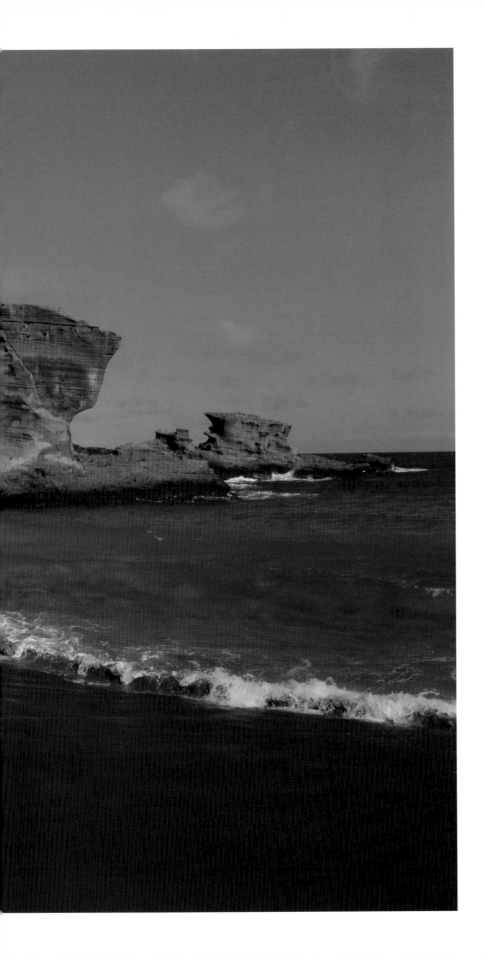

▼ *Imagine a beach made from gems. This is almost the case at Green Sand Beach. A semi-precious gem called olivine is liberally sprinkled with black lava flecks mined from the sidewalls by the tireless ocean.*

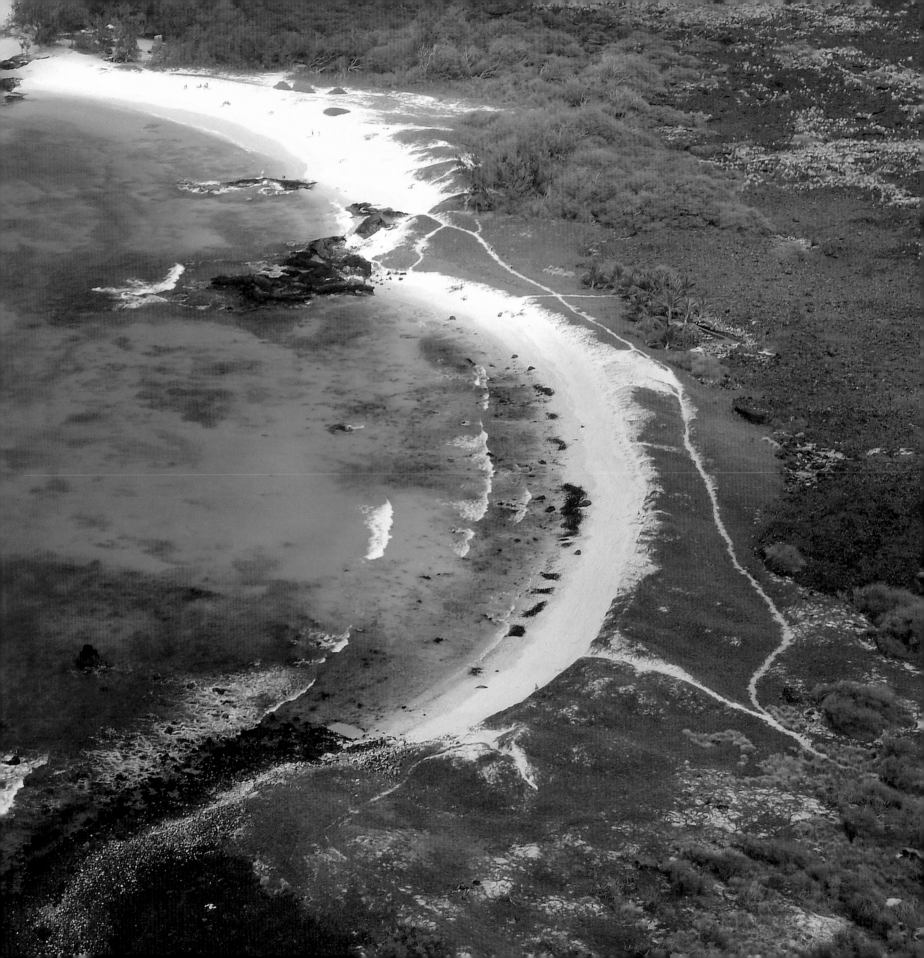

Makalawena Beach near Kona is one of the grandest beaches on the island. You can't drive right up to it, but for those willing to hike a bit, you'll be rewarded with the beach of your dreams.

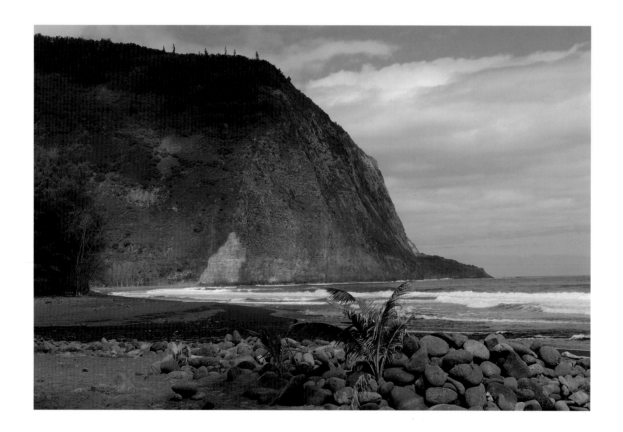

A series of seven valleys defines the Hamakua Coast. Waipio on the left has a few dozen hardy souls living there. The next one, Waimanu, is totally uninhabited.

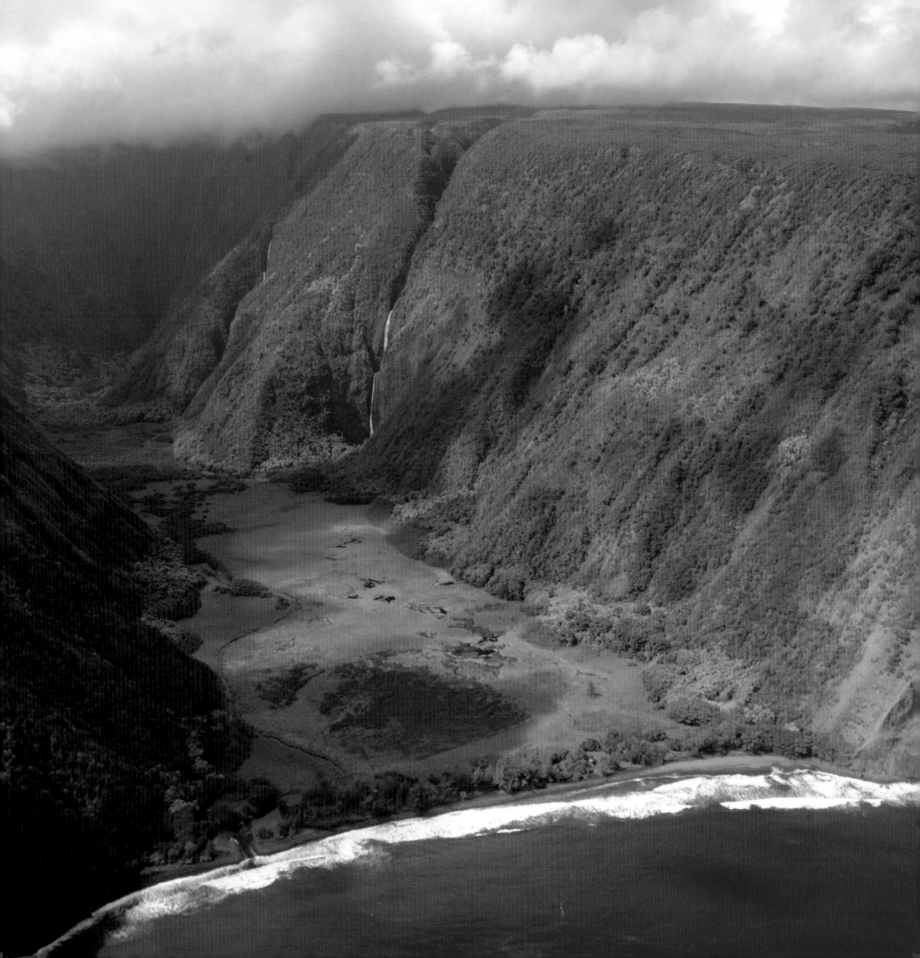

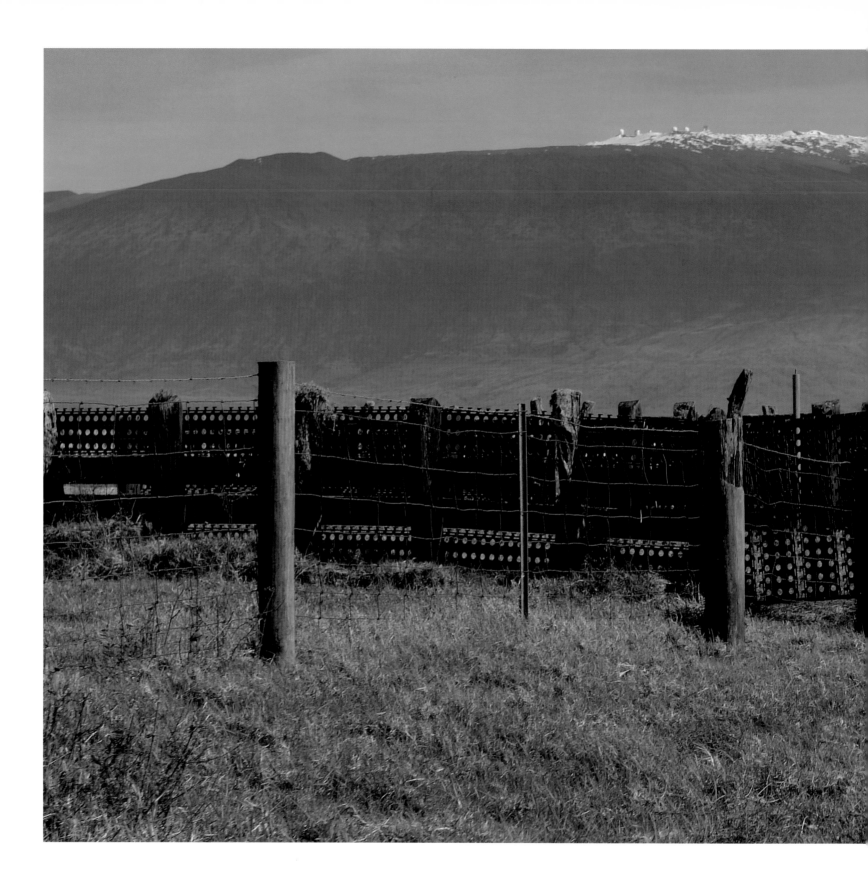

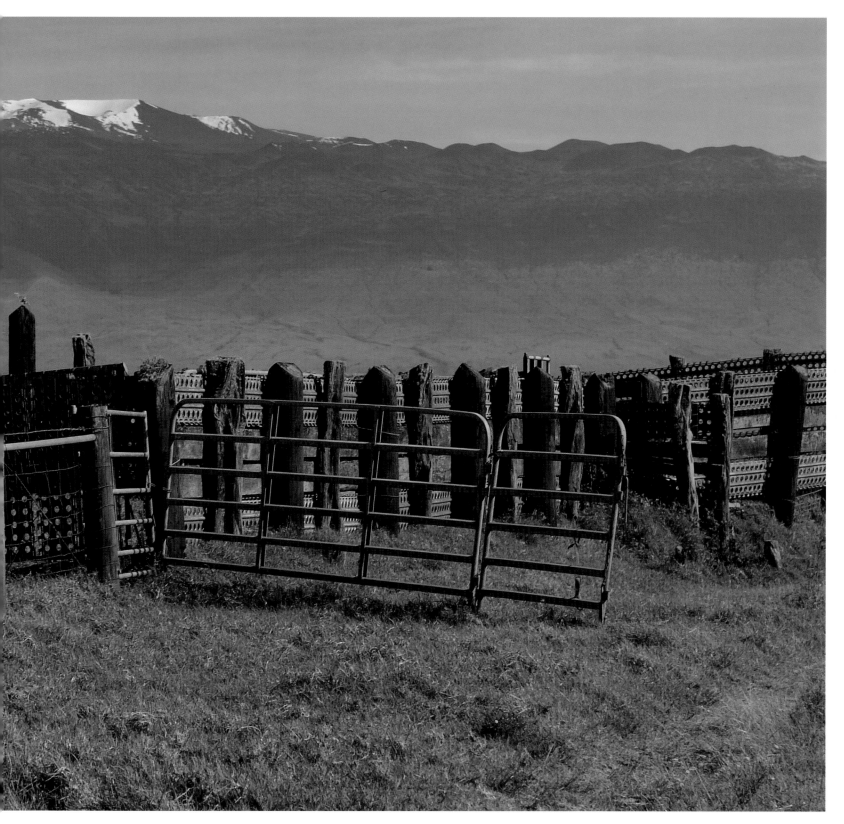

▼ *Cattle corrals and snow-covered mountains. Not exactly what you expected in a Hawaiian scene, is it?*

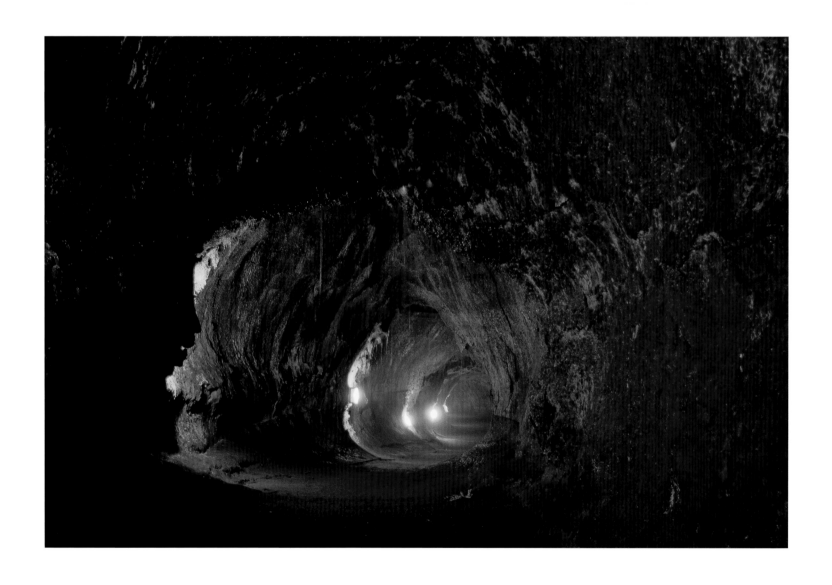

◥ *Lava tubes are simply nature's plumbing, moving magma from its source to its destination.*

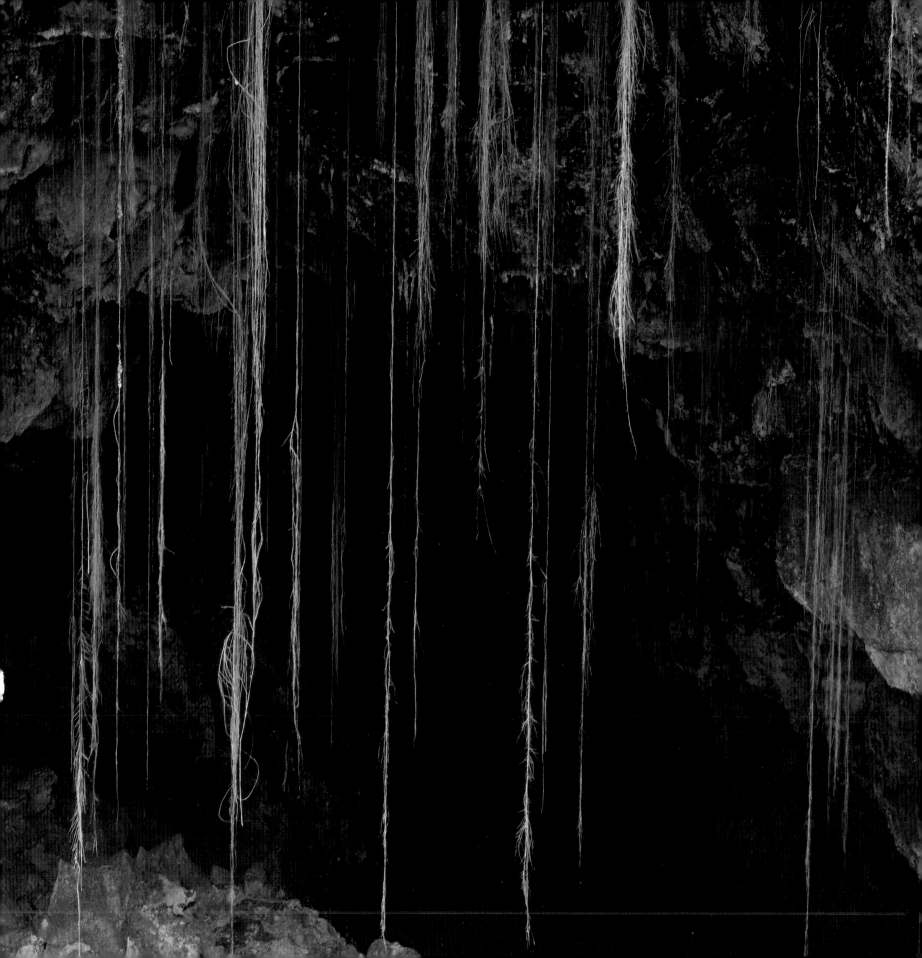

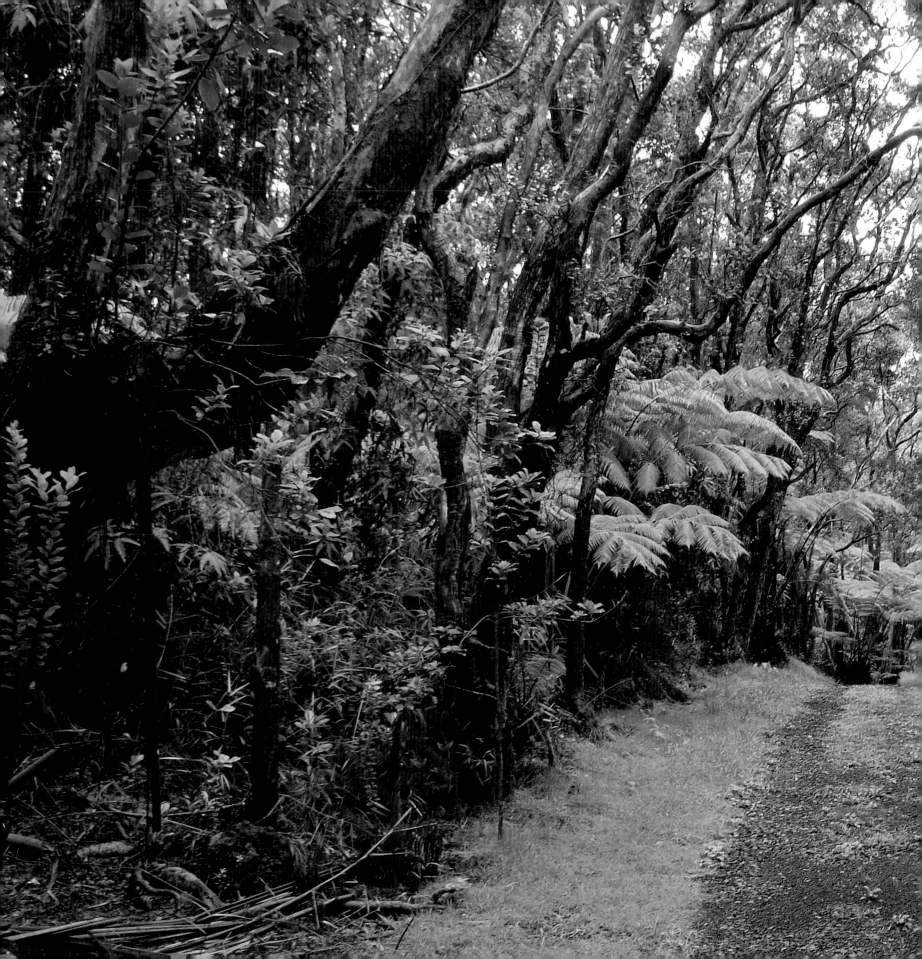

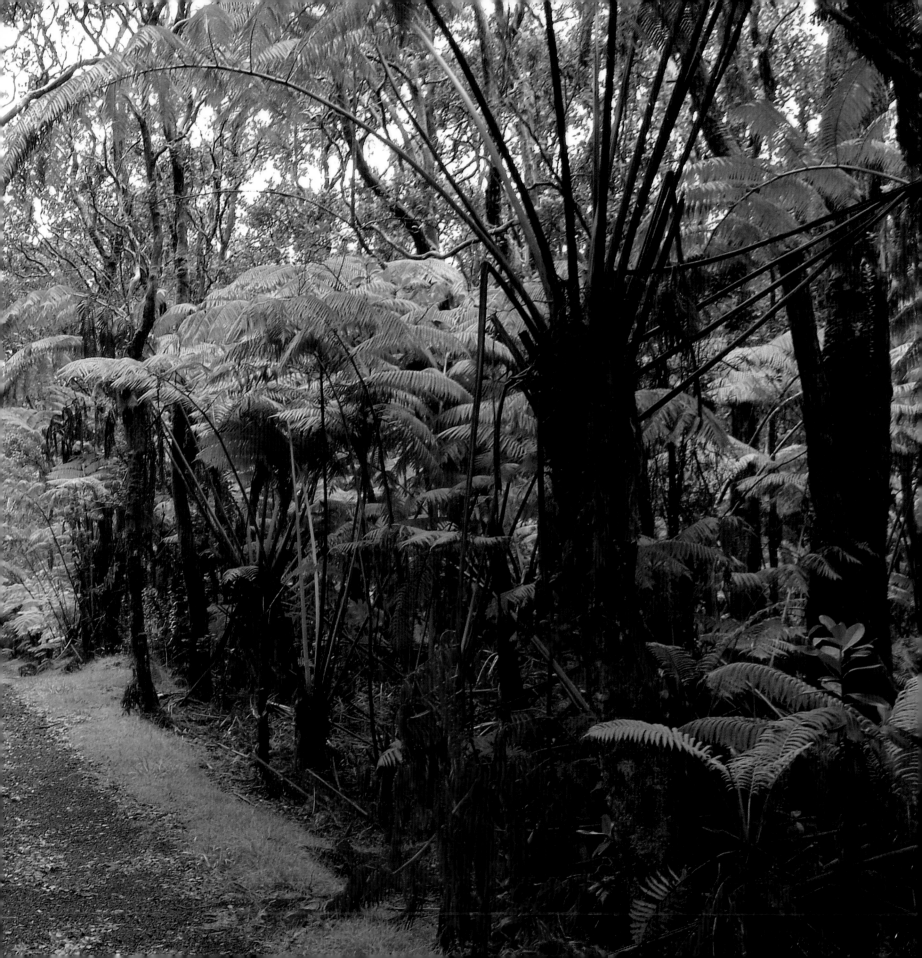

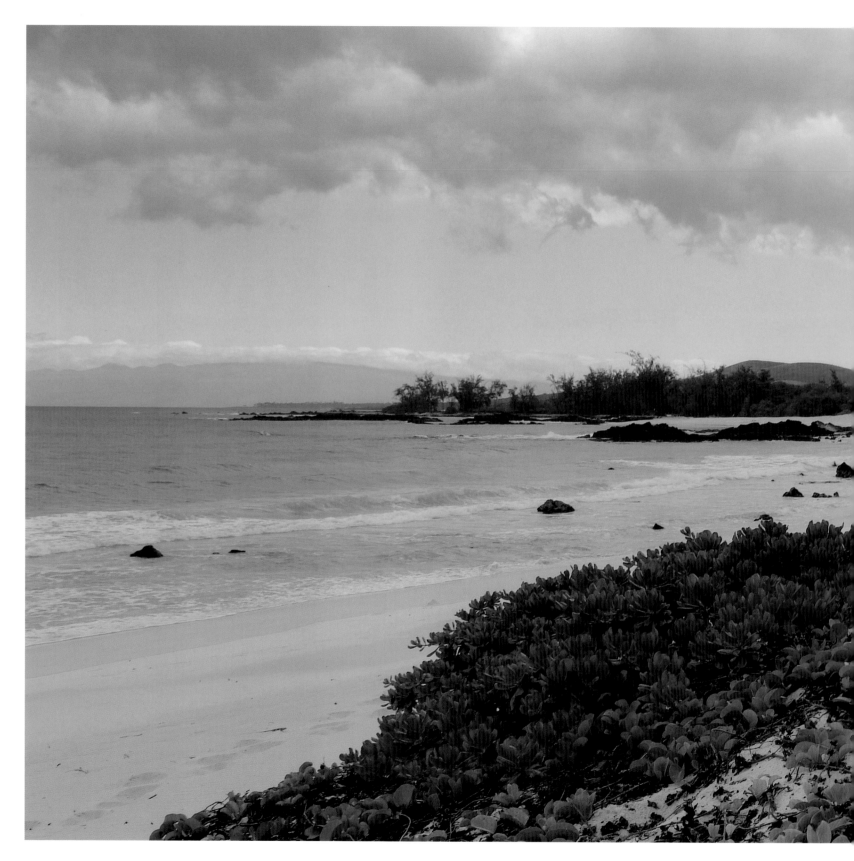

▼ *An etherial walk through lush forests dripping with life.*

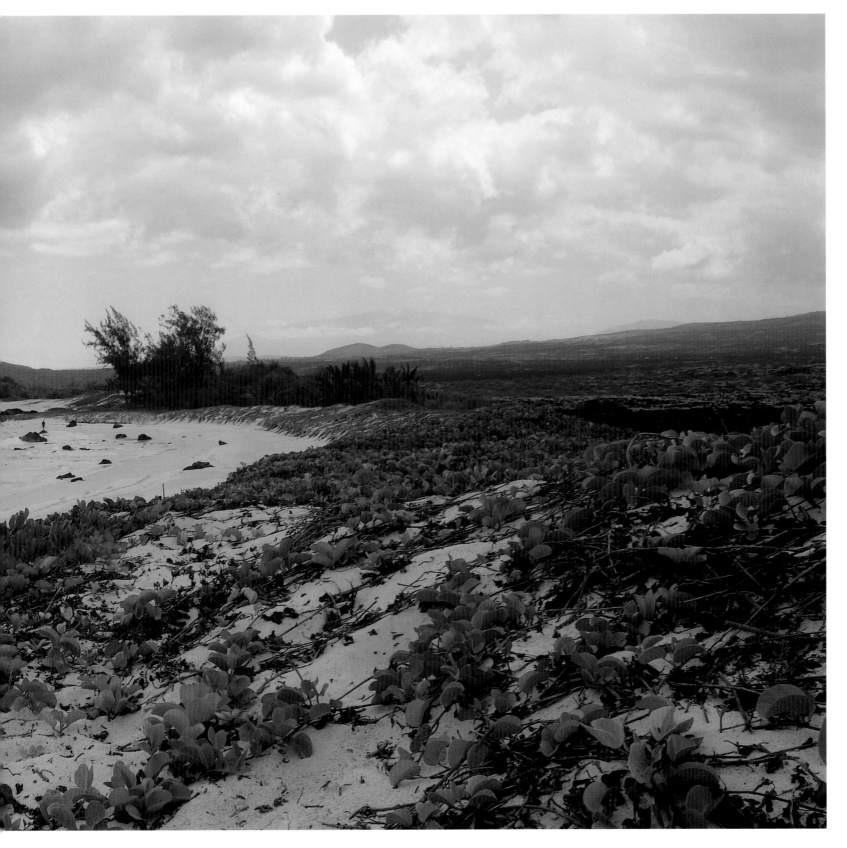

▼ *A crowd of one walks a secluded Big Island beach.*

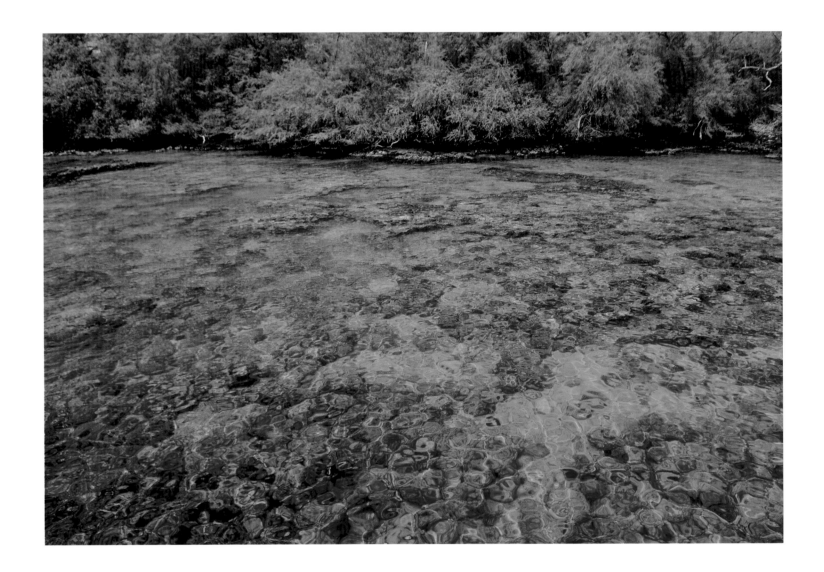

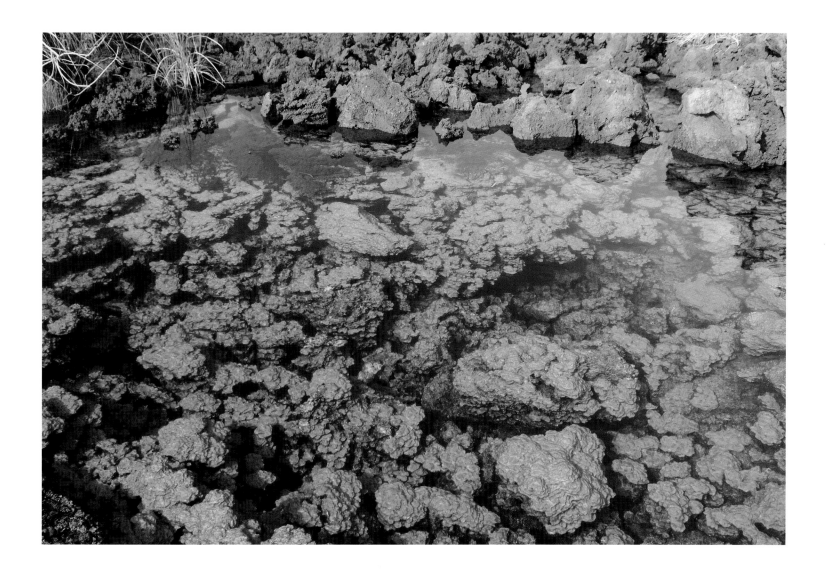

▼ *Whether it's a rich coral reef, such as the one on the left at the Captain Cook Monument, or a reef made from gold-colored algee at an ancoline pond on the right, wonderful textures abound on the Big Island.*

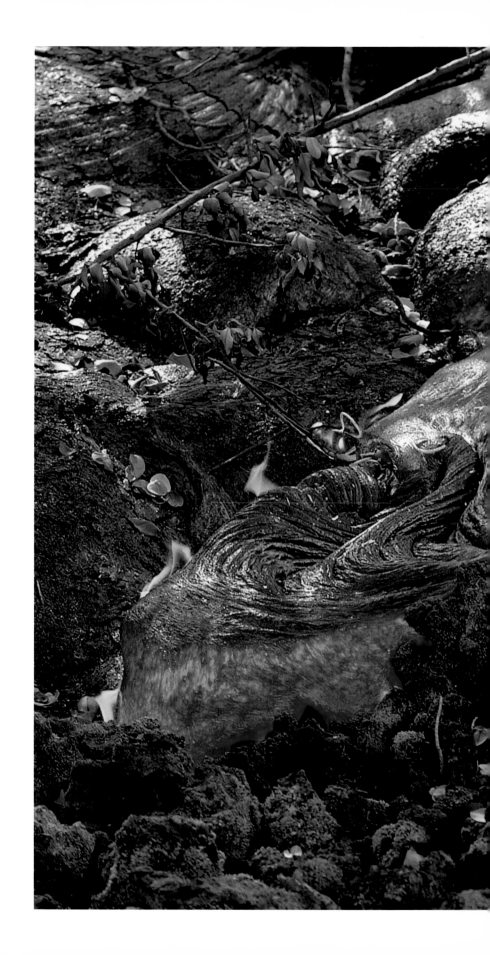

◥ *Lava consumes the old and creates the new all at the same time.*

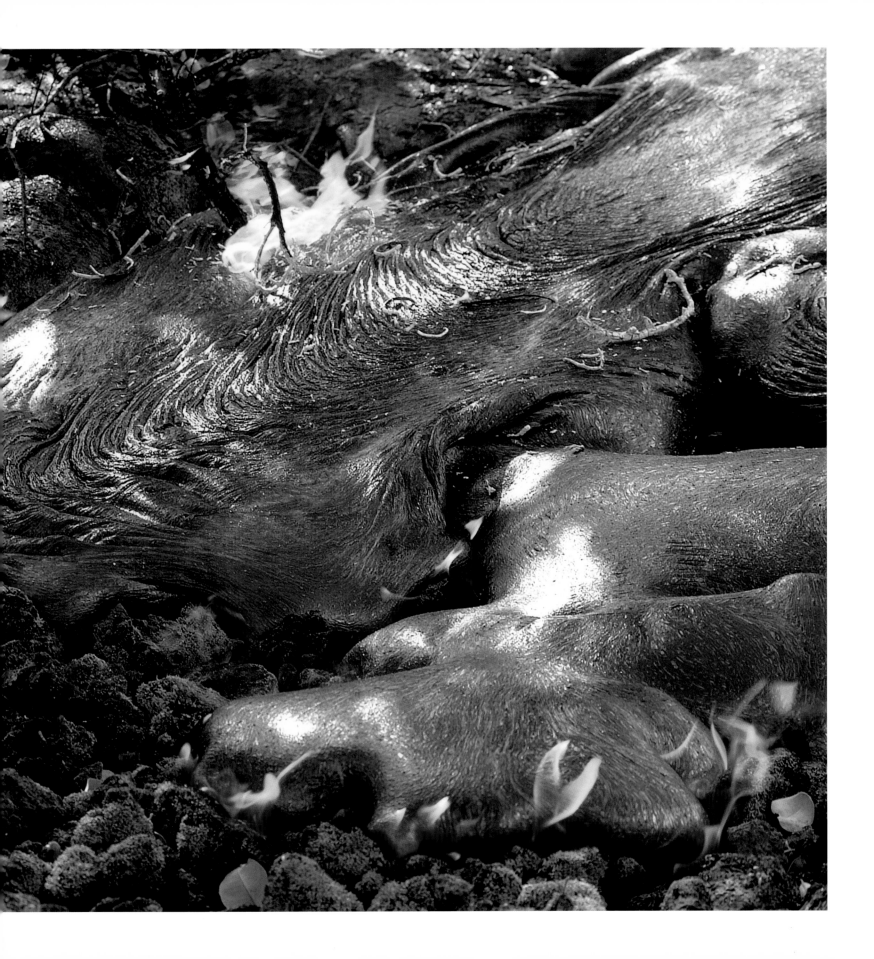

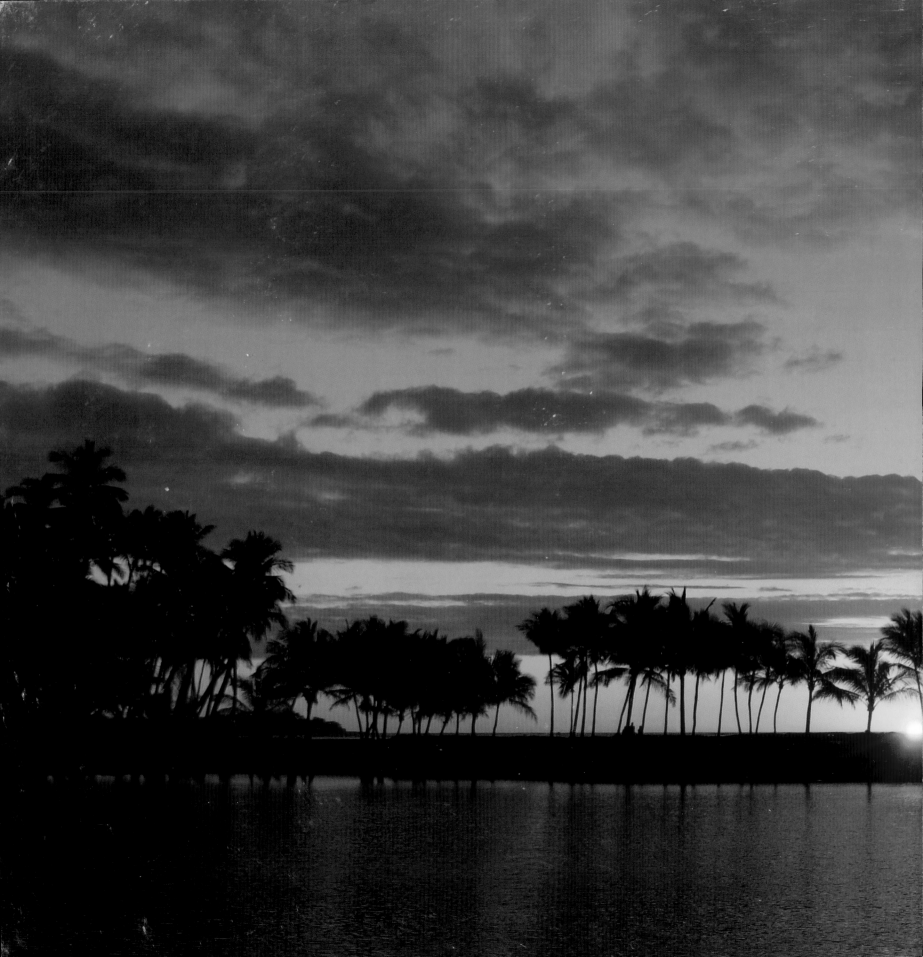

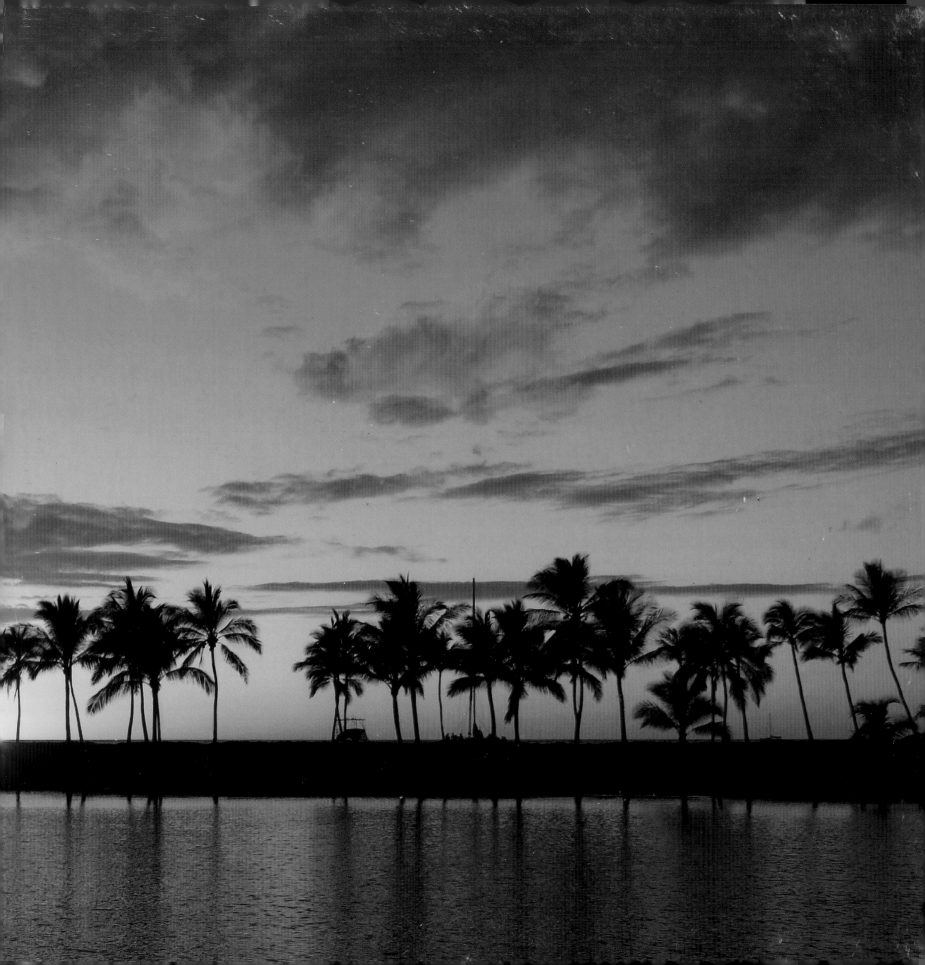

Photography Credits

Andrew Doughty: Pages 6, 10, 18, 20, 26, 27, 30, 36, 39, 40, 42, 45, 49, 54, 56 58, 64, 66, 67, 72, 84, 85, 86, 93, 100, 101, 102, 104, 108, 110, 114, 115, 125, 132, 133, 134, 136, 138, 141, 144, 153.

Leona Boyd: Cover, pages 2, 4, 12, 14, 16, 17, 22, 23, 24, 28, 32, 33, 34, 38, 44, 46, 48, 50, 52, 55, 60, 61, 62, 68, 70, 73, 74, 76, 78, 79, 80, 82, 87, 88, 90, 91, 92, 94, 96, 98, 106, 107, 112, 116, 118, 119, 120, 122, 124, 126, 128, 130, 140, 142, 145, 146, 148, 150, 151, 154.

Acknowledgments

Thanks to all the family and friends who waited patiently for this photo series to finally arrive. To the folks at Everbest for a rock-solid record of coming through for us. To Jan Haag for her keen proofing eye at substance and tyypos. To Lerisa Heroldt for being the front line of defense and the one to run to. To Margaret for her get-'er-done attitude. To Chris, wherever he may be. And finally to Lisa Pollak, who designed this beautiful book and remains the unsung hero and tireless backbone here at Wizard Publications.

Look for our other books...

Hawaii The Big Island Revealed: The Ultimate Guidebook

Maui Revealed: The Ultimate Guidebook

Oahu Revealed: The Ultimate Guidebook

The Ultimate Kauai Guidebook: Kauai Revealed

Other books in this photographic series include:

Hawaii Dreamscapes Revealed–Kauai

Hawaii Dreamscapes Revealed–Maui

Hawaii Dreamscapes Revealed–Oahu